Introduction

The hundred works in the Gallerie Nazionali di Arte Antica illustrated in this volume are usually kept a few kilometers apart in the rooms of the Galleria Corsini and Palazzo Barberini. The gallery, created by Cardinal Neri Corsini, the only 18th-century Roman painting collection that still survives today in its original display and the *raison d'être* of our museum, deserves to be kept exactly as it was displayed by its creator and maintained by his descendants. Works from other collections—Torlonia, Chigi, Odescalchi, Sciarra, Hertz, Barberini—or purchased individually over the years are on display in Palazzo Barberini. Most of the one hundred masterpieces in our collections can thus be found side-by-side only in the pages of this book, a survey and a visual testament to a collection that is at once full of surprises and extraordinarily coherent.

Most of the works in the Gallerie Nazionali di Arte Antica share the same history: they were executed in Rome in the 17th and 18th centuries, commissioned, and exhibited by the same collectors who then passed them on to other later connoisseurs. Eventually, they came to form the core of one of the first state museums established in Rome after the Unification of Italy and opened to the public in 1895 in Palazzo Corsini in Via della Lungara. The ambition of Adolfo Venturi (1856–1941), founder of this and other state collections, was to create a national gallery modelled on those of the great capitals of Europe, though the museum's history has been a turbulent one. The nine rooms of the Corsini Gallery were completely inadequate from the outset and the Italian state's eventual purchase of Palazzo Barberini to house the gallery in 1949 did not significantly improve matters since much of the building was occupied by the Ministry of Defense officers' club. Only in 2018 did the entire building become a museum.

For these and other reasons—and luckily for us—the Gallerie Nazionali are now a very different museum from that envisioned by Adolfo Venturi. After becoming an independent institution in 2015, they took the name of Gallerie Nazionali Barberini Corsini in honor of the two papal families who played a leading role in the arts and culture of the 17th and 18th centuries, in Rome and internationally, and whose deeply intertwined history substantially shaped the museum. Developed around Neri Corsini's extraordinary painting collection, our collections also tell the story of how works of art have been viewed, arranged in space, narrated, and exchanged from the 18th century to the present.

The Gallerie Nazionali Barberini Corsini are thus an extraordinary and, in their way, unique contextual museum, important not only for the undeniable masterpieces they preserve but also for the web of artworks and personalities that the ˌˌ ˌˌ light. Walking through the halls (and storerooms) of the Gallerie imm arts in Rome between 1600 and the late-18th century triggered by the works of Caravaggio and their countles Italian and foreign followers; the classicism of the Bo blossoming of Baroque painting in the frescoes by Pietro da ˌˌˌˌˌ

the classicism of the second half of the 17th century, the international milieu of the *Grand Tour*, the dawn of Neoclassicism. These were centuries in which, at any rate from an artistic and cultural point of view, Rome was still the center of the world. For at least three hundred years, both in Europe and in the Americas, anyone who wished to become an artist, collector or writer on art visited and lived in Rome or dreamed of doing so: our collections represent this cosmopolitan world, real and imagined, better than any other.

Caravaggesque paintings constitute the extraordinary core around which the museum as we know it developed: over a hundred works created in Rome between 1600 and 1630 by artists such as Giovanni Baglione, Orazio Gentileschi, Orazio Borgianni, Carlo Saraceni, Giovanni Serodine, Simon Vouet, Valentin de Boulogne, Jusepe de Ribera, Hendrick ter Brugghen and many others. This is a large, complex, and coherent group that allows us to discover and familiarize ourselves with the connections between individual artists during a period of artistic creation that transformed European art.

The Caravaggesque paintings in our collection vividly illustrate the beginnings of another equally revolutionary cultural phenomenon: the establishment in Rome of a generation of connoisseur-collectors who in the early decades of the 17th century gave rise to a new way of writing about, looking at, and trading art. In these years painting collections became common in Roman palaces and people began to write about art from the perspective of the collector, that is, of the viewer. Art criticism was thus invented—a completely new kind of writing that emerged between 1617 and 1621 with the *Considerazioni sulla pittura* by Giulio Mancini, Maffeo Barberini's doctor, analyzing the interpretations of Caravaggio by his associates and followers.

In the halls of Palazzo Barberini we find some Caravaggesque paintings that in the 1620s were kept in the gallery whose decorations were commissioned by Asdrubale Mattei (1566–1638), with his brother Ciriaco one of the major patrons of Caravaggio and his followers, we find some of the individuals belonging to the group of intellectuals gravitating around Palazzo Barberini, like the musician Marco Marazzuoli (1602–1666), who commissioned Giovanni Lanfranco to paint the *Allegory of Music*, a portrait of the magnificent Barberini harp played by Venus. This gallery of protagonists culminates with Neri Corsini (1685–1770), who was not only one of the major collectors of his time but also, with his adviser Giovanni Gaetano Bottari (1689–1775), the mastermind behind the foundation of the Capitoline Museums, Europe's first public museum, opened in 1734 during the pontificate of his uncle Clement XII. Since the time of Neri and systematically since the 19th century, the Corsini Gallery has been open to the public every day and visited by travelers from all over Europe.

The rooms hosting the collection are art works in their own right and are presented as such in this book. Maffeo Barberini (1568–1644), elected to the papal throne as Urban VIII in 1623, with his nephews Francesco (1597–1679) and Antonio (1607–1671), were the creators of Palazzo Barberini, the place where the Baroque takes life and form in the extraordinary allegorical frescoes decorating its monumental halls: Andrea Sacchi's *Divine Wisdom* executed in 1629–1630, and Pietro da Cortona's *Divine Providence*, completed between 1632 and 1639. The experimental prototype of secular Baroque architecture, Palazzo Barberini is also the place where Gian Lorenzo Bernini and Francesco Borromini tackled architectural space for the first time, respectively in the Square staircase and the Spiral staircase, experimenting with new forms that in the following decades were to transform Rome and that still inspire architects all over the world.

During the long reign of Urban VIII (1623–1644), Palazzo Barberini was the true court of Rome, a place where the aesthetic dimension of art was inseparable from its rhetorical and political aspects. It is no coincidence that the palace is designed to be visited, if not physically then at least in the imagination. One of the first descriptions of Pietro da Cortona's hall, *Il pellegrino o vero la dichiaratione delle pitture della Sala Barberina* (1639), was written by Francesco Bracciolini (1566–1645), a poet at the Barberini court who in the text impersonates a butler guiding a foreigner around the palace. During the 18th century, all the numerous guides to the city devoted ample space to the palace, describing the rooms and some works in the collection in detail, especially the *Fornarina*, Raphael's famous portrait of his lover painted a few months before his death. During the 19th century, another "portrait" of a woman attracted ecstatic admirers from all over the world: the presumed image of Beatrice Cenci then attributed to Guido Reni of which Percy Bysshe Shelley wrote in the tragedy *The Cenci* (1819), Stendhal in the short story *The Cenci* (1837), later part of the *Italian Chronicles*, Nathaniel Hawthorne in *The Marble Faun* (1860), and many others.

Palazzo Corsini takes the form familiar to us about a century after Palazzo Barberini, starting in 1734 when Neri Corsini commissioned the architect Ferdinando Fuga to transform the existing Palazzo Riario in Via della Lungara. At Palazzo Corsini, Baroque splendor gives way to an airy and rational architecture clearly reflective of both the personality of Neri and the pontificate of his uncle Lorenzo (1652–1740), who ascended to the papacy in 1730. The building's public purpose is built in and inspired by a vision of culture's role in the public sphere that is already, in its own way, that of the Enlightenment: in 1734 Pope Clement XII began to open the Capitoline Museums to the public on a regular basis and Neri arranged for the creation of a sumptuous catalogue. The building in Via della Lungara is designed to display the important collections assembled by Lorenzo and Neri: the extraordinary collection of books and prints, for example, is housed in a splendid library, designed as the first public library in Trastevere and now home to the Accademia dei Lincei.

Neri was an enthusiastic collector and personally dedicated himself to arranging the works in his apartment on the *piano nobile* of the building where they can still be seen today, displayed according to the information provided by the inventory of his possessions drawn up after his death in 1771. The cardinal's choices reflected the classicizing taste of his time, but at the same time Neri was a curious collector open, for example, to the painting of the Caravaggesques or of northern European artists such as Rembrandt—of whom he owned an extraordinary self-portrait—Pieter Paul Rubens and Antoon Van Dyck, or Spaniards, like Esteban Murillo, purchased both in Rome and in Brussels where he had gone on his travels as a diplomat; he also appreciated Caravaggio and the paintings of his followers and interpreters like Orazio Gentileschi, Jusepe de Ribera, Simon Vouet and many others.

This fundamentally non-academic curiosity is reflected in his picture gallery, inspired by the principles of symmetry and balance but in fact arranged so as to encourage the visitor to identify visual, formal, and even conceptual associations. Yet one room resists this playful intellectual spirit: the so-called Canonization Room, where a series of important paintings commissioned by the family have been housed since Neri's time around the extraordinary mosaic portrait of Clement XII and his nephew. This is a room that exudes religious devotion and that for precisely this reason clashes with the remainder of the painting gallery. Yet this slightly jarring combination of devout and secular is perhaps one of the salient features of the first half of the 18th century, visible in the spaces of the Corsini Gallery and in many works in Palazzo Barberini, above all the extraordinary group portrait, *The Quarantotti Family*, painted by Marco Benefial in 1756.

Since the 1830s, the "gallery of paintings" on the *piano nobile* of Palazzo Corsini has been a museum open to the public every day from 9 a.m. to 3 p.m. Eugène Loudun's *Les gardiens des musées*, a sort of comparative analysis of the ways in which visitors were received in various European museums, published in 1884, praises the well-informed curators who accompanied visitors, the paintings mounted on pivots so that they could be rotated to be shown in the most favorable light, and the lensless spectacles made available to visitors to visually isolate the paintings for observation.

As in other European countries, also in Italy, the situation of the great aristocratic families changed radically in the second half of the 19th century. In 1883, Prince Tommaso Corsini sold the palace in Via della Lungara to the Italian state and at the same time gave away all the collections kept within. This was the initial act of foundation of the Gallerie Nazionali and an event that was to have an enormous impact on Italy's cultural heritage. To make the donation possible, parliament passed a new law permitting the alienation of the Roman fideicommissary collections—which according to pre-existing papal legislation could not be dismembered or moved from their original home—as long as they were purchased by the Italian state or by charitable institutions that guaranteed their public accessibility in perpetuity. Thanks to this law, the Corsini, Borghese and Spada collections became public heritage.

After the Unification of Italy, Rome was the only major city that did not host a state museum. The Corsini donation and the purchase of the palace in Via della Lungara thus marked the birth not only of the Gallerie Nazionali, but of a state policy with respect to Rome's cultural institutions.

The six hundred works of the Corsini donation were joined in the same year by about two hundred paintings from the Monte di Pietà, the Vatican lending institution absorbed in 1874 by the Cassa Depositi e Prestiti. In 1849, the then president of the Monte, Marquis Giampietro Campana (1808–1880) managed to have the statutes of the institution revised, allowing people to pawn works of art in exchange for cash loans. The Monte di Pietà thus accumulated thousands of objects that were never redeemed by their owners and an immense deficit. In 1857, Campana was found guilty of embezzlement and about three thousand objects were dispersed in a series of sales that distributed works of exceptional importance among public and private collectors in Italy and abroad.

The two hundred paintings acquired by the Italian state in 1883 were selected by the painter Nicola Consoni, then president of the Accademia di San Luca and now completely unknown. He was an academician educated in the tradition of classicism and able—unlike the art historians of his generation—to recognize the merits of naturalist, Baroque, classicizing and neoclassical painting. This allowed him to identify works that, merging perfectly with the Corsini collection, gave the later Gallerie Nazionali their extraordinary coherence: Giovanni Baglione's *Sacred and Profane Love* from the collection of Cardinal Benedetto Giustiniani, Valentin de Boulogne's *Expulsion of the Merchants from the Temple* and eight other paintings from the legendary collection of Cardinal Fesch, uncle of Napoleon Bonaparte; and again, Orazio Gentileschi's *St. Francis Supported by an Angel* or Carlo Saraceni's *St. Cecilia*, up to Anton Raphael Mengs' *Jupiter and Ganymede*. These were the last remnants of a fortuitous and yet amazing storehouse of wonders, the final stage in the tortuous process of relocating the immense artistic heritage of Rome's aristocratic families following the historical transformations triggered by the French Revolution and the Risorgimento.

A few years later, in 1892, Adolfo Venturi managed to acquire about three hundred paintings donated to the Italian state by the Torlonia family, with the condition that they were to enter a

public gallery. Collected in the early decades of the 19th century by Giovanni Torlonia (1754–1829), a banker of recent and immense wealth advised by Giuseppe Valadier, the Torlonia collection also reflects the transformations that took place in the wake of the French Revolution as well as the emergence of a new category of collectors. The latter were bankers and entrepreneurs for whom acquiring works of art was primarily a way of asserting their social status and identity in both the private and the public sphere, a group of which Torlonia was one of the greatest Italian exponents. This is a highly eclectic collection, made up of works purchased from declining Roman families, but also of objects found on the international market; it is no coincidence that some of the most interesting portraits in the Gallerie Nazionali come from the Torlonia collection, including the *Portrait of Henry VIII* executed in Hans Holbein's workshop.

Finally, on 9 June 1895, the Galleria Nazionale di Arte Antica was opened to the public with an exhibition display curated by Adolfo Venturi, who was nonetheless well-aware of the considerable limitations of the project: the totally inadequate spaces and the absence of representative works of the Renaissance. Some of the most important in the collection, such as the *Annunciation* by Filippo Lippi, arrived after 1913, the year of the donation of Henrietta Hertz (1846–1913), a Jewish-German philanthropist. With her friend Ludwig Mond (1839–1909)—a German industrialist residing in England who donated his own collection to the National Gallery in London—and Jean Paul Richter (1847–1937)—a connoisseur and merchant who studied under Giovanni Morelli—Hertz was involved in a singular collecting venture, unusually taking the form of a collective rather than an individual enterprise. Other 16th-century paintings, like Agnolo Bronzino's extraordinary *Portrait of Stefano IV Colonna* of 1546, arrived in the gallery in 1896 with the Sciarra donation. A few years earlier, in 1891, the latter collection, largely consisting of works originally owned by the Barberini family, had been at the center of a scandal: a sensational sale of twenty-one paintings illegally exported to Paris.

The extraordinary and crucial Barberini collection, however, never arrived. Despite the attempts of the family and numerous public officials to ensure a public takeover, the Italian state, now under the Fascist regime, failed to act. Indeed, a law of 1934 allowed the Barberini family to disperse the collection in exchange for the donation of some works, including the *Fornarina* and the *Portrait of Beatrice Cenci*. The history of the Gallerie Nazionali is thus also a history of misguided and failed policies, and it should not be forgotten. At the same time, the gallery has, since its foundation, been a collection in the making that has welcomed exceptional finds, such as Caravaggio's *Judith and Holofernes*, rediscovered in 1951 by Pico Cellini and Roberto Longhi and purchased twenty years later.

Our founders are Neri Corsini, an 18th-century collector eager to ensure public accessibility; Adolfo Venturi, who with others gave shape and purpose to the idea of national heritage; Federico Hermanin (1868–1953), who directed the gallery in the early years of the 20th century and developed an enthusiasm for 17th-century painting, taking to heart the dissemination of the most innovative art-historical research, the collection's international dimension, the opening to modern art and new acquisitions, above all the *Narcissus*, the extraordinary painting discovered by Longhi whose donation to the galleries Hermanin managed to arrange in 1914; and finally Henrietta Hertz, a visionary inspired by a notion of philanthropy and the restitution of private wealth to the public originating in the English-speaking world and far removed from the Italian cultural context, who, at a time of rampant nationalism, donated her works of art to her chosen homeland.

The hundred masterpieces illustrated in this volume represent the sum of their visions: an imaginary museum that has become real.

Bibliography

The Barberini palace and family
M. Aronberg Lavin, *Seventeenth-Century Barberini Documents and Inventories of Art*, New York 1975

P. Waddy, *Seventeenth-Century Roman Palaces: Use and the Art of the Plan*, New York-Cambridge-London 1990

J. B. Scott, *Images of Nepotism: The Painted Ceilings of Palazzo Barberini*, Princeton 1991

P. Rietbergen, *Power and Religion in Baroque Rome: Barberini Cultural Policies*, Leiden-Boston 2006

I Barberini e la cultura europea del Seicento, ed. by L. Mochi Onori, S. Schütze, F. Solinas, Rome 2007

The Corsini palace and family
Storie di Palazzo Corsini. Protagonisti e vicende nell'Ottocento, ed. by A. Cosma, S. Pedone, Rome 2016

Palazzo Corsini a Roma, ed. by A. Zuccari, Modena 2019

Rembrandt alla Galleria Corsini: L'autoritratto come San Paolo, ed. by A. Cosma, Turin 2020

La Madonna del latte di Murillo alla Galleria Corsini. Storia e restauro, ed. by A. Cosma, Venice 2021

History of the Galleria Nazionale di Arte Antica
A. Fineschi, *Lo scandalo Sciarra: libero mercato o pubblico interesse?*, "Gazzetta Antiquaria", 25/26, 1995, pp. 42-53

G. Agosti, *La nascita della storia dell'arte in Italia. Adolfo Venturi dal museo all'università (1880-1940)*, Venice 1996

P. Nicita, *Musei e storia dell'arte a Roma. Palazzo Corsini, Palazzo Venezia, Castel Sant'Angelo e Palazzo Barberini tra XIX e XX secolo*, Rome 2009

La donazione di Enrichetta Hertz, 1913-2013, ed. by S. Ebert-Schifferer, A. Lo Bianco, Cinisello Balsamo 2013

The collection
Caravaggio e i suoi: percorsi caravaggeschi da Palazzo Barberini, ed. by C. Strinati, R. Vodret, Naples 1999

L. Mochi Onori, R. Vodret, *Galleria Nazionale di Arte Antica, Palazzo Barberini. I dipinti*, Rome 2008

Baroque Pathways: The National Galleries Barberini Corsini in Rome, ed. by M. Cicconi, M. Di Monte, I. Richter, O. Westheider, München-London-New York 2019

Collecting and art criticism in Rome in the 17th century
Life and the Arts in the Baroque Palaces of Rome: Ambiente Barocco, ed. by S. Walker, F. Hammond, New Haven 1999

Decorazione e collezionismo a Roma nel Seicento: vicende di artisti, committenti, mercanti, ed. by F. Cappelletti, Rome 2003

P. Cavazzini, *Painting as Business in Early Seventeenth-Century Rome*, University Park 2008

Display of Art in the Roman Palace, 1550-1750, ed. by G. Feigenbaum, Los Angeles 2014

D. L. Sparti, *Novità su Giulio Mancini. Medicina, arte e presunta 'Connoisseurship'*, "Mitteilungen des Kunsthistorischen Institutes in Florenz", 52, 2008, pp. 53-72

A. Frigo, *Can One Speak of Painting if One Cannot Hold a Brush? Giulio Mancini, Medicine, and the Birth of the Connoisseur*, "Journal of the History of Ideas", 73, 3, 2012, pp. 417-436

Palazzo Barberini

Bernini's and Borromini's staircases

The complex process of constructing Palazzo Barberini (1625–1633), commissioned by Pope Urban VIII, was begun by Carlo Maderno, enlarging an earlier palace belonging to the Sforza family. On Maderno's death (1629), work carried on under the direction of Gian Lorenzo Bernini, who continued the collaboration already under way in the palace with Francesco Borromini. A Baroque masterpiece, the building abandons the typical Renaissance courtyard layout in favor of a plan with two opposing residential wings, linked by the main body and by two vertical connecting elements. This arrangement was already in place at the end of the 16th century, though the decision to create a ceremonial square staircase and an oval one intended for private use appears unique and innovative. Over time, the two staircases, similar in their formal design with paired columns overlooking an open balustraded stairwell and lit from above, became teaching models in academies and their uncertain attribution—the square one to Bernini and the oval one to Borromini—a pretext for an ongoing debate on the characteristics of the Roman Baroque.

Square staircase

The square staircase, also used as a ceremonial route, served the wing of the palace reserved for the secular branch of the family. The design had to take into consideration numerous constraints, including compliance with the floor levels established by Maderno's project, already partially completed, and the need to intercept a series of openings: on the basement floor that leading onto the courtyard of the Cavallerizza (now Via Barberini), on the ground floor the entrance to the apartments of Taddeo Barberini and, on the upper floors, the entrances to the quarters of Anna Colonna and Costanza Magalotti, the prince's wife and mother respectively. The typological choice of a square staircase with four flights appeared the most suitable for combining all these elements.

The modernity of the Palazzo Barberini staircase compared to 16th-century typologies lies in the choice of an open stairwell with pillars and columns, lit from above, probably influenced by French architecture. Inspiration for the unprecedented formulation of the staircase also came from the design experiments of the Bolognese architect Ottaviano Mascherino.

The decorative program was probably defined in collaboration with Pietro da Cortona, adopting the antiquarian taste that was becoming established at the start of Urban VIII's papacy. The entrance to the *piano nobile* takes the form of a loggia in the shape of a triumphal arch, decorated on the lower part by a low relief—a lion—and on the upper part by an aperture onto a room intermediate with respect to the central hall and symmetrical with respect to the other wing. The landings are adorned with niches hosting ancient sculptures and oblique perspectival inserts.

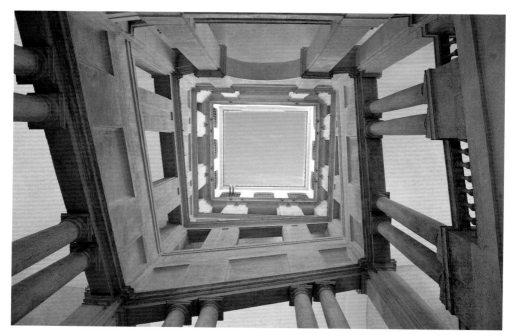

The load-bearing elements adjacent to the stairwell change progressively from bottom to top: from the corner pillars with paired columns connected by balustrades along the three flights ascending to the *piano nobile*, to the wall panels with inserts, up to the second-floor loggia with twin pilasters aligned with the columns. A simple spiral molding registers the ascent of the flights and of the barrel vaults, shrinking as the height of the storeys progressively decreases.

This decorative and functional program results from various contributions, still not fully identified: from the more traditional approach of Maderno to the innovative role of Borromini and Bernini. To the latter, in collaboration with Bernardino and Agostino Radi, we owe the overall stylistic program. Indeed, Borromini left the site after a quarrel with Bernini and his collaborators.

Oval staircase

The oval staircase led to the apartments destined for the cardinal nephew Francesco Barberini. The staircase, very light and airy in its structure, unfolds with paired Doric columns arranged along the perimeter of the elliptical stairwell in correspondence with the long and short axes of the ellipse. The reference model may be the elliptical staircase by the architect Ottaviano Mascherino, much admired by Borromini, built in the Quirinal palace (1583–1585). Borromini's interpretation seems to preface later solutions in which the twisting of the cornices and balustrades around a central pivot is variously proposed, ascending uninterruptedly even at the height of the landings. Some notes ascribable to Borromini can be found in the study drawings of the academician Vincenzo Della Greca (1592–1661), but the attribution of the work to the architect from Ticino rests essentially on the caption in an engraving (1702) by the academician and architect Alessandro Specchi. The latter had trained in the workshop of Carlo Fontana, a pupil of Bernini, and was therefore probably well-informed about the individual contributions to the building's design. Based on the most up-to-date analyses, Bor-

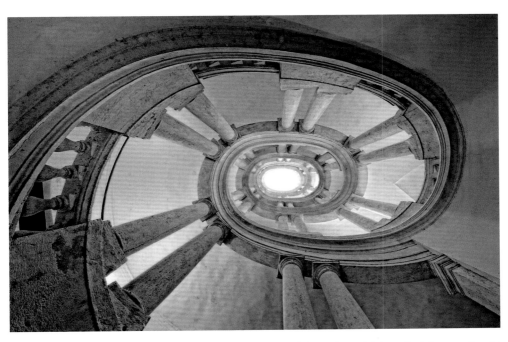

romini's contribution to the design of the building, and thus also of the oval staircase, should probably be identified in the interpretation of Maderno's overall ideas, based on a relationship of collaboration and kinship that, especially in the final phase, left him sole operational responsibility for the worksite with ample room for maneuver. However, this freedom was called into question by Bernini's appearance on the scene after Maderno's death, followed by conflicts until Borromini abandoned the worksite. In the first of the preparatory drawings created by Borromini under Maderno's direction, the staircase is still circular and the columns are single rather than paired; it subsequently took on an oval shape, experimenting with the curvilinear steps. Construction, which began under Bernini's direction in April 1633, perfected the 16th-century model of the spiral staircase and exerted a long-lasting influence on architectural culture, becoming one of the most recurrent themes studied and practiced by the students of the Accademia di San Luca and foreign architects on study trips to Rome.

PN

Bibliography: M. Tabarrini, *I due scaloni d'onore di Palazzo Barberini: tradizione, innovazione e fortuna*, in *La festa delle arti. Scritti in onore di Marcello Fagiolo per cinquant'anni di studi*, ed. by V. Cazzato, S. Roberto, M, Bevilacqua, Rome 2014, pp. 402–411 (with preceding bibliography); N. Resnick, *Thoughts on the Ellipse: Borromini's Staircase at the Palazzo Barberini*, "Thresholds", 28, 2005, pp. 47–57 (monographic issue, *Concerto Barocco: Essays in Honor of Henry A. Millon*).

Andrea Sacchi
(Nettuno, 1599–Rome, 1661)

Allegory of Divine Wisdom
1629–1630
fresco

Bibliography: P. Waddy, *Seventeeth-Century Roman Palaces: Use and the Art of the Plan*, New York 1990, pp. 131, 179–180, 201–202; J.B. Scott, *Images of Nepotism: The Painted Ceilings of Palazzo Barberini*, Princeton 1991, pp. 3–104; A. Lo Bianco, in *Andrea Sacchi: 1599-1661*, cat. of the exhibition (Nettuno-Roma 1999), ed. by C. Strinati, Rome 1999; pp. 59–60; J.B. Scott, *Galileo and Urban VIII. Science and Allegory at Palazzo Barberini* in *I Barberini e la cultura europea del Seicento*, conference proceedings (Rome 2004), ed. by L. Mochi Onori, S. Schütze, F. Solinas, Rome 2007, pp. 127–136; S. Pierguidi, *Sacchi and Camassei: Painters in the Service of Taddeo Barberini*, "The Burlington Magazine", CLXII, 1402, 2020, pp. 32–36.

The fresco of *Divine Wisdom* is located in the apartment of Princess Anna Colonna, wife since 1627 of Taddeo Barberini, nephew of the pontiff and the member of the family designated to pass on its name. The allegory adorns a large room leading into the small chapel used—unlike the hall of *Divine Providence*—for family occasions. The decorative project functionally and iconographically links the fresco painted by Andrea Sacchi to the small adjacent chapel decorated in 1631–1632 by Pietro da Cortona.

Looking at it from the chapel side, the composition appears oriented toward us. The fresco is illuminated by the natural light entering from the windows, which is reflected on the solar disk painted on the ceiling that illuminates the crucified Christ in the chapel. With an innovative treatment of space and light, Sacchi paints an open sky, metaphysical and looming, in which he arranges a solemn array of symbolic figures. The composition is only ostensibly sober given its highly complex underlying meaning. *Divine Wisdom* is an apology for the papacy of Urban VIII and his family. The allegory, appropriate to both the majesty of the palace and to the Barberini family, gives expression to the idea that Urban VIII was elected to govern

the Church in the name of God, and that he leads it with the help of heavenly Wisdom and its virtues. An anonymous 17th-century manuscript and the eulogistic guide to the palace by Gerolamo Tezio (1642), written after the execution of the fresco, identify the source of the theme in the biblical book of Solomon's *Wisdom*, a text believed to have been written by the king of Israel himself.

At the center of the composition is Wisdom, seated on the celestial throne (the throne of Solomon), dressed in white and wearing a queen's crown. She is compared to a celestial body, the Sun, the heraldic emblem of the Barberini family. She sits on the world and holds a mirror in her hand, as a reflection of the divine light, holding a scepter adorned with the eye of God. Her attributes are embodied by the female figures surrounding her,

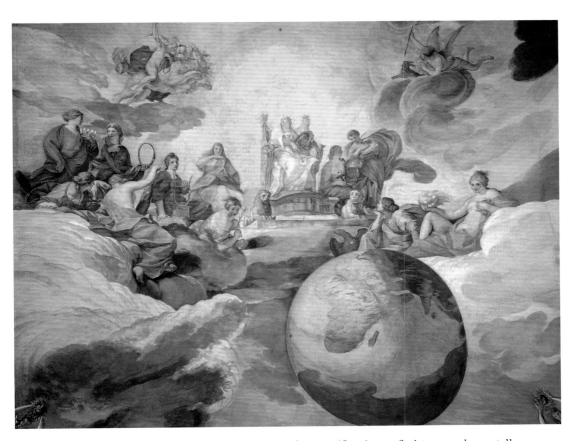

presented in accordance with the double code of personifications of virtues and constellations: from the left Regality with Ariadne's crown, Eternity with the snake, Harmony with the lyre, Divinity with the triangle, Justice with the scales, Strength with the club, Charity with the ear of corn; on the right Sanctity with the altar, Purity with the swan, Perspicacity with the eagle, Beauty with the lock of Berenice. Since Wisdom must be both loved and feared, she is shown in the act of commanding two angels (symbols of Love and Fear) to shoot at the target of the world: one rides a lion and shoots a golden arrow as a sign of the perfection of Love, the other leads a hare and is armed with a silver arrow that pierces the hearts of the weakest. The virtues of wisdom are also identified with constellations with an astrological meaning that refers to the birth and election of Urban VIII, on 6 August 1623, when the Sun was in the house of Leo. The meaning of the fresco is centered on a solar metaphysics not without an attention to Galilean science (the globe of the earth is in an off-center position with respect to the sun) and the philosophy of Tommaso Campanella, considered the possible inspirer of the cycle's iconographical program. The array of figures with composed and severe poses, evoking the Roman *gravitas*, is characterized by a gentle and fluid application of paint in almost evanescent colors. Here a new metaphysical classicism is born, in deference to Raphael but devoid of narrative or fantastical elements, with a renewed spatial structure, lacking architectural geometries and dominated by the void, in which the earth is no longer at the center of the universe.

PN

Pietro Berrettini, called Pietro da Cortona
(Cortona, 1597–Rome, 1669)

Allegory of Divine Providence
1632–1639
Fresco

Bibliography: G. Briganti, *Pietro da Cortona o della pittura barocca*, Florence 1962 (updated ed., Florence 1982); J. Beldon Scott, *Images of Nepotism: The Painted Ceilings of Palazzo Barberini*, Princeton 1991; L. Mochi Onori, *Pietro da Cortona per i Barberini*, in *Pietro da Cortona 1597–1669*, cat. of the exhibition, (Rome 1997), ed. by A. Lo Bianco, Milan 1997, pp. 73–86; A. Lo Bianco, *La volta di Pietro da Cortona*, Rome 2004; A. Lo Bianco, *Pietro da Cortona e gli anni della volta Barberini*, in *I Barberini e la cultura europea del Seicento*, conference proceedings (Rome 2004), ed. by L. Mochi Onori, S. Schutze, F. Solinas, Rome 2007, pp. 213–220.

The fresco covers the vast surface of the ceiling in the main hall of Palazzo Barberini and was painted by Pietro da Cortona between 1632 and 1639, with an interruption in 1637 when the painter travelled to Florence and northern Italy. As attested by the documents, for this grandiose undertaking Cortona received the very substantial sum of 3910 *scudi* and was consecrated as the inventor of a new figurative language, the Baroque. The conceptual basis of the complex decorative program is the allegorical poem *L'elettione di Urbano Papa VIII* by the humanist from Pistoia Francesco Bracciolini (1566–1645), secretary of the cardinal nephew Antonio Barberini, published in 1628 with suggestions from the poet-pope himself. The subject illustrates the plans of Divine Providence for the election of Urban VIII and its beneficial effects on the Papal States. With sophisticated inventions that transform conceptual allegories into harmonious images—animating the surface of the vault with warm and bright colors; and lively, massive, and dynamic figures—Pietro da Cortona succeeded in fusing mythology with epic, Roman history, legend and fable, bringing conceptual ideas to life in the form of symbolic characters and projecting ancient history onto the present. The painter heeded the wishes of the pontiff to the extent that the fresco has the appearance of a poem structured like a figurative epic, derived from classical themes but aimed at the present.

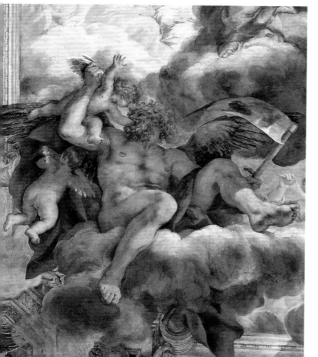

In a Rome shaken by the unrest that ensued when the papal throne was left vacant after the death of Gregory XV, the eternal struggle between vices and virtues unfolds, but it is a game and an artificial expedient: the outcome is already written thanks to the providential plan that sees in the election of Maffeo Barberini the triumph of peace and prosperity for the Christian people. The painter created fake architectures, a genuine illusionistic system populated by painted statues and adorned with floral festoons, masks, dolphins, cherubs, and imitation bronze medallions with episodes from Roman history, dividing the space into five sectors (a large central panel and four side scenes). This arrangement dilates the structure, ensuring its

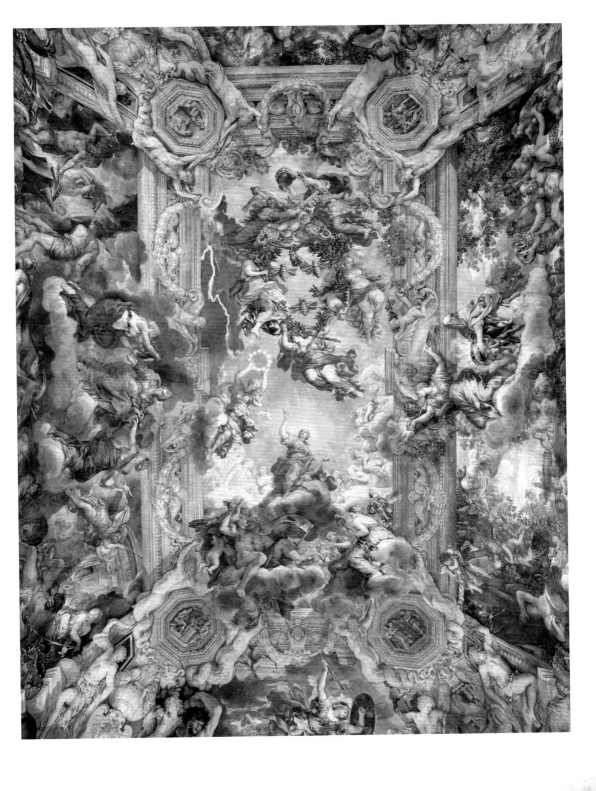

unity through connections and hierarchies, and creates the effect of breaking through the masonry thanks to which the real space of the viewer seems to open up and project itself into infinity. At each corner, an animal depicts the virtue corresponding to the story narrated in the medallion: the hippogriff (Perspicacity), the female bears (Sagacity), the lion (Strength), the unicorn (Temperance). A myriad of personifications of new or unusual allegories spill out of the fake frames and invade the architectural structure, thanks to an illusionistic system that signals its distance from the tradition of the "imitation painting" and creates an astonishing choreography and overall effect, so much so that the ceiling appears—as the painter's biographer Giovan Battista Passeri wrote—to have been painted in a single day.

At the center is the figure of Providence, seated on a throne of clouds and wrapped in a golden cloak. Below, Time with his great feathered wings devours his children, while on the right the three Fates weave the threads of existence. Immortality crowns the three bees of the Barberini emblem with stars. The theological virtues (Faith in a white robe, Hope in green, Charity in red) hold laurel branches, a symbol of immortality but also an allusion to Urban, the poet-pope. Above, the personifications of Rome and Religion crown the coat of arms with the papal tiara and the gigantic crossed keys. The ensemble symbolizes Urban's election to the papal throne, heralded by the arrival at the conclave of a swarm of bees "buzzing like planes flying in formation" (Giuliano Briganti). Cortona's invention was brilliant, integrating the Barberini emblem into the action, encapsulating in this feature the celebratory significance of the entire decorative program.

The episodes at the sides of the central panel illustrate the good governance of the pontificate and the virtues of the pope: Justice accompanied by Abundance with the scene of Hercules defeating the Harpies who fall ruinously, the battle against Heresy with the figure of Pallas, armed with a spear and shield, destroying Pride in the form of the Giants who attempt to dethrone the gods. On the long sides are Piety and the struggle against the enemies of orthodoxy, with the triumph of Religion and Wisdom over Lust and Intemperance in the form of the drunken Silenus, surrounded by satyrs, fauns, and bacchantes. On the other side is

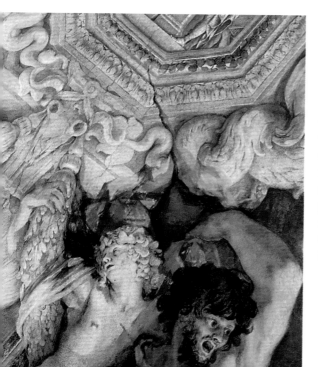

the celebration of Peace, dressed in gold and blue, with Prudence next to her and Authority behind with a key and papers ready to receive his orders; in the background the temple of Janus is about to be closed (its doors were closed in time of Peace by the ancient Romans), while below are the naked Fury chained to Meekness and the forge of Vulcan with the Cyclopes. In this extraordinary theatrical program, Pietro surpassed the sophisticated boundaries between reality and wonder and invented the new visual language of political absolutism, the Baroque, while simultaneously reviving Rome's international cultural primacy at the time of Raphael and Michelangelo.

PN

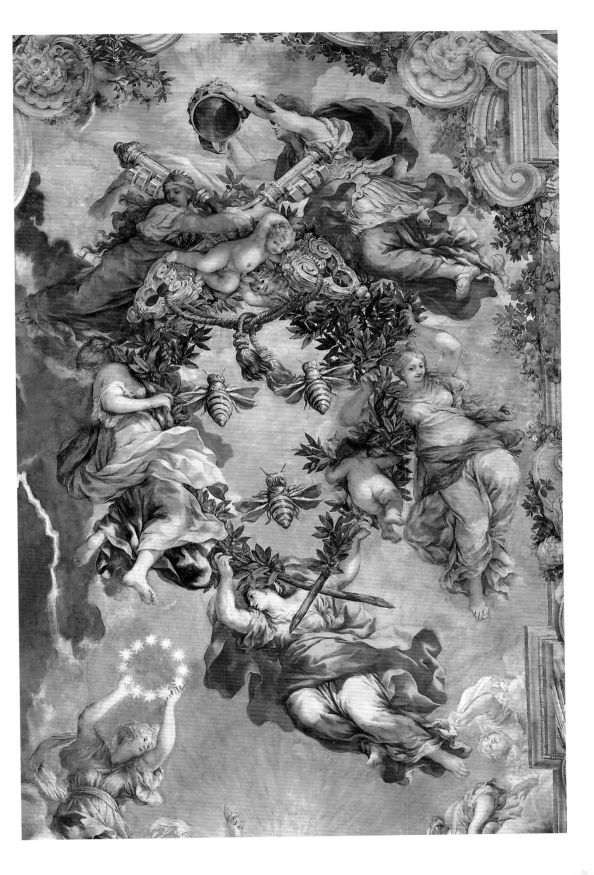

Domenico Corvi

(Viterbo, 1721–Rome, 1803)

Chiaroscuro Dressing Room

ca. 1770
Fresco in grisaille

Bibliography: C. Magnanimi, *Palazzo Barberini*, Rome 1983; G. Magnanimi, *The Eighteenth-Century Apartments in the Palazzo Barberini*, "Apollo", cxx, 272, October 1984, pp. 252–261; S. Rudolph, *Le committenze romane di Domenico Corvi*, in *Domenico Corvi*, cat. of the exhibition (Viterbo 1998–1999), ed. by V. Curzi, A. Lo Bianco, Rome 1998, pp. 19–33; L. Barroero, *Exempla virtutis. La pittura storica di Domenico Corvi (1721–1803) e il suo magistero*, cat. of the exhibition (Rome 2005), Rome 2005; V. Curzi, *Memoria dell'antico nella pittura di storia a Roma tra Seicento e Settecento*, in *Settecento romano*, ed. by B. Alfonzetti, Rome 2017, pp. 255–272.

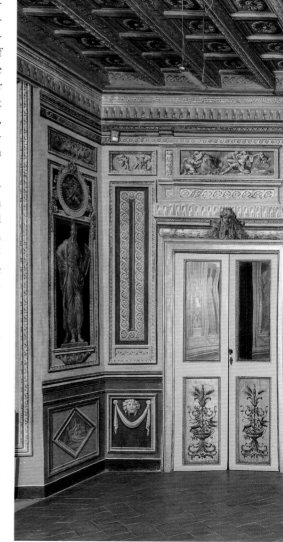

The primacy held by the painter from Viterbo in the Roman figurative culture of the seventh decade of the 18th century, with the development of a precocious form of Neoclassicism, is clearly apparent in the decoration of this refined room. It concludes a wing of the 18th-century apartment on the second floor of the Barberini residence, a superb complex that was completely renovated, decorated, and furnished in the second half of the century, reflecting the gradual transition of Roman art from Rococo to the Neoclassical style.

The cozy and elegant apartment was inhabited by the last heir of the family, Cornelia Costanza Barberini (1716–1797), who married very young (1728) to Giulio Cesare Colonna di Sciarra (1702–1787), prince of Carbognano and Bassanello. The project to decorate and furnish it was begun by her uncle Cardinal Francesco Barberini junior (1662–1738) immediately after his niece's wedding, following the artistic trends in vogue in the middle years of the 18th century.

Domenico Corvi had already collaborated on the decoration of the reception hall, known as the Room of the Battles, adapting his style to the celebration of some events in the history of the two noble families. In the Chiaroscuro dressing room, the artist drew on the rich formal repertoire of the antiquarian culture very fashionable in the 18th century, making a very personal use of the decorative, iconographic, and symbolic legacy of the classical world adopted as a mythical reference model.

The walls present an architectural partition in grisaille conceived in connection with the white marble fireplace vaguely inspired by Piranesi. Within the monochrome framework are figures from mythology and ancient history, surmounted by roundels and friezes with mythological scenes. The central compartment of the wall, divided into panels, is decorated with facing sphinxes alternating with masks. Below, lozenge-shaped partitions alternate with figures of centaurs and scenes of the loves of Jupiter. The rich range of ornament draws on the Greek, Etruscan, and Roman decorative repertoire, updating it to the new taste of the time.

The large neo-antique figures, depicted as marble sculptures, are identified by the inscriptions beneath them: *Lucretia, Tullia, Aeneas, Dido, Cleopatra, Alexander the Great, Sulla, Tuccia, Scipio, Cyrus, Sophonisba* and *Zenobia*. The noble deeds of the ancients are glorified and proposed as a model of behavior with an explicit didactic and moral purpose, embodying the principal civil and military virtues pursued by the Barberini themselves.

TC

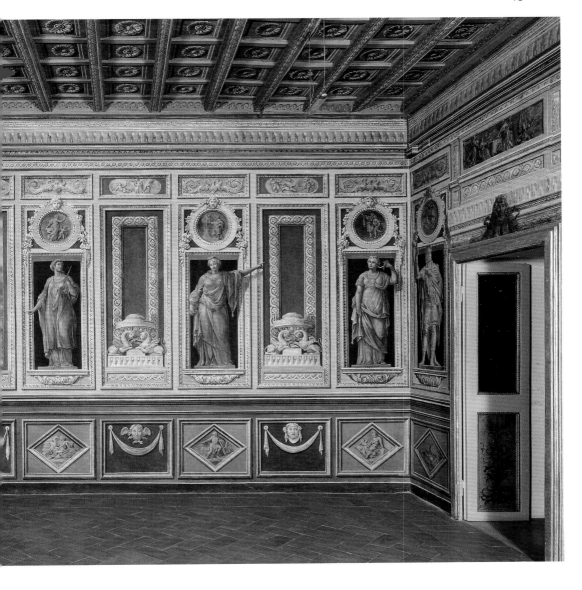

Palazzo Corsini
alla Lungara

On 27 July 1736, Cardinal Neri Maria Corsini and his brother Bartolomeo, the future viceroy of Sicily, bought Palazzo Riario (1511–1518) to provide the family with an official residence appropriate to the election of their uncle Lorenzo as Pope Clement XII (1730–1740). In this regard, Duke Filippo, nephew of the cardinal, recalls in a memoir of 1757 that Neri Maria "rightly desirous of seeing the family's residence established in Rome, deigned to join his brother in the purchase of the Palace, later enlarging it at his sole expense and filling it with selected paintings and a well-stocked library, all things that have greatly contributed to the prestige of the family."

The imposing restoration and enlargement of the building—which took over 15 years—was entrusted to the Florentine Ferdinando Fuga, who transformed the 16th-century residence into a true 18th-century palace made up of three large structures and enriched by the large garden stretching up to the top of the Janiculum hill. Each of these structures had a very specific function: the monumental and spectacular central staircase, inspired by the entrance to Palazzo Barberini, was the very image of the "prestige of the family," while the two side wings housed the library and the collection of art works on the *piano nobile*.

The former, occupying as many as seven specially-built and frescoed rooms, contained the extraordinary family library—over 30,000 books alongside prints and drawings—which Neri

Maria wished to open to the public from as early as 1754. The latter, on the other hand, was displayed in the private rooms of the cardinal and contained, as the *Mercurio errante* notes in 1771, "very precious statues and furnishings, with large numbers of beautiful paintings executed by famous masters."

Among these rooms, however, a particular importance belongs to the bedroom, the so-called *alcova*. The only room to preserve its late 16th-century decorations—the ceilings with *Stories of Solomon and Moses*, probably the work of the little-known Vitruvio Alberi—it has maintained the form and function given to it by Queen Christina of Sweden who lived here from 1659 until her death in 1689. This was probably a tribute by the cardinal to her memory.

AC

Bibliography: E. Borsellino, *Palazzo Corsini alla Lungara. Storia di un cantiere*, Fasano 1988; H. Hyde Minor, *Neri Corsini committente del palazzo alla Lungara*, in *I Corsini tra Firenze e Roma. Aspetti della politica culturale di una Famiglia papale tra Sei e Settecento*, atti del convegno (Roma, 2005), edited by E. Kieven, S. Prosperi Valenti Rodinò, Milan 2013, pp. 97-105; E. Borsellino, *Palazzo Riario-Corsini alla Lungara tra architettura, decorazione e collezionismo*, in *La Roma di Raffaele Riario tra XV e XVI secolo*, ed. by L. Pezzuto, Rome 2017, pp. 23-34.

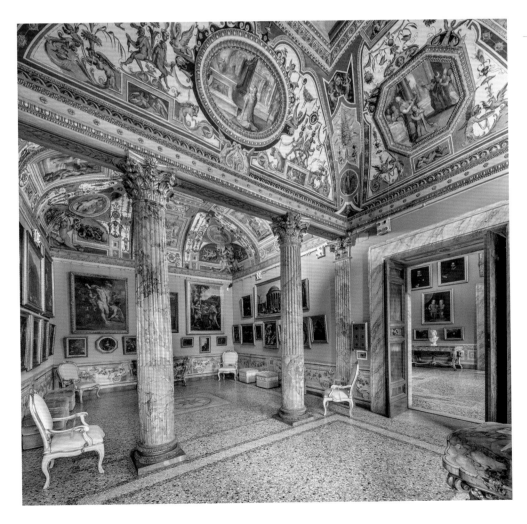

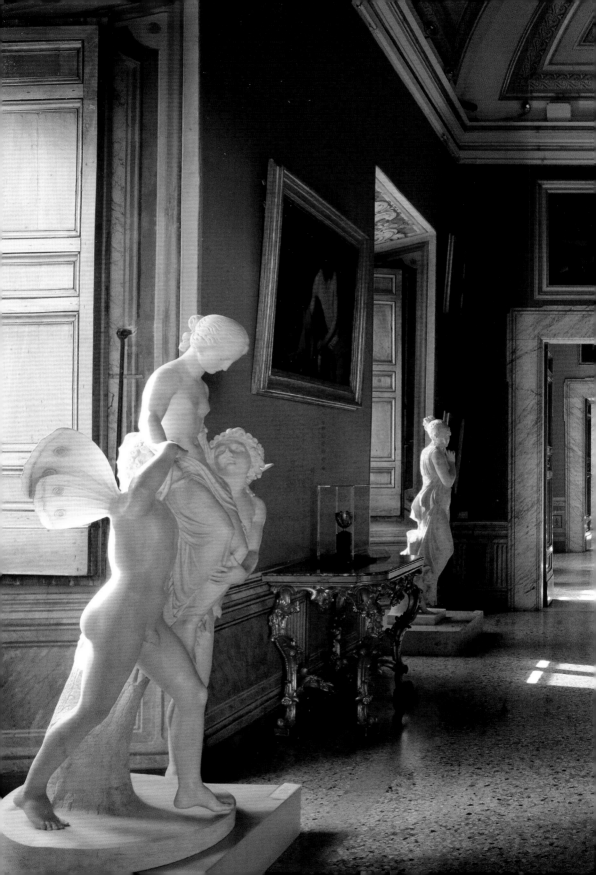

1OO

MASTERPIECES

Corsini Throne

ca. 40 BC
white marble, 82.5 × 49.5 cm
Galleria Corsini, inv. 666

Bibliography: P. Ducati, *La Sedia Corsini*, "Monumenti Antichi. Reale Accademia dei Lincei", XXIV, 1916, pp. 402–458, plts I–VIII; G. De Luca, *I monumenti antichi di Palazzo Corsini in Roma*, Rome 1976, pp. 93–99, no. 54; M. Torelli, *La "Sedia Corsini", monumento della genealogia etrusca dei Plautii*, in *Mélanges Pierre Lévêque. Anthropologie et société*, Université de Franche-Compté, V, Besançon 1990 ("Annales littéraires del l'Université de Besançon", 429), pp. 355–376; C. Zaccagnino, in *Gli Etruschi*, cat. of the exhibition (Venice 2000), ed. by M. Torelli, Milan 2000, p. 638; E. Borsellino, *Le sculture della Galleria Corsini di Roma: collezionismo e arredo*, in *I Corsini tra Firenze e Roma. Aspetti della politica culturale di una famiglia papale tra Sei e Settecento*, proceedings of the conference (Rome 2005), ed. by E. Kieven, S. Prosperi Valenti Rodinò, Milan 2013, pp. 108–109.

The work is a faithful late Republican copy of an Etruscan princely throne dating to the end of the 5th century BC: *a* unique piece in the context of ancient sculpture. The precious work was discovered by chance in 1732 during the preliminary excavations for the construction of the Corsini chapel in the basilica of San Giovanni in Laterano.

The cylindrical body of the base widens at the bottom and at the height of the seat. The broad back is also flared and presents a decoration of figured registers alternating with ornamental bands. On the lower part, above a plant frieze, runs a band depicting a sacrificial funeral procession heading toward an altar: at the front is a *victimarius* holding an axe and leading the sacrificial bull, accompanied by a young man who drives the animal forwards with a switch and holds a vase for libations. They are followed by a woman holding a basket, connected to the sacred ritual, and two priests wearing cloaks, while two seated young men watch the scene. The narrative continues with the representation of the funeral games: boxing, wrestling and horse racing. Here we see two boxers with dumb-bells and a helmet with a plume placed at the center as a prize (start of the race) and two outlined figures, merged into a single body; there follow two wrestlers and a rider. Finally, above the funeral procession runs a plant frieze enclosed within two ribbons with a wave motif.

The back of the *Throne* is decorated only on the inside: on the upper register is a parade of nine warriors with elliptical shields, hoplites and riders; below a boar hunting scene with bows and spears unfolds.

From a typological point of view, the *Corsini Throne* belongs to the series of princely funerary thrones, made of metal or clay, that supported canopic vases (holding the ashes of the deceased), peculiar to the necropolis of Chiusi in the Archaic period and widespread in the 5th century in Etruscan regions. The place of discovery, near the Lateran, has made it possible to identify the owner of the urban villa that extended beneath the Lateran basilica as M. Plautius Lateranus, a member of the Plautii Silvani family and husband of Urgulania, a princess of Etruscan heritage. The *Throne* thus came to be a sign of power that, by alluding to the pre-Roman model, supported the self-celebration of its ancient patron, descended from the ancient rulers of Etruria.

TC

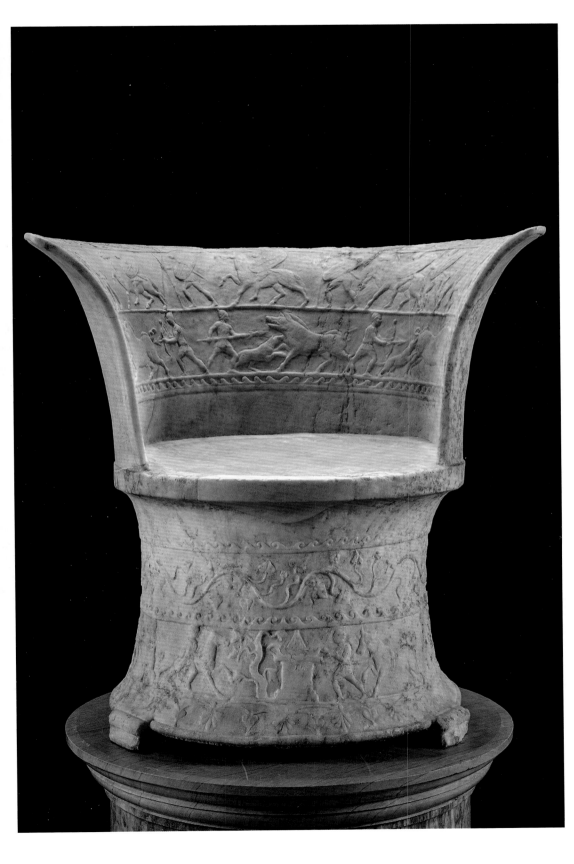

Corsini Cup, kantharos with the Judicium Orestis (Judgement of Orestes)

ca. 50 BC
silver, h. 53 cm, top diameter 10 cm
Galleria Corsini, inv. 671

Bibliography: G. De Luca, *I monumenti antichi di Palazzo Corsini in Roma*, Rome 1976, pp. 127–132, no. 73; G. De Luca, in *Laboratorio di restauro 2*, cat. of the exhibition (Rome 1998), Rome 1988, pp. 76–85; J. Raspi-Serra, in *La fascination de l'Antique 1700–1770. Rome découverte, Rome inventée*, cat. of the exhibition (Lyon 1998), ed. by J. Raspi-Serra, F. de Polignac, Paris 1998, pp. 119–120, no. 97; L. Pirzio Biroli Stefanelli, *Le argenterie nel mondo romano*, in *Argenti a Pompei*, cat. of the exhibition (Naples 2006), ed. by P.G. Guzzo, Milan 2006, pp. 19–29; M. Pontisso, in *Anzio e i suoi Fasti: il tempo tra mito e realtà*, cat. of the exhibition (Anzio 2010), Anzio 2010, pp. 94–98, no. 9.

This precious piece testifies to the Roman passion for repoussé silverware of Greek manufacture, which was much copied and imitated. The ancient *kantharos* consists of an internal undecorated ovoid cup supported by a molded foot, and of a fine silver casing adorned with repoussé figures. The handles, attached only at the bottom, are also undecorated.

The relief band, which comprises six well-spaced figures on the two sides, shows the events dramatized by Aeschylus: Orestes, the youngest son of Agamemnon, is ordered by Apollo to avenge the killing of his father, perpetrated by his mother Clytemnestra and her lover Aegisthus. As the executioner of his own mother, Orestes is persecuted by the Furies, the deities who avenged crimes within the family, from whom he is liberated only after the intervention of Athena, who acquits him with her deciding vote.

Since Winckelmann's erudite publication of the *Cup*, which also described its discovery in 1759 near Villa Corsini at Porto d'Anzio, the precious artefact has been the subject of numerous studies focused on the interpretation of the famous story illustrated in the figured band.

The high point of the drama is clearly depicted on the main face: Athena, dressed in a chiton, cloak and helmet, is placing her vote (*psefisma*) in the urn in favor of Orestes, identified as the young man standing and facing right on the reverse of the vase, depicted at the exact moment of the *judicium* (judgement). Next to the goddess are the Furies: the girl on the left waits to learn the verdict, while the other, resting on the rock, illustrates the fatigue caused by the long pursuit. The setting of the episode in a public place, as the Court of the Areopagus in Athens was, is suggested by the presence on the reverse of the sundial and a pillar, delimiting the space reserved for the protagonists of the drama. The other two figures at the center of the back, whose identification is more uncertain, might be Orestes and his sister Electra, the two siblings who committed the crime.

The compositional uncertainties of the two scenes have led many scholars to rule out an attribution of the *Cup* to the famous metalworker Zopyros (a Greek artist who lived in the 1st century BC, mentioned by Pliny the Elder), and to consider this precious item of silverware a copy of a famous original not completely faithful to its model. It seems more likely, however, that the Roman engraver created an eclectic compendium of several scenes among those mentioned by Pliny.

TC

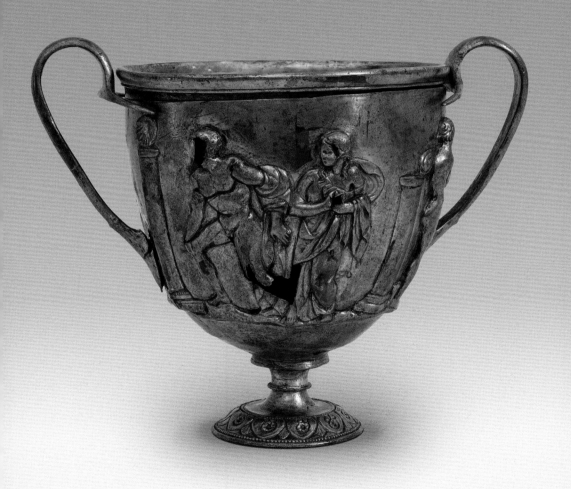

Madonna Advocata

tempera on panel covered with canvas, 107 × 57.5 cm
Palazzo Barberini, inv. 4212 (Cini purchase, 1987)

Bibliography: L. Mochi Onori, R. Vodret, *Capolavori della Galleria Nazionale d'Arte Antica Palazzo Barberini*, Rome 1998, p. 16, no. 1; M. Bacci, in *Luca evangelista, parola e immagine tra Oriente e Occidente*, cat. of the exhibition (Padova 2000–2001), ed. by G. Mariani Canova, P. Ferraro Vettore, M. Bacci, Padova 2000, p. 304, no. 35; D. Sgherri, in M. Andaloro, S. Romano, *La Pittura medievale a Roma 312–1431. Corpus*, IV, Milan 2006, pp. 117–120, no. 17; R. Vodret, in L. Mochi Onori, R. Vodret, *Galleria Nazionale d'Arte Antica Palazzo Barberini. I dipinti, catalogo sistematico*, Rome 2008, p. 391; G. Leone, *Icone di Roma e del Lazio 1. Repertori dell'Arte del Lazio 5–6*, Rome 2012, pp. 66–67, no. 14.

The icon comes from the oratory of San Gregorio Nazianzeno within the Benedictine complex of Santa Maria in Campo Marzio, from where it was moved in 1914 to the Oblate convent of Tor de' Specchi. In 1945 it was purchased by Vittorio Cini and in 1987 entered the collections of the Galleria Nazionale.

The *Advocata* stands out at the center against the dark background of the painting, formerly an intense blue color. Her bust and head are turned slightly to accompany the gesture of the hands, raised in an attitude of supplication toward the blessing Christ, depicted at the top left. The Virgin wears a mantle decorated with small white crosses, the *maphorion*, edged with a gilded hem that frames her face, embellished with a diadem with painted gemstones alternating with pearls. Beneath the mantle, the *mitella* or tunic can be glimpsed, while the head is surrounded by a large golden halo. The bust of Christ is smaller and depicted in a foreshortened view, his right hand blessing in the Greek manner in front of his mother's halo. He too wears a bright red tunic decorated with crosses and a brown *himation*, while his head is surrounded by a golden cruciform halo.

The iconography develops the familiar type of the most famous icon of Mary, thought at the time to be the work of the evangelist Luke, executed at the request of the Virgin herself: the *Madonna* belonging to the monastery of Santa Maria in Tempulo, later moved to San Sisto and now in the convent of Santa Maria del Rosario in the Monte Mario district. The cult of this sacred image spread throughout Rome to various monasteries and convents during the 12th and 13th centuries, especially among the regular clergy.

The unusual presence of Christ has also been interpreted as an allusion to a lost image of the *Advocata* venerated in the oratory of San Gregorio, which according to legend was brought to Rome from Constantinople in the 8th century by the founders of the Benedictine convent. In time, the eastern icon came to be identified with this panel to which miraculous qualities were ascribed, soon extended to the entire community of nuns. Christ's gesture, stretching his arm over the image of the *Advocata*, was thus read as the sign of divine protection over the whole convent.

The dedicatory inscription "SANCTA VIRGO VIRGINUM" on the lower edge of the frame reflects the nuns' identification with their own icon. The dates hitherto proposed by scholars for this work range from the third quarter of the 11th to the end of the 12th century.

TC

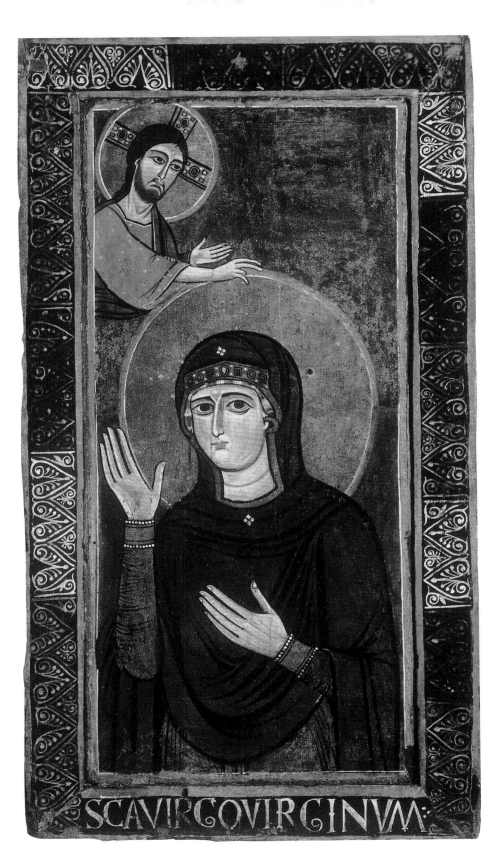

SCA VIRGO VIRGINVM:

4 | Giovanni da Rimini
(Rimini, known from 1292 to ca. 1315)

Scenes from the Life of Christ
ca. 1305–1310
tempera on panel, 52.5 × 34.5 cm
Palazzo Barberini, inv. 1441

Bibliography: P.G. Pasini, *Fra scrittura e pittura. Fortuna e arte di Neri da Rimini miniatore notaio*, in *Neri da Rimini. Il Trecento riminese tra pittura e scrittura*, cat. of the exhibition (Rimini 1995), ed. by A. Emiliani, Milan 1995, pp. 39–40; A. Koopstra, *Giovanni da Rimini: Scenes from the Lives of the Virgin and Other Saints*, London 2017.

This splendid painting is a fine work by the 14th-century School of Rimini, an important artistic school launched at the beginning of the century and influenced by the famous stories of St. Francis frescoed in Assisi. The novelties introduced by Giotto and perhaps also those initiated in Rome, principally by Pietro Cavallini, must have contributed to this sudden development. The artistic flowering in Romagna was interrupted in mid-century, perhaps by the devastating plague of 1348, as claimed by Millard Meiss. The repertoire of Riminese painting remains uncertain, despite continuous historical and critical reinterpretations. The serial partition of the scenes indicates that the complex originated from the east coast of Italy, reflecting a conception of painting developed in Constantinople.

The execution of our panel should be viewed against this background; it is attributed to Giovanni da Rimini and was formerly paired with another work (New York, Lauder collection; later London, National Gallery), depicting *Scenes from the Lives of the Virgin and Other Saints*. The latter was exported with the collection of Giovanni Battista Camuccini, an artist who held official positions but who seems at the same time to have been involved in smuggling.

Both panels had belonged to the Barberini collections since the 17th century and were considered, like many Gothic pieces more generally, to be works by Giotto. Some 17th-century writings on the back of both supports refer to this pioneer. They have hitherto been interpreted erroneously, but actually read: "Di M[aestro] Giotto … " on our panel and " … M[aestro] Giotto da [Ve]spininano" on that formerly in the Lauder collection.

The two panels were painted on both sides, making them fairly resistant to changes in climate. Critics are unsure whether the panels formed diptychs, typologically linked to the local school, or other objects of worship that are difficult to identify. The gold presents very light incisions limited to the haloes, revealing an adherence to the deliberate choices of Giotto, who does not seem to have wished to follow the international fashion for punching the foil. For the Florentine master, this treatment of the background clearly implies an attempt to create spatial indicators, impossible in the presence of "loud" decorations. The same could be said in our panel of the polishing of the gold background, executed without creating a significant sheen. These features depart from other contemporary works from Rimini, including that by Giovanni Baronzio in this same museum (no. 5).

AGDM

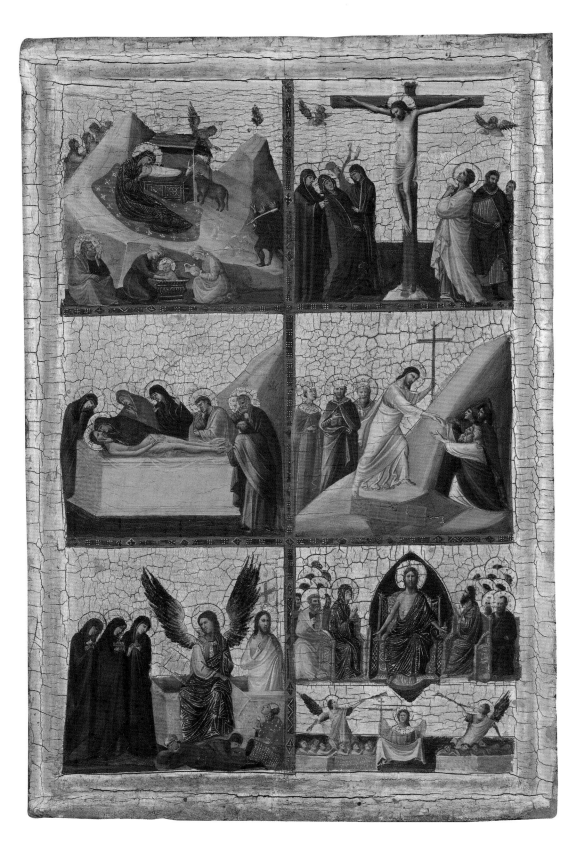

(Rimini, known from ca. 1345 to 1362)

Stories of the Passion of Christ

ca. 1325–1340
tempera on panel, 71.5 × 112 cm
Palazzo Barberini, inv. 1657 (1919, E. Hertz gift)

Bibliography: F. Zeri, *Una deposizione di scuola riminese*, "Paragone", 99, 1958, pp. 46–54; M. Medica, *Una proposta per la provenienza del "Dossale" di Giovanni Baronzio: la chiesa di Villa Verucchio*, "L'Arco", supplemento al I e II quadrimestre, 1, 2006, pp. 13–16; D. Ferrara, in *Giovanni Baronzio e la pittura a Rimini nel Trecento*, cat. of the exhibition (Rome 2008), Cinisello Balsamo 2008, ed. by D. Ferrara, pp. 86–88, no. 2.

The panel entered the museum as a Hertz gift from the Corvisieri collection. Federico Zeri realized that it was originally paired with a companion piece depicting earlier episodes from the life of Christ and acquired in 2006 by the Fondazione della Cassa di Risparmio di Rimini. Together they formed a large dossal—a painting attached to the back of the altar, preceding the development of the altarpiece—that seems to have originally been in the church of the Franciscan monastery at Villa Verucchio (Rimini), founded after repeated visits from St. Francis. Hypotheses have been advanced regarding its commission by the Malatesta family, connections with the 13th-century *Cross* in the apse of the same church and the meaning of its iconography, though all these proposals seem to rely on excessively conjectural data. However, we can imagine that between this piece and its companion, illustrating the life of Christ before and after his death respectively, there must have been an image of the *Crucifixion*.

The attribution of the piece to Baronzio dates to 1915 and has generally been accepted, though not without some dissent. The work has therefore seen fewer reassignments by critics than others of the 14th-century School of Rimini, short-lived but achieving a high artistic quality. This school was closely linked to the birth of western painting that took place in the upper basilica at Assisi, and thus to the role of Giotto and of Cavallini and his workshop in Rome.

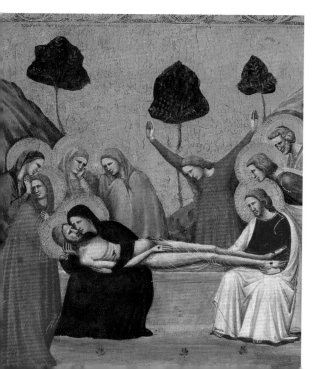

The gold is worked on two different levels of depth. The first presents deeper impressions and is used for the decorative bands separating the scenes. The second is shallower and used for haloes and backdrops, revealing traces of a punch, circles drawn with a compass and marks drawn freehand. This is a fairly commonplace procedure for the School of Rimini, which only adhered to a limited extent to the increasingly complicated tooling of the gold leaf developed in the Gothic period. In this respect, then, it seems only partly to observe the propensities of Giotto, who attempted to reduce the brilliance and the decoration of gold in his moveable paintings.

The figures are elongated and sometimes accompanied by solidly structured architec-

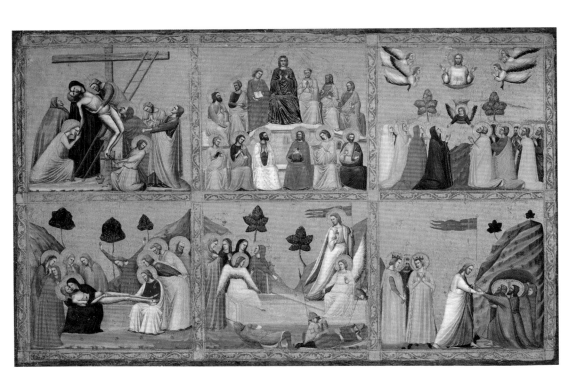

tural elements, in accordance with a solution somewhat reminiscent of the Florentine Master of St. Cecilia, an "early follower of Giotto." The composition with little scenes arranged sequentially on several registers indicates contact with paintings influenced by the world of Constantinople, not coincidentally common along Italy's Adriatic coast.

AGDM

6 | Giovanni da Milano
(Caversaccio, ca. 1325–ca. 1370)

Virgin and Child Enthroned, Annunciation, Nativity, Crucifixion, Lamentation and Six Saints
1346–1355
tempera on panel, 87 × 55 cm
Galleria Corsini, inv. 558

Bibliography: M. Boskovits, *Giovanni da Milano*, Milan 1966, pp. 10, 36; D. Parenti, in *Giovanni da Milano. Capolavori del gotico fra Lombardia e Toscana*, cat. of the exhibition (Florence 2008), ed. by D. Parenti, Florence 2008, pp. 188–200 (with preceding bibliography).

Published by Xavier Barbier de Montault (1870) as a work by Giottino, the panel was attributed by Wilhelm Suida (1905) to Giovanni da Milano: this attribution is no longer contested. Giovanni was the most important exponent of the Giottesque style in Lombardy, but he is known to have been active primarily in Florence and Prato. Documents on a visit to Rome survive. He developed the style of Giotto, giving it a personal solemnity and elegance.

From Marabottini onwards the panel has been dated to around 1350–1355, not particularly early for a painter born in around 1320–1325 and who in 1346 was already mentioned among the foreign artists in Florence. However, the painting is one of the first known pieces by Giovanni, for whom youthful works have recently been proposed in the Milan area. The dating of the piece is based on some allusions to early works by Giotto, though there are also parallels with mature works by Bernardo Daddi and Maso di Banco. One of the six saints depicted holds a deer that identifies him as Eustace, whose popular legend gave rise to that of St. Hubert, more widespread in the north.

The work entered the Corsini collections in the 19th century. A mark that is no longer visible referred to the Papal Tobacco Factory. On the back is a seal of the Papal Customs of Rome dated 1814, when the tobacco factory was moved to the convent of Santa Maria Maddalena delle Convertite, also assigned to the Fine Arts. A second fragmentary wax seal connected the work to a lost frame and dates to the time of its purchase by the Italian state. This must be the "antique [painting] on panel with eight compartments, representing Mysteries. By the Camaldolese Monk Lorenzo" with the "customs seal," recorded on a list reported to me by Silvia Pedone (cf. Getty Provenance Index). The list was drawn up in Rome in late 1850 and includes works kept at Palazzo Corsini by Luigi Rossini and Raffaello Giannini, in anticipation of their definitive sale, with detailed and imaginative attributions. The painting does not therefore seem to have belonged to the group of paintings sold in 1868 to Filippo Corsini by his Pisan aunt Luisa Scotto. The panel has also been displayed in the Roman museums of Palazzo Venezia and Palazzo Barberini.

The structure of the piece has often been considered a modern reassembly of fragments from a dismembered polyptych. This deduction is understandable, but wrong. An examination of the back reveals that the support consists of two poplar boards joined at an early date, to which the strips dividing the panels were applied (those now present may date to the 19th century). On the same side, two large holes with square piercings can be seen along the left edge, probably made by nails or wooden pegs intended to connect the work to another structure. At the top are marks made by a large crossbar attached with nails. The rectangular format of the composition has suggested a provenance from the Po Valley and contacts with Rimini, although comparable pieces also exist in Tuscany. The gold working is very fine, especially in the delicate tooling within the haloes, which confirms the contacts with Bernardo Daddi.

AGDM

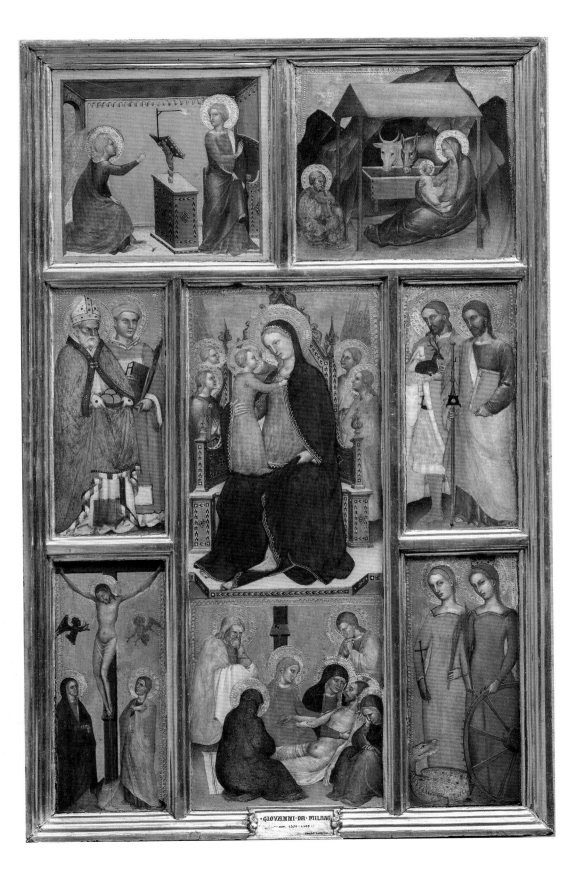

GIOVANNI · DA · MILANO

Ascension, Last Judgement, Pentecost

ca. 1440–1450
tempera on panel, 55 × 18.5 cm; 55 × 38.5 cm; 55 × 18 cm
Galleria Corsini, invv. 395; 396; 397

Bibliography: J. Pope-Hennessy, *Fra Angelico*, London 1974, p. 218; P. Palladino, in *Fra Angelico*, cat. of the exhibition (New York 2005), ed. by L. Kanter, P. Palladino, New York 2005, pp. 165–171, no. 32; *Il Trittico del Beato Angelico della Galleria Corsini*, ed. by D. Porro, Rome 2015.

The triptych is a fine example of the art of Fra Angelico, a Dominican friar belonging to the monastery of San Marco in Florence. Indeed, it contains powerful religious elements combined with great figurative novelties, chosen among the most advanced experiments of early Renaissance Florentine painting. Specifically, Fra Angelico successfully developed the use of light to achieve realistic effects and represented the spaces in accordance with Euclidean geometry, as is clearly apparent in the central panel of this triptych. At the same time, all his figures present an exquisite internal coherence. Despite these novelties, the artist was adopted as a model of behavior in the first half of the 19th century, lauded in the reactionary climate of the Restoration for his chaste role as an artist and monastic friar, detached from current events.

The work adopts a compositional subdivision familiar to the painter, which was also used in other surviving works; the most similar to this panel is the *Last Judgement* in the Gemäldegalerie in Berlin. The same scheme was again adopted in paintings on a similar subject held in the Museo di San Marco in Florence.

The work's history can be reconstructed starting from its appearance in the Corsini papers of 1740, having entered the collection through a donation. We can assume that this transfer took place at around the time in which a member of the family was pope, namely Clement XII

(1730–1740): such gifts, meant as bribes, are common in the papal history of the time. The Florentine cardinal Girolamo Bardi, elected in 1743, is mentioned in a note by Bottari in connection with the "gift": perhaps this was a concrete expression of gratitude toward someone who was helping him to obtain the precious cardinal's hat. The structure of the work is also debated, and various hypotheses have been advanced suggesting manipulation. However, it should be stressed that it is fully in keeping with other works by Angelico. This, combined with a careful examination of the edges of the panels, tends to rule out any major changes.

The period of execution is also controversial and is variously dated to different phases of the friar's career. However, a comparison with the other pieces cited above and with

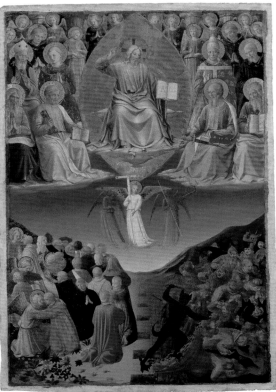
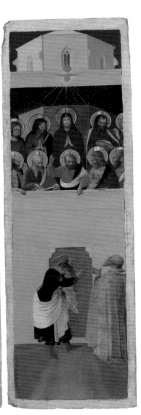

the remainder of the artist's production suggests that the Corsini triptych was painted during Angelico's mature phase, at some point after 1440.

The state of conservation is good, although the surface has been retouched in places to repair losses caused mainly by the instability of the support. The work was painted on poplar, by far the most commonly used wood in this phase of Italian art.

Formerly kept in a transparent airtight box to protect it from changes in climate, it was later decided to regulate the exchange of humidity on the back using an innovative control system. This device, among other things, makes it possible to view the painting without the many reflections created by the earlier screen.

8 | Filippo Lippi
(Florence, 1406–Spoleto, 1469)

Tarquinia Madonna
1437
oil on panel, 151 × 66 cm
Inscriptions: "MCCCCXXXVII", on the center bottom of the panel, in a painted cartouche; "PHIL..." on the frame
Palazzo Barberini, inv. 5054 (1953, from Tarquinia, church of San Marco)

Bibliography: P. Toesca, *Una tavola di Filippo Lippi*, "Bollettino d'arte", 11, 1917, 5–7, pp. 105–110; *Altro Rinascimento. Il giovane Filippo Lippi e la Madonna di Tarquinia*, cat. of the exhibition (Rome 2017), ed. by E. Parlato, Milan 2017.

BARBERINI
GALLERIE
CORSINI
NAZIONALI

This work was discovered in a church in Tarquinia a little over a century ago and originated from another sacred building that had been demolished. It was found by the great art historian Pietro Toesca who had it placed in the local museum for safeguarding and to ensure it was available to the public. It entered the Galleria Nazionale di Palazzo Barberini only after the last war. It was not difficult for Toesca to identify it, on the basis of its formal qualities, as a painting by Filippo Lippi, whose works are among the most easily recognizable to those interested in Italian figurative art. Indeed, the attribution has never been questioned. The execution of the *Tarquinia Madonna* is dated to 1437 by the inscription on the cartouche at the foot of the throne. Lippi was relatively young at the time, but already famous and on the way to becoming a prominent figure in an art capital like Florence. However, this leading role conflicts with his less straightforward biography: he began his painting career as a Carmelite monk and died while frescoing a church after having had a son with a nun.

The presence of this panel in an outlying place like Tarquinia has given rise to various explanations. It has usually been considered evidence of the ties between the local lord—Giovanni Vitelleschi—and Cosimo the Elder, or at least the Medici rulers of Florence. The existence of political relations of this kind is highly probable since Vitelleschi was, among other things, the archbishop of Florence.

The panel is a pivotal work, executed by the great Florentine artist at around the age of thirty, when he had not yet begun to develop the style dominated by the outlining of the contours, destined to become typical of his mature period and well-documented by the *Annunciation*, also in Palazzo Barberini (no. 9). The *Tarquinia Madonna* was executed as a small altarpiece and is still in its original frame, although the latter has been partly altered. The painting clearly indicates that the painter had pondered the ground-breaking innovations introduced in Italy in the early years of the century by Masaccio and Donatello. The inspiration drawn from those pioneers is easily perceived in the compact volumes of the heads and in the rigorous spatial quality conferred on the room in which the figures are positioned.

Alongside this adherence to the most advanced artistic developments to be seen in his hometown, Filippo demonstrates a marked attention to distant models in this work. Indeed, some figurative elements are derived from Dutch masters, especially the Van Eyck brothers and Rogier van der Weyden, the absolute protagonists of that world. Features imported from northern Europe are clearly apparent in the room depicted in the *Tarquinia Madonna*: in the representation, as if seen through a slightly wide-angle lens, and in the landscape, alongside certain details such as the leaded windowpanes and in general the attention to the furnishings.

AGDM

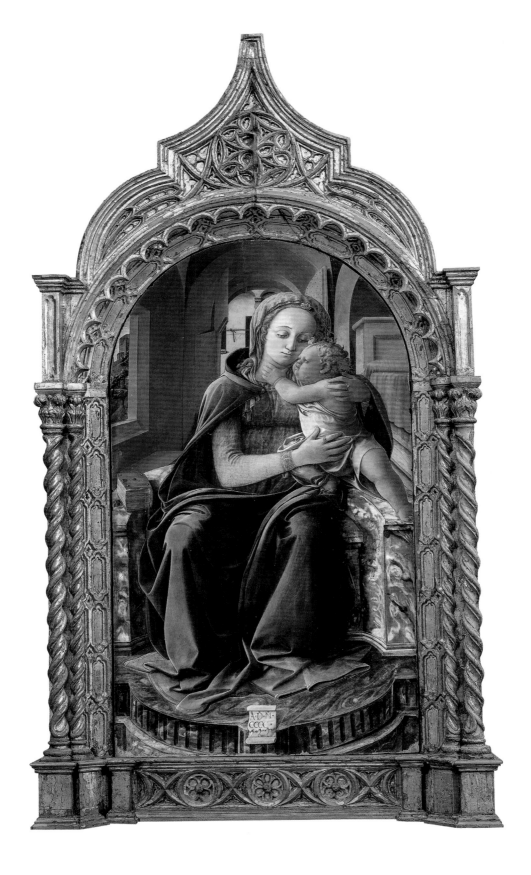

9 | **Filippo Lippi**
(Florence, 1406–Spoleto, 1469)

Annunciation and Two Worshippers
ca. 1440–1450
oil on panel, 155 × 144 cm
Palazzo Barberini, inv. 1877 (gift of E. Hertz, entered the museum in 1919)

Bibliography: G.B. Cavalcaselle, J.A. Crowe, *A New History of Painting in Italy*, ed. by R. Langdon Douglas, G. De Nicola, London 1892, IV, pp. 228–229; *Altro Rinascimento. Il giovane Filippo Lippi e la Madonna di Tarquinia*, cat. of the exhibition (Rome 2017), ed. by E. Parlato, Milan 2017, p. 145, no. 10.

This work, which may portray two members of the De' Bardi family, later belonged to the Piccardi family, who were involved in a dispute for it with the Florentine hospital of San Bonifacio. Giovan Battista Cavalcaselle (1892) saw it in Rome at the home of Ludwig Mond, a chemical industrialist and later collector who had attempted to export it in 1890. In 1907 the painting passed to Enrichetta Hertz, who gave it to the Italian state.

Many scholars have assumed that the painting was only partially executed by Filippo. However, it is difficult to say more, given the coherence of the work. It is an early example of a square altarpiece, later characteristic of the Florentine Renaissance. The disproportionately sized donors at the bottom, almost as large as the sacred protagonists, are a humanist development with respect to medieval imbalances of scale. In the background, partitions and low walls surround a closed garden, an attribute of the Virgin, executed with reference to the real boundaries still visible in Florence and its surroundings. The two young women on the back right have been identified as the companions of Mary mentioned in some medieval texts.

The execution is generally dated to shortly after 1440, roughly contemporary with the Maringhi *Coronation* in the Uffizi (1447). Other parallels can be found with the *Annunciations* in Munich (Alte Pinakothek) and Rome (Galleria Doria Pamphilj), in which Lippi engraved and glazed the gold in a similar way. This decoration of space marks the gap that had opened up between the artist and the more rigorously constructed images of the Florentine Renaissance. The scene is constructed mainly on the basis of the outlines that surround objects and people. This drawing technique became extremely popular in Florence, but it abandoned the more rigorous and thorough representation dating back to Giotto and Masaccio.

At first sight, the architectural elements of our *Annunciation* may appear solid but, compared to the great Florentine perspectival tradition, they are not. Their structure was corrected during execution, as evidenced by the versions that reappeared after excessively deep cleaning, as in the lectern and chair.

The painted marbles are invented and do not resemble any existing varieties of stone, though they are still far removed from Fra Angelico's fantastical representations. This striking dissociation between the Renaissance and antiquity, clearly evident here, is surprising and demonstrates how intellectual Florentine reconstructions of the ancient world were. However, this strange phenomenon is not restricted to Lippi. Nonetheless, a long tradition indicates familiarity at least with the painted representation of Egyptian porphyry and the green serpentine of the Peloponnese. The architectural elements of the panel are also incongruous in their coloring, which shifts from pink on the left to grey on the right, and in their shading.

The work is an early precursor to developments in Florentine art from Lippi to Botticelli.

AGDM

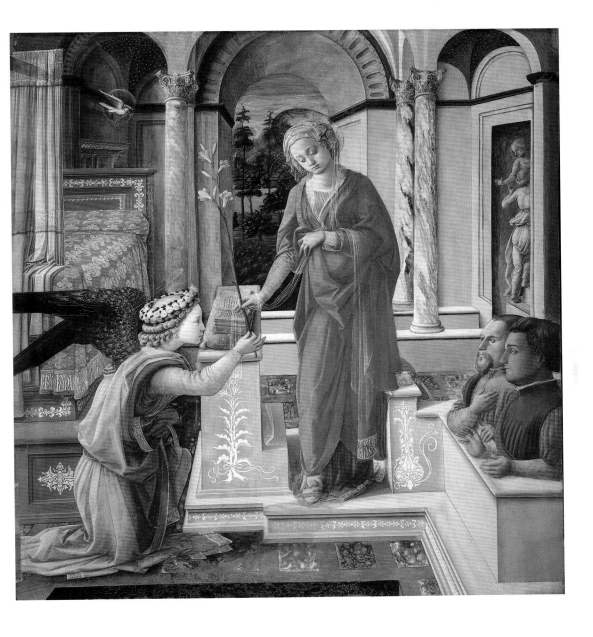

10 | Antonio Aquili, called Antoniazzo Romano
(Rome, 1430/1435–1508)

Virgin and Child with St.s Paul and Francis
1487
oil on panel, 166 × 155 cm
Palazzo Barberini, inv. 1436 (Poggio Nativo, church of San Paolo)

Bibliography: A. Cavallaro in *Antoniazzo Romano. Pictor Urbis. 1435/1440–1508*, cat. of the exhibition (Rome, 2013), ed. by A. Cavallaro and S. Petrocchi, Cinisello Balsamo 2013, no. 31.

The panel is signed at the bottom and dated on a pink pilaster strip decorating the architectural structure of the Virgin's throne. The painted support is square, in accordance with the typological formula established by the Florentine Renaissance. The altarpiece appears in the historiography in 1872, when it was reported as being in the church of San Paolo in Poggio Nativo, in the province of Rieti. It was later displayed in the Galleria Nazionale in Palazzo Corsini in 1897. Adolfo Venturi organized this transfer, while also acknowledging the limitations of the work and of the artist himself, who is nonetheless one of the finest of his time among those born in the Rome area. We know little about Antoniazzo's life (and nothing at all until the earliest information about him, when he was already a mature painter), but his importance was undisputed: he was the greatest Roman painter of the Renaissance. Despite the considerable artistic vitality of the papal capital in the 15th century, a local school did not emerge because the popes preferred to summon great artists from other areas of Italy. Antoniazzo therefore looked to the works of some of these important painters (Melozzo da Forlì, Benozzo Gozzoli, Perugino and others) to develop his own original style, itself destined to become a model in Renaissance Rome.

While the imitation stone reliefs on the Virgin's throne are reminiscent of some pieces sculpted by the Bregno family, the piece is indicative overall of the repetitive quality of the works of Antoniazzo, who obtained numerous commissions between the 15th and 16th centuries in and around Rome.

AGDM

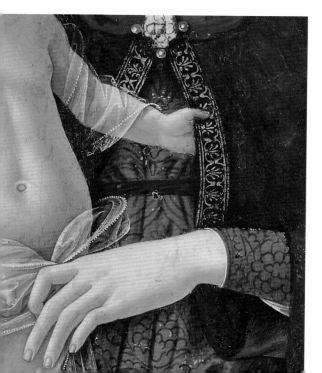

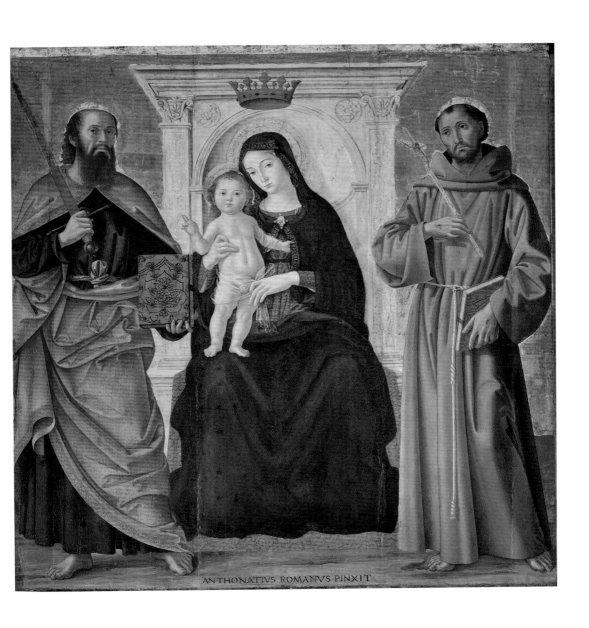

ANTHONATIVS ROMANVS PINXIT

11 | **Pietro Vannucci, called Perugino**
(Città della Pieve, 1446–Fontignano, 1523)

St. Philip Benizi
1505–1507
oil on panel, 79 × 62 cm
Palazzo Barberini, inv. 896 (1892, Torlonia donation)

Bibliography: P. Scarpellini, *Perugino*, Milan 1984, pp. 143–151, no. 150 (with preceding bibliography); F. Marcelli, in *Perugino, il divin pittore*, cat. of exhibition (Perugia 2004), ed. by V. Garibaldi, F. F. Mancini, Cinisello Balsamo 2004, pp. 278–279, no. I.49a

This is a fragment of a large rectangular altarpiece with two sides, one facing the public and the other the choir, formerly in the church of the Annunziata in Florence. According to archival mentions of the 19th century, in around the year 1500 Zaccaria di Lorenzo ordered the design of the architectural structure from Baccio d'Agnolo. Vasari recalls that the patrons initially intended to hire Leonardo as the painter, but, as on other occasions, he never actually began the work. The undertaking was then assigned to Filippino Lippi, who had barely had time to begin the panel with the *Deposition from the Cross* in the Florentine Accademia (333 × 218 cm), when he died in 1504. The following year, therefore, the commission went to Perugino, who by 1507 had completed the whole complex, probably also making use of collaborators. The other main panel with the *Assumption of Mary* remains at the Annunziata, where the altar was dismantled and largely removed in 1654. It had originally included another half-length saint, now in a private collection in South Africa, and four further saints shown full-length: two now in the Metropolitan Museum of Art in New York and two in the Lindenau Museum in Altenburg. It is unclear whether this *St. Philip* and the saint preserved in South Africa were painted in this format, or if their size was reduced at a later date, as the edges of our panel show signs of having been cut. The large altar was reconstructed thanks largely to Federico Zeri, who imagined that it might also have had a predella, suggesting two panels: one also in the Metropolitan Museum and the other in the Art Institute of Chicago.

Filippo Benizi is seen here within an architectural niche with moldings, which reappears in identical form for the other five saints in the series and was to fit coherently within the complicated two-sided structure.

Perugino's painting played a unifying role and was copied in many areas of the Italian peninsula. It thus seems to have had a function similar to that of the Italian language, rising above traditional regionalisms. However, this altar shows that this role was beginning to become less significant. Perugino's balanced compositional constructions were reworked simultaneously by Raphael and by Fra Bartolomeo, with results that opened up new possibilities.

AGDM

SERVVS· TVVS
SVM·E GO
ET·FILI VS·A
NCILLE· TVE

12 | **Piero di Cosimo**
(Florence, 1462–1522)

St. Mary Magdalene Reading
ca. 1490
tempera on panel, 77.5 × 56 cm
Palazzo Barberini, inv. 1468 (1907, gift of the baron Barracco, formerly Monte di Pietà)

Bibliography: E. Fahy in *Piero di Cosimo 1462–1522. Pittore eccentrico fra Rinascimento e Maniera*, cat. of the exhibition (Florence, 2015) ed. by E. Capretti, A. Forlani Tempesti, S. Padovani and D. Parenti, Florence 2015, no. 15 (with preceding bibliography), and now in Id., *Studies on Tuscan Renaissance Painting*, Rome 2020, I, pp. 416–418.

The work was acquired through the Monte di Pietà with an old attribution to Mantegna, abandoned by Giovanni Morelli in favor of Piero. The opinion of this pioneer of philological method applied to forms has not been questioned since. The painting is one of the artist's masterpieces and is also among his best-preserved works. Piero di Cosimo developed a style that distanced itself from the official lines of Florentine art, not based on outlines or on the emphasis on draughtsmanship characteristic of the local Renaissance. His intense lighting sometimes reflects an interest in the art of the Low Countries, while the soft blurring of some chiaroscuro effects and the rounded volumes evidence the influence of Leonardo da Vinci. Federico Zeri has dated the painting to around 1485–1490, followed by Everett Fahy, due to the painting's points of contact with Filippino Lippi, while most critics have dated it to the early 16th century.

The image has sometimes been described as a portrait of a Florentine lady dressed as the Magdalene. The colors of the garments worn by the figure have also been interpreted as allusions to the misdeeds and redemption of the Sinner. Although, the beautiful young woman intent on reading seems to be painted from life, her physical type is in keeping with the artist's repertoire and is unlikely to represent a specific individual. Rather, she presents connections with the iconographical tradition of the Netherlands, where the saint is often depicted in luxurious garments. Overall, we see a representation of the subject that is not contaminated by the sexually repressive and fundamentalist climate of Florence under the influence of Savonarola. Nor does the image reflect other tensions of this type, which were shortly to lead to the Protestant Reformation. On the contrary, the painting is representative of mature Humanism, not yet called into question by these momentous changes. The Magdalene is portrayed as a woman of high status at ease as she reads, displaying her book which was to be the object-instrument of choice of Florentine figurative culture for a further few decades.

The spatial composition with the painted frame surrounding the figure reappears in a *St. John the Evangelist* by the same painter now in the Art Academy of Honolulu. For this reason, almost all critics have considered the latter panel and our painting as part of a single coherent series, though they differ considerably in style, size, and quality to the advantage of our *Magdalene*.

AGDM

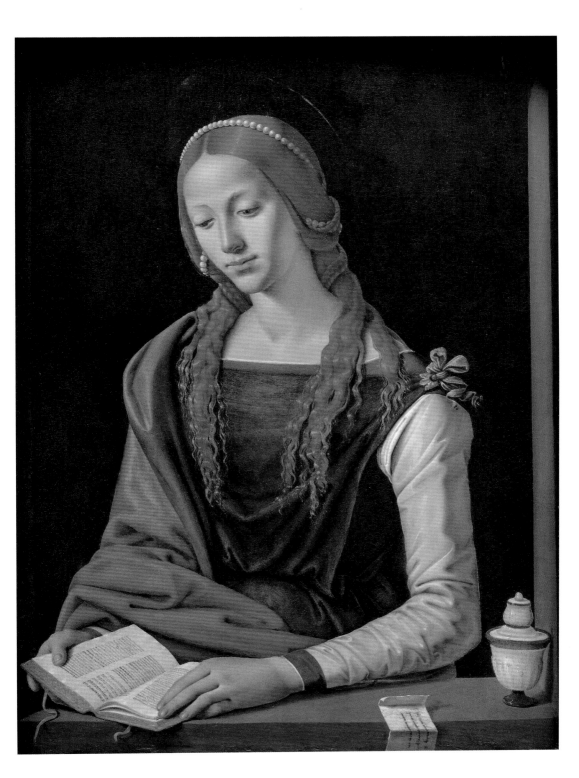

(Urbino, 1483–Rome, 1520)

Portrait of a Woman (La Fornarina)

ca. 1519–1520
oil on panel, 87 × 63 cm
Palazzo Barberini, inv. 2333 (Barberini purchase, 1936)

Bibliography: *La Fornarina*, cat. of the exhibition (Rome 2000), ed. by L. Mochi Onori, Rome 2000; L. Mochi Onori, in *Räphael. Grâce et Beauté*, cat. of the exhibition (Paris 2001–2002), ed. by P. Nitti, M. Restellini, Milan 2001, pp. 134–140, no. 13; *La Fornarina di Raffaello*, cat. of the exhibition (Milan 2002), ed. by L. Mochi Onori, Milan 2002; R. Pisani, *Le Veneri di Raffaello (tra Anacreonte e il Magnifico, il Sodoma e Tiziano)*, "Studi di storia dell'arte", 26, 2015, pp. 97–122; V. Farinella, in *Raffaello 1520–1483*, cat. of the exhibition (Rome 2020), ed. by M. Faietti, M. Lafranconi, Milan 2020, pp. 312–313, no. VII.5.

A very fine see-through veil covers the belly of the half-naked girl, with a soft red cloth wrapping her hips. Her left arm is adorned with a bracelet bearing the artist's signature in gilded capital letters: RAPHAEL VRBINAS. The unadorned body contrasts with the sumptuous, albeit not courtly, hairstyle, consisting of a turban of Middle Eastern inspiration that collects the raven hair, enriched by a precious head ornament set with a ruby and a small emerald or sapphire from which hangs a pearl: gems symbolically alluding to love and union. The woman portrayed is traditionally identified as the model loved by Raphael, also depicted in the *Woman with the Veil* in Palazzo Pitti, as confirmed by the derivation of the iconography from the Capitoline Venus type. In this type, the goddess is totally naked and making the modest gesture of covering her pubic area with one hand and her breasts with the other, wearing an armilla on her left arm (where Raphael's signature marks possession of the woman portrayed) and turning her head slightly sideways. Adopting the image of a modest Venus and other elements alluding to concepts of conjugal love, including the garments in red and white, the Petrarchan colors of love, is appropriate for the portrait of a much-desired lover expressed through the iconography of the early 16th century intended for brides. This is also

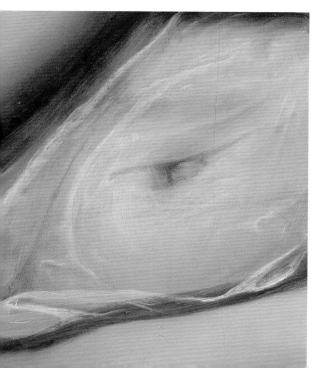

confirmed by the presence of the veil and the mantle revealing the fertile womb, as well as the small wedding ring she wears on her left ring finger.

Even the background, initially a natural landscape in the style of Leonardo that was later replaced with luxuriant myrtle, quince, and laurel shrubs, refers to the figure of Venus and to conjugal fidelity. The portrait, resulting from the painter's close intimacy with the model, was not fully completed in Raphael's workshop (1520) before it reappeared in 1595 in the collection of Countess Caterina Sforza of Santa Fiora. It later passed to the Buoncompagni family and was ultimately bought by the Barberini family in the early years of the papacy of Urban VIII (1623–1644).

TC

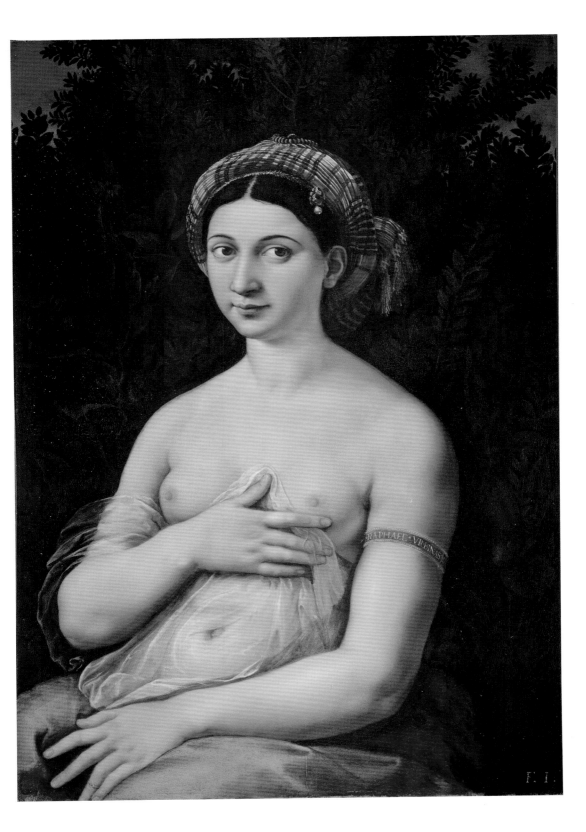

14 | Giulio Pippi, called Giulio Romano
(Rome, 1499–Mantua, 1546)

Virgin and Child (Hertz Madonna)
ca. 1517
oil on panel, 37 × 30.5 cm
Palazzo Barberini, inv. 1661

Bibliography: F. Hartt, *Giulio Romano*, New Haven 1958, pp. 54–55; K. Oberhuber, *Raffaello. L'opera pittorica*, Milan 1999, p. 235; J. Meyer zur Capellen, *Raphael. A Critical Catalogue of His Paintings. II: The Religious Paintings, ca. 1508–1520*, Landshut 2005, pp. 269–271; A. Lo Bianco, in *La donazione di Enrichetta Hertz. 1913–2013*, cat. of the exhibition (Rome, 2013), ed. by S. Ebert-Schifferer, A. Lo Bianco, Cinisello Balsamo 2013, pp. 118–121.

The *Virgin and Child* are depicted in this precious little devotional painting by Giulio Romano in accordance with the most canonical and venerable Marian iconography. Yet the painter, following in the footsteps of Raphael and through him of Leonardo, aspires to combine the sacred and almost liturgical significance of ancient icons of the Virgin with a more immediate atmospheric power, at once unequivocally domestic and elusively arcane.

The mother and son emerge fully lit from the dense gloom that fills the room. In the background, on the left, the *thalamus virginis*, the Virgin's bed, decorated with a partially raised green curtain, can be seen in the darkness. The meaning of the image refers to the intimate and sublime mystery of the incarnation, and perhaps this same meaning is also intentionally alluded to in the singular pose of the Child, who seems to slip from his mother's lap and between her legs. Yet the figures also recall the role of helper and co-redemptrix that medieval theology assigned to Mary, who raises Christ's arm and gently encourages him to dispense an early blessing to the devout viewer, thus conferring an affective and psychological character on the solemn and prophetic connotations of the gesture.

The space and lighting of the painting therefore form more than a simple backdrop and are instead charged with a subtle symbolic significance that transforms the room in which the miracle of the Annunciation—and not of conception—took place into a sort of visual metaphor for Mary's own body. That this is not a fortuitous combination is also demonstrated by the enigmatic but certainly deliberate treatment of the background. The Virgin's bedroom opens onto a narrow and bare passage, illuminated from the left by a source of light that we do not see and closed on the right by a locked door. On the ground is a white dove. Whilst this curious solution—which seems to adopt the lighting effects typical of paintings from elsewhere in Europe—serves to visually measure the depth of the space, it also qualifies and connects to the dominant theme of the image. Indeed, it is no coincidence that the painter took care to illustrate with the precision of a miniaturist the cord and counterweight mechanism attached to doors to ensure that they closed on their own: an expedient then in common use, but rarely represented in images. The door that opens without anyone pushing it may allude to the *mysterium incarnationis*, an invention as abstruse as it is unprecedented, as is often the case in the painting of Giulio Romano, in this respect to a worthy heir to Raphael.

MC

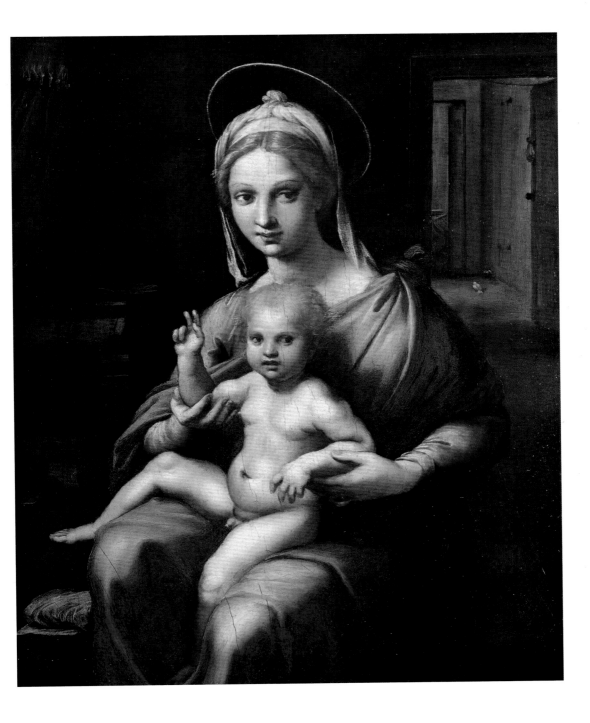

15 | Baccio della Porta, called Fra Bartolomeo
(Savignano di Prato, 1472–Florence, 1517)

Holy Family with the Infant St. John the Baptist
1516
oil on panel, 136 × 126 cm
Galleria Corsini, inv. 116 (formerly Doni collection; purchased from the Corsini family)

Bibliography: F. Caglioti, *L'Amore Attis di Donatello, caso esemplare di un'iconografia d'autore*, in *Il ritorno d'Amore. L'Attis di Donatello restaurato*, cat. of the exhibition (Florence 2005–2006), ed. by B. Paolozzi Strozzi, Florence 2005, p. 63, note 70; S. Alloisi, *Guida alla Galleria Corsini*, Rome 2000, pp. 32–33; S. Padovani, in *L'Età di Savonarola. Fra' Bartolomeo e la sua Scuola*, cat. of the exhibition (Florence 1996), ed. by S. Padovani, Venice 1996, pp. 111–113; *Fra Bartolomeo et son atelier. Dessins et peintures des collections françaises*, cat. of the exhibition (Paris 1994–1995), ed. by C. Fischer, Paris 1994, p. 122; A. Cecchi, *Agnolo e Maddalena Doni committenti di Raffaello*, in *Studi su Raffaello*, proceedings of the international conference, Urbino 1987, p. 437 and note 39 (with preceding bibliography).

An extraordinary masterpiece belonging to the Corsini collection and described by Vasari as "extraordinarily beautiful," the painting is exceptionally dated 1516 and signed with the devotional formula ORATE PRO PICTORE, alluding to Baccio della Porta's status as both friar and painter in the Dominican and Savonarolan congregation of the monastery of San Marco.

The scene, set in an airy landscape, depicts in the foreground the encounter between the baby Jesus, held up by the Virgin, and the infant St. John the Baptist in the presence of Joseph. This was an extremely fashionable theme among Florentine painters in the 16th century given its political overtones, as St. John the Baptist was the patron saint of Florence and a very popular figure among the Republican faction.

Left out of the official Gospels, the subject appears in medieval literature, for example in the writings of Fra Domenico Cavalca, according to which the young Baptist, after escaping the slaughter of the innocents ordered by Herod, hid in the desert protected by the angel Uriel. During the flight into Egypt, he met the baby Jesus, who blessed him and foretold his mission as a *proto-Baptist* and his tragic destiny.

The grandiose composition inherits from Raphael (Canigiani *Holy Family*, Munich, Alte Pinakothek) the pyramidal arrangement originating with Leonardo da Vinci and reflects the solemn naturalism of the friar's mature works. The complex intertwinings and poses of the figures, starting from the central positioning of the two children, communicate mutual affection and a complex dynamic of physical and spiritual movements.

In this late phase of his career, Fra' Bartolomeo returned to painting themes tackled in his youth, such as the Virgin and Child, in the form of the *Madonna Humilitas*, with the Virgin humbly seated on the ground to allow the baby Jesus to play with the infant Baptist. The figures, sculptural and well finished, are very different from those of his earlier works, rendered as flattened reliefs, and take on a greater physicality and dynamism that highlight the influence of Roman culture on the artist following his stay in the city (1513–1514). This influence is also evidenced in this work by the dynamic, serpentine torsion of St. Joseph, reminiscent of the powerful images of the Sistine chapel, the twisting motion of the Virgin and the acrobatic pose of the baby Jesus, alongside the vividly iridescent colors of the garments.

The documents record that Cardinal Neri Maria Corsini (1685–1770) purchased the painting in Florence directly from the Doni family, which had used it to adorn the altar of the chapel in their residence.

MC

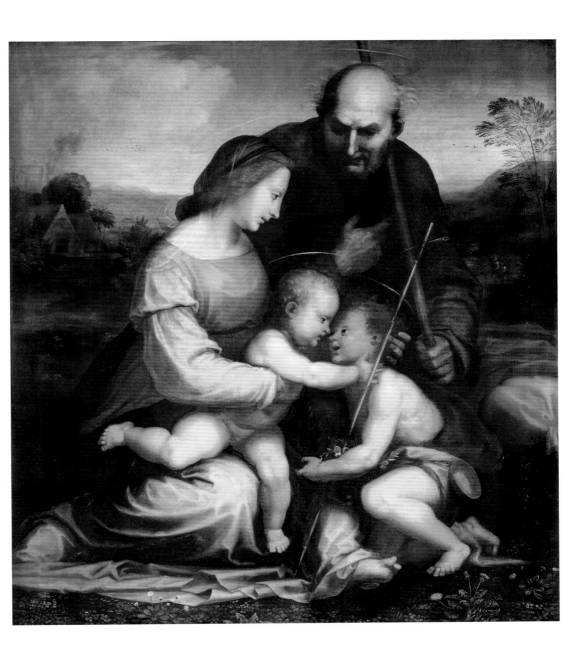

16 | Andrea d'Agnolo, called Andrea del Sarto
(Florence 1486–1530)

Holy Family
1525–1526
oil on panel, 140 × 104 cm
Palazzo Barberini, inv. 2332

Bibliography: S. J. Freedberg, *Andrea Del Sarto: Catalogue raisonné*, Cambridge, MA, 1963, p. 178; J. Shearman, *Andrea del Sarto*, Oxford 1965, II, p. 263; A. Natali, A. Cecchi, *Andrea del Sarto*, Florence 1989, p. 124; *Andrea del Sarto: The Renaissance Workshop in Action*, cat. of the exhibition, ed. by J. Brooks, D. Allen, X. F. Salomon, Los Angeles 2015, pp. 118–120; A. Daveri, A. G. De Marchi, L. de Viguerie, H. Glanville, C. Merucci, S. Pedetti, M. Radepont, M. Vagnini, P. Walter, *Andrea del Sarto in the Galleria Nazionale d'Arte Antica in Palazzo Barberini*, "Kermes", 104–105 (2016–2017), pp. 39–55.

According to the testimony of Giorgio Vasari, usually well-informed about his teacher's works, Andrea "painted a most beautiful picture of Our Lady nursing a baby, and a Joseph" for the wealthy Florentine merchant Zanobi Bracci, meant for a chapel in his villa at Rovezzano near Florence (Vasari, *Vite*, 1550 and 1568). The panel was soon moved to the family's city palace and was subsequently purchased in 1580 by the Salviati family, in whose Florentine collections it remained until the second half of the 17th century. Brought to Rome in 1667, the work entered the collections of the Colonna family in the early 18th century; it is listed in the latter already in 1714, before finally passing to Palazzo Barberini after 1818.

The painter, who tackled this subject several times over the course of his career, aspires here—as a true heir to the tradition of the Tuscan Renaissance—to create a carefully balanced amalgam of the sculptural solidity of Michelangelo's drawings, the sophisticated teachings of Leonardo's *sfumato* and the devout composure of Fra' Bartolomeo. In a moment of repose, perhaps during the return from their Egyptian exile, the Virgin nurses the Child, but the viewer's presence outside the frame suddenly distracts them, casting a shadow of disquiet that is revealed in the faces and movements of the figures. The mother instinctively embraces her son in a protective gesture and Jesus turns toward the viewer with a timorous movement. The theme of the image is thus the melancholy portent of Christ's death, of which the mother and son are already aware in their divine foreknowledge, but of which even the elderly Joseph seems sadly cognizant—not coincidentally, in an early version, later erased and altered during the execution of the painting, the painter had placed a crucifix in his hand.

From a narrative point of view, the scene may implicitly allude to the encounter between the baby Jesus and the young John the Baptist in the desert, a motif present in the apocryphal and devotional literature and dear to the Florentine iconographical tradition. As well as explaining the pensive atmosphere that envelops the figures, the allusion to the prefiguration of the Redeemer's ministry and sacrifice may also explain the presence of the tangled roots at the feet of the three tree trunks that appear behind the Virgin: this detail does not seem accidental in an otherwise very plain, even stark, scene. As in the prophetic verses of Isaiah (11, 1), Christ himself is the shoot that sprouts from the roots of the tree of Jesse, but as John the Baptist prophesied (Matthew 3, 10) his coming also proclaims that "even now the axe is laid to the root of the trees" and the baptism of water will be followed by baptism with the Holy Spirit and fire.

MC

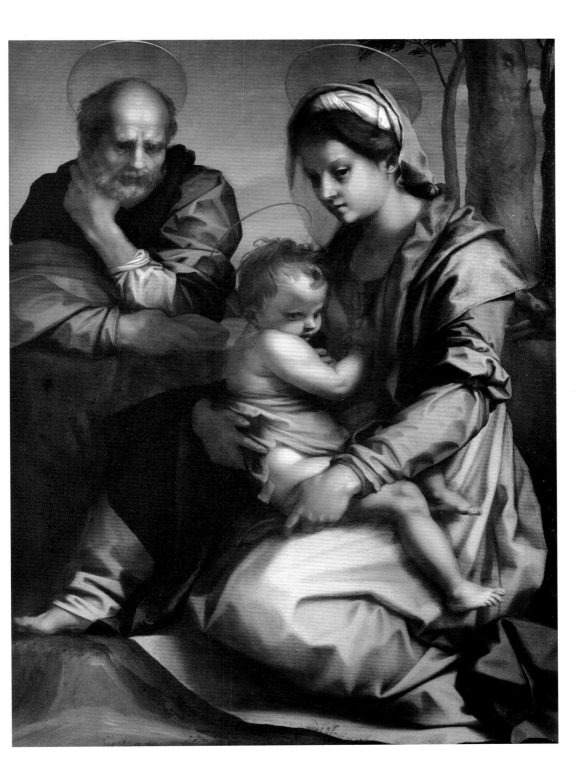

(Murcia, Spain, active between the late 15th and the first quarter of the 16th century)

The Vision of the Blessed Amadeo de Menes Sylva

ca. 1513–1514
oil on panel, 277 × 320 cm
Palazzo Barberini, inv. 3574 (purchased from the Sciarra collection, 1897)

Bibliography: F. Navarro, *Lo Pseudo-Bramantino: proposta per la ricostruzione di una vicenda artistica*, "Bollettino d'Arte", xxxvii, 14, 1982, pp. 37–69; M. Tanzi, *Pedro Fernández da Murcia lo Pseudo Bramantino. Un pittore girovago nell'Italia del primo Cinquecento*, cat. of the exhibition (Castelleone 1997), Milan 1997, pp. 27, 119, no. 7.

The archangel Gabriel, suspended on a ring of clouds, points out the heavenly court to a Franciscan monk. Christ and the Virgin sit on the highest podium, surrounded by a group of angels, with various characters from the Old (right) and New Testament (left) arranged beneath them. At the center, St. Joseph and St. John the Baptist act as a link between the two groups. The elderly friar kneeling and praying is the Blessed Amadeo de Menes Sylva (ca. 1420–1482), an ascetic of Iberian origin and founder of the Amadeite congregation, which professed a more rigid observance of the rule than the two main components of the order (conventual and observant). He was a charismatic figure who gained the protection of many powerful people, particularly Pope Sixtus IV (1471–1484), whose confessor he was. According to tradition, Amadeo was also the author of the *Apocalypsis Nova*, a theological treatise based on his visions on the Janiculum Hill, in the place where St. Peter was believed to have been crucified and where the new Amadeite family built the church and convent of San Pietro in Montorio as its stronghold.

The Barberini panel is a faithful figurative rendering of the first of the visions handed down by the manuscripts, in which Amedeo was "kidnapped" by the archangel Gabriel and brought before Christ to be initiated into the revelation of the most arcane mysteries of the Faith. The open book with a pen and ink next to it, placed at the feet of the revered prophet, emphasizes this close correlation between lived experience and its textual evocation. Equally telling is the recurrence of the number seven, referring to the Apocalypse of St. John: there are seven angels, seven protagonists of the Old and New Testaments respectively, seven points in Mary's diadem. The presence of the ladder also lends itself to a dual level of analysis: as well as recalling Jacob's ladder, as an instrument of conjunction between man and God, it refers to the kabbalistic and eastern interests widespread in the culture of the early Renaissance.

The broad landscape that dominates the lower portion of the panel has been compared to the area near Montorio Romano (Rieti), formerly home to the church of San Michele Arcangelo for whose main altar the work was conceived. The landscape also re-

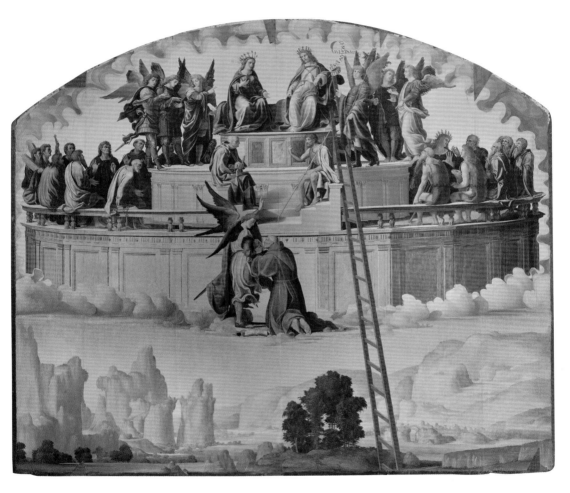

veals the principal features of the strong artistic personality of the Spaniard Pedro Fernández, influenced by the culture originating with Leonardo, also apparent in some caricatural faces, developed during repeated visits to Lombardy. From a compositional point of view, there are obvious parallels with the *Disputation over the Holy Sacrament* in Raphael's Room of the Segnatura (1509–1510).

MC

18 | Marco Bigio
(Siena ca. 1500–1550)

The Three Fates
ca. 1530–1540
oil on panel, 212 × 200 cm
Palazzo Barberini, inv. 2350

Bibliography: J.A. Emmens, *Een fable van Ariosto*, "Netherlands Yearbook for History of Art", 15, 1964, pp. 97–98; F. Sricchia Santoro, in *Da Sodoma a Marco Pino: pittori a Siena nella prima metà del Cinquecento*, cat. of the exhibition (Siena 1988), ed. by Ead., Florence 1988, pp. 138–139; L. Mochi Onori, in Ead., R. Vodret, *Galleria Nazionale. Palazzo Barberini. I dipinti. Catalogo sistematico*, Rome 2008, p. 95; P.H.D. Kaplan, *Italy 1490–1700*, in *The Image of the Black in Western Art. From the "Age of Discovery" to the Age of Abolition: Artists of the Renaissance and Baroque*, ed. by D. Bindman, H.L. Gates Jr, Cambridge, MA, 2010, pp. 131–135; M. Kondziella, *"Pieno di misteri, e di figure": die "Drei parzen" des Marco Bigio im Palazzo Barberini in Rom*, "Marburger Jahrbuch für Kunstwissenschaft", 40, 2013, pp. 93–112 (with previous bibliography).

The work depicts the three Fates intent on spinning the thread of life of every human being. On the right, Clotho spins the white thread of life with her distaff, on the left Lachesis winds the thread around the spindle, while at the center Atropos leans forward to cut it with her shears. The artist chose to represent the three women as young nudes inspired by classical statuary, but also included in the painting a long series of other figures who reveal the work's direct source. This is the image of the Fates as described by Ariosto in Cantos XXXIV and XXXV of the *Orlando Furioso*, when Astolfo and St. John the Evangelist travel up to the moon to recover Orlando's wits. In the poem, the three women are assisted in their task by Death and Nature, represented in the painting respectively as a skeleton with the customary scythe and as a woman of color with two pairs of breasts from which milk gushes forth. Again, in Ariosto, we find an explanation for all the other details of the painting. The text tells that the name of the owner of each skein of thread was stamped on plaques made of iron, silver, or gold; these were carried away in the folds of his cloak by Time, depicted in the middle ground behind Atropos, and thrown

into Lethe, the river of forgetfulness. However, some plaques were carried away by birds, while a very few were rescued by two white swans—an allegory for poets—who returned them to the river bank where a nymph—the figure on the far right—affixed them to the column of the temple of immortality, clearly visible at the back left.

This is thus a complex allegory, closely reliant on Ariosto's text and thus potentially suggesting a commission linked to Ferrara, given also that in the foreground, among the gold plaques, we see the names Alfonso and Lucrezia. These may be a reference to Alfonso d'Este (1476–1534) and his second wife Lucrezia Borgia (1502–1519), suggesting a date in the fourth decade of the century, after the publication of the definitive version of Ariosto's poem in 1532.

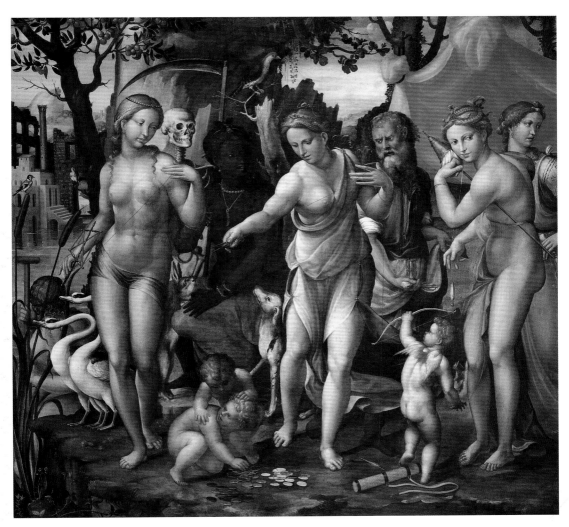

At the present state of knowledge, the first known mention of the painting dates to 1786, when Guglielmo Della Valle described a painting by Marco Bigio "full of mysteries and figures," representing the Fates, in the house of Antonio Pieri in Siena. The work remained in the Pieri collection until 1935 with an attribution to Sodoma; it was then purchased by the Minister for National Education, Giuseppe Bottai, and subsequently entered the collections of the Galleria Nazionale di Arte Antica di Roma. Based on Della Valle's testimony and the similarities with other works by Marco Bigio, Fiorella Scricchia Santoro correctly attributed the painting to the Sienese artist, making it an important reference point for reconstructing a catalogue that still remains very incomplete.

AC

19 | Girolamo Genga
(Urbino, 1476–1551)

Mystic Marriage of St. Catherine of Alexandria
Third decade of the 16th century
oil on panel, 131 × 112 cm
Palazzo Barberini, inv. 1767 (purchased from the Chigi family, 1918)

Bibliography: A.M. Petrioli Tofani, *La resurrezione del Genga in S. Caterina a Strada Giulia*, "Paragone", 177, 1964, pp. 48–58, p. 54; A. Colombi Ferretti, *Girolamo Genga e l'altare di Sant'Agostino a Cesena*, Bologna 1985, pp. 61, 66; R. Bartalini, *Genga nell'Urbe*, in *Girolamo Genga, una via obliqua alla maniera*, ed. by B. Agosti et al., Bologna 2018, pp. 179–195 (with preceding bibliography); A. Caffio, in *Raffaello e gli amici di Urbino*, cat. of the exhibition (Urbino, 2019–2020), ed. by B. Agosti, S. Ginzburg, Florence 2019, pp. 260–261, no. VI.7.

The foot of the Virgin brushes against the frame of the painting, inviting the viewer into the intimacy of the domestic space where, in a decidedly unusual iconography, the mystic marriage of St. Catherine of Alexandria and the Christ child is being celebrated. Mary, lit by a shaft of light passing through the closed window (an allusion to her virginity), holds her son, who is seated on a stool, and consecrates the mystical union, grasping the martyr's wrist as the Child gives her the ring. St. Catherine of Siena and, in a more off-center position, St. Bernardino participate in the event; on the ground between the two women is the lily, an attribute of the Dominican nun and a symbol of chastity, here referring to the bride, curiously depicted without the symbols of her martyrdom, the wheel and the palm. In the background, St. Elizabeth and St. Zaccharias with the infant St. John the Baptist have just crossed the threshold and pay homage to the event with a gift of two doves. Theirs is an unusual presence because they are rarely associated with this subject (but see the contemporary *Mystic Marriage* by Parmigianino in the National Gallery in London), a fact that may perhaps help to better define the occasion on which the work was commissioned and its date, both of which remain problematic. Indeed, the family group underscores the liturgical dimension of the painting linked to the theme of marriage, connected to the cult of this saint of Hellenistic origin from the late Middle Ages (Jenkins, Lewis 2003; Walsh 2007).

The work, which comes from the Chigi collection, where it is attested with certainty from the mid-17th century, has been connected to the patronage of Sigismondo Chigi (who died in 1525), the Sienese ambassador to Rome and brother of Agostino the Magnificent, the wealthiest and most powerful banker of the Papal court; or, more plausibly, to that of his wife Sulpizia (1489–1557), daughter of the "tyrant" of Siena, Pandolfo Petrucci. The 17th-century sources, which also mention the magnificent frame executed by Lorenzo Tori da Siena, already noted the presence of the noblewoman's portrait, though they identified her in the face of the Virgin; in fact, as critics have demonstrated, she should be recognized in the pronounced features of the young bride.

MC

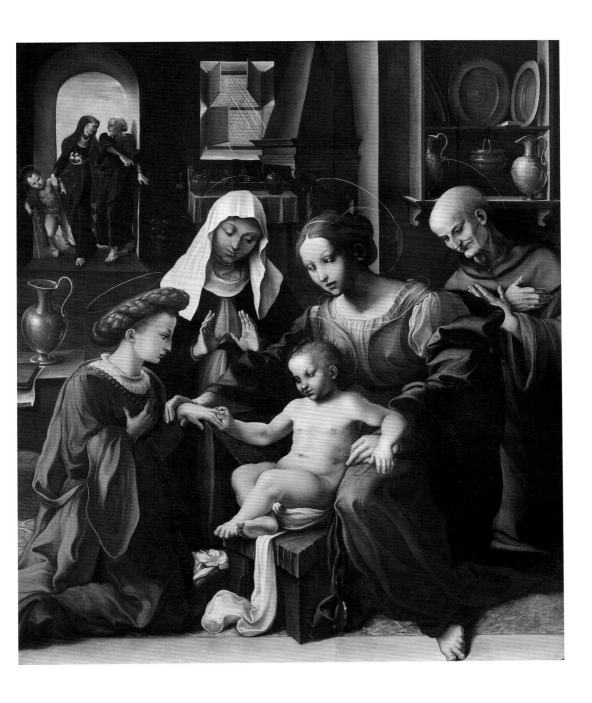

20 | Domenico di Giacomo di Pace, called Beccafumi

(Cortine di Valdibiena, 1486–Siena, 1551)

Madonna and Child with the Infant St. John the Baptist

ca. 1541
oil on panel, 90 × 65 cm
Palazzo Barberini, inv. 2410 (purchased from the Barberini family, 1959)

Bibliography: D. Sanminiatelli, *Domenico Beccafumi*, Milan 1967, p. 115, no. 66; R. Barbiellini Amidei, in *Aspetti dell'arte a Roma prima e dopo Raffaello*, cat. of the exhibition (Rome 1984), Rome 1984, pp. 65–66; C. Alessi, in *Domenico Beccafumi e il suo tempo*, cat. of the exhibition (Siena 1990), Milan 1990, pp. 210–211; P. Torriti, *Parmigianino*, Milan 1998, pp. 184–187; L. Mochi Onori, in *Parmigianino e il manierismo europeo*, cat. of the exhibition (Parma 2003), Milan 2003, p. 156.

The Mannerist painter provides a very personal interpretation of the old iconography of the *Virgo lactans* accompanied by the infant St. John the Baptist, in an eccentric and restless vein. The monumental figure of Mary, rotated centrally as if on a pivot, is shown in the act of offering a breast to the chubby baby Jesus, whose pose is drawn from Michelangelo's figure of *Dusk* on the tomb of Lorenzo de' Medici in San Lorenzo in Florence.

St. John, an intense expression on his face, is emotionally engaged in the scene, which glorifies the Virgin's role as mother and the humanity of Christ, emphasizing the concept of the incarnation, key to Jesus' path from the Passion to Death and Redemption.

The visionary climate of the scene is heightened by the setting of the figures, placed in a vast and luminous void filled with a warm and almost phosphorescent atmosphere, from which the rocky slopes emerge in the background, bathed in splashes of light. The lighting is boldly pushed to the maximum degree of expressivity, flecking the figures with metallic glints that strike and break up their volumes, dissolved into a warm fluid matter vibrant with light and color.

In the smoky chiaroscuro of the faces, where the artist abandons precise outlines in favor of hazy modulations of color, we see the teachings of Sodoma, while the slender, elongated oval of the Virgin and Child still preserves reminiscences of Raphael, reworked in a highly original way.

The painting reflects the style of the final phase of Beccafumi's career, also profoundly influenced by Michelangelo's masterpiece of the *Judgement*, and presents affinities with other works executed by the artist in around 1540, and in particular with the *Coronation of the Virgin* in the church of Santo Spirito in Siena. It also reveals formal debts to the style of Perin del Vaga and the Mannerist followers of Michelangelo in the extreme accentuation of forms and colors.

The painting was purchased by the Italian state in 1959. Despite the numerous attempts by scholars to trace it in earlier documents, it can be identified in the Barberini collection only from 1817, when it is mentioned in the inventory of the family's executor drawn up by Vincenzo Camuccini, where it is described as unfinished.

TC

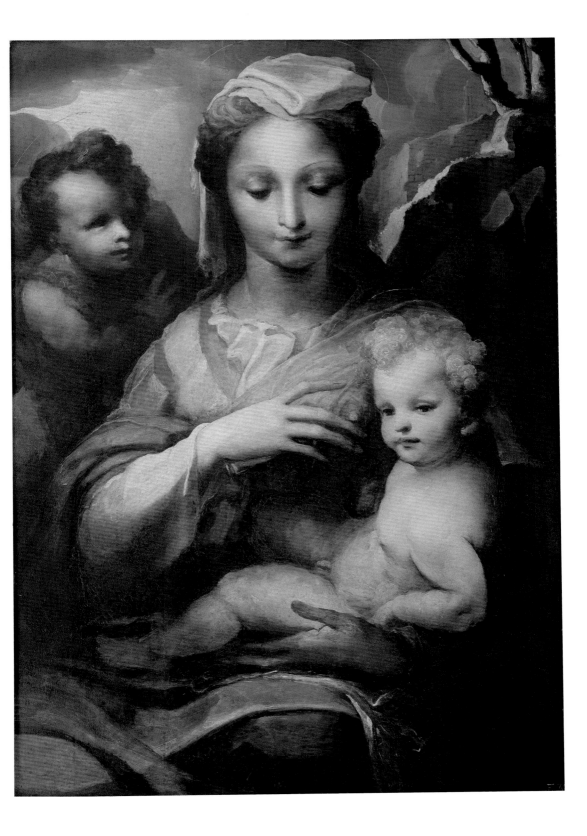

21 | Master of the Manchester Madonna

Pietà

ca. 1500
oil on panel, 134 × 111 cm
Palazzo Barberini, inv. 1314 (Monte di Pietà purchase, 1895)

Bibliography: F. Zeri, *Il Maestro della Madonna di Manchester*, "Paragone", 43, 1953, pp. 15–27; *The Young Michelangelo*, cat. of the exhibition (London 1994), ed. by M. Hirst, J. Dunkerton, London 1994; M. March, *The Master of the Manchester Madonna: Restoration, Technique, and a Context for Attribution*, in *Studying and conserving paintings. Occasional Papers on the Samuel H. Kress Collection*, London 2006, pp. 145–163.

In the panel, a dead Christ supported by the Virgin is painted in grisaille, principally in a dark yellow, against a dark background. White is used to highlight the brightest areas. The composition is clearly based on Michelangelo's famous sculpture of the *Pietà* now in the Vatican. The connection with the marble is underlined by the grisaille painting technique, also combined with statuary on other occasions. However, this is not a faithful copy, as indicated by the various differences. The date of the panel is early, around 1500, almost contemporary with the marble masterpiece. The similarity has always been noted and has inspired very different theories on the artist responsible for the painting. After several unconvincing attempts to attribute it to Michelangelo himself, Luca Signorelli was proposed. At this point Federico Zeri intervened, including the work in a group comprising the *Manchester Madonna* (London, National Gallery) among others. This group, which presents close affinities with the youthful works of Michelangelo, has never been linked to a historical name.

Michael Hirst and Jill Dunkerton later re-examined the issue, describing the two panels in the National Gallery in London (the *Entombment* and the *Manchester Madonna*) as early instances of Buonarroti's work as a painter. To support their hypothesis, they alleged the quality of the execution and some technical analyses. However, the theory is weak: the English panels in poplar, the wood most used at the time in Italy, though described as being of very careful workmanship, actually consists of poorly cut sections of the plant. No comparisons were made between the technical information on the two "upgraded" pieces in London and those in the demoted group. The execution with hatched lines, described as typical of Michelangelo, also appears in other paintings in the series, including our *Pietà*. Thus, the change of attribution proposed by Hirst and Dunkerton in favor of a hypothetical and equally anonymous "Associate of Michelangelo" is a fruitless one. Finally, there are some evident differences in quality within the London *Entombment*, also present in the *Manchester Madonna*.

In a book dedicated to Mario Modestini, a restorer who became famous in the United States, Molly March summarized the theory advanced by the two scholars, tentatively questioning it on the basis of technical considerations on the group of works assigned in London to the "Associate of Michelangelo."

The use of grisaille on panel has few contemporary parallels. The surface presents numerous antique scratches and incisions, and the quality of execution is not particularly high.

AGDM

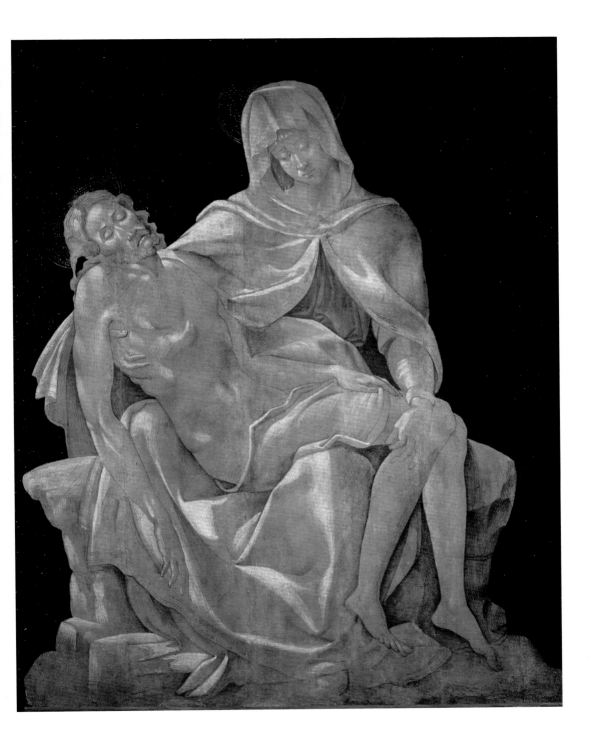

David and Goliath
ca. 1550–1551
oil on slate, 33.7 × 43.9 cm
Palazzo Barberini, inv. 1877 (G. Pisciscelli purchase, 1918)

Bibliography: A.G. De Marchi, *Daniele da Volterra e la pietra del paragone*, Rome 2014 (with preceding bibliography).

The painting, originally painted on both sides of the support and believed for centuries to be a Roman work by Michelangelo, has recently been identified as a masterpiece by Daniele da Volterra of around 1550–1551, based on ideas and models by Buonarroti (a lunette in the vault of the Sistine Chapel, some drawings in the Ashmolean Museum in Oxford and in the Morgan Library in New York, the *Wrestlers* in Casa Buonarroti and a lost *Samson* in bronze). In his *Lives* of 1568, Giorgio Vasari mentions a work of this kind executed for Monsignor Della Casa, the famous author of the *Galateo*, who had "begun to write a treatise on painting and, wanting clarification of certain specific particulars from men of the profession, he had Daniello make, with all possible diligence, a finished model of a David in clay; and afterwards he had him paint, or rather portray, in a picture the same David, which is most beautiful, on both sides, that is, the front and the back." Acquired by the Marquis Del Carpio when he was Spanish ambassador to Rome between 1677 and 1682, the work is recorded in the inventory of the Marquis' possessions as a "picture painted on slate on both sides, showing David cutting off the head of the giant Goliath on either side." In the 1687 inventory of the same collection two separate pieces are listed. The emblem of the marquis is placed on the wooden protection on the back, made when the painting was divided into two, perhaps by the restorer Pinacci, according to whom our slate painting "served as the first model for the large work" in the Louvre. The work was acquired by the Italian state only a century ago; long considered a wood panel painted by Lelio Orsi, it was kept as such in the museum's

storerooms until its recent discovery. At this point it was identified—more plausibly than the panel in Paris—as the work belonging to Monsignor Della Casa mentioned by Vasari together with the terracotta model of David.

Painting on slate was fairly rare during this phase of the 16th century and must have been chosen for the unusual type of commission that required both sides to be available, free from the frame of canvases and from the crosspieces of panels. A role seems to have been played by the shared inorganic nature of slate and terracotta, compared in the context of the debate—a lively one in mid-century intellectual disputes—over the primacy of painting or sculpture, together with Daniele's

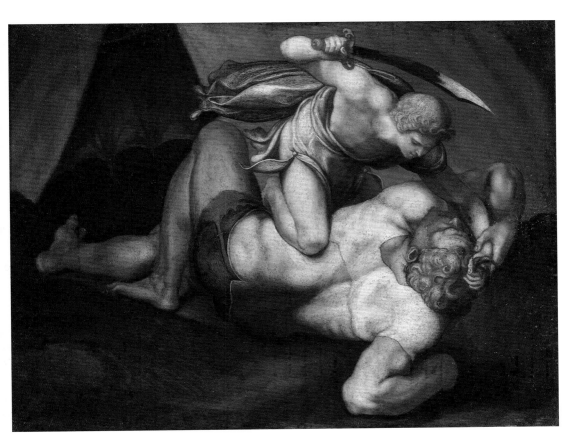

personal relationship with Sebastiano del Piombo, credited with the invention of painting on stone. Through this innovation the latter aimed to extend the life of paintings while also giving them greater internal stability, smooth surfaces, and a luxurious character. Painted slates were seen as precious objects, ideally suited to the collections of the neo-feudal Counter-Reformation world.

Alongside the series of prestigious models mentioned above, the refined formal composition of the work also recalls the intertwined bodies in the Roman marble group of the *Wrestlers* (Uffizi, inv. 1914, no. 216), to the point of suggesting that the latter may have been discovered prior to the generally accepted date of 1583.

AGDM

23 | Jacopino del Conte
(Florence, ca. 1510/1515–Rome, 1598)

Entombment of Christ
ca. 1550–1560
oil on panel, 180 × 129 cm
Palazzo Barberini, inv. 2501 (Italian state purchase, 1966)

Bibliography: C. Strinati, in *Roma 1300–1875*, cat. of the exhibition (Rome 1984–1985), ed. by M. Fagiolo, M.L. Madonna, Milan 1984, p. 387; A. Vannugli, *La Pietà di Santa Maria del Popolo di Jacopino del Conte: dalla identificazione del quadro al riesame dell'autore*, "Storia dell'Arte", 71, 1991, pp. 59–73 (with preceding bibliography); A. Donati, *Ritratto e Figura nel manierismo a Roma: Michelangelo Buonarroti, Jacopino del Conte, Daniele Ricciarelli*, San Marino 2010, pp. 146–149; M. Corso, in *Michelangelo a colori. Marcello Venusti, Lelio Orsi, Marco Pino, Jacopino del Conte*, cat. of the exhibition (Rome 2019–2020), ed. by F. Parrilla, Rome 2019, pp. 106–110 (with preceding bibliography).

Jacopino del Conte trained in Florence with Andrea del Sarto and among the artists working in Rome was one of the most receptive to the manner of Michelangelo, with whom he was friendly until the 1540s; the Barberini *Entombment* is one of the most compelling instances of the master's multifaceted influence.

Little is known about the material history of the panel, perhaps mentioned in a late 17th-century inventory of the properties of Cardinal Camillo Massimo (1620–1677). The subject and the dimensions suggest that it was intended for an altar, albeit not a public one considering its absence from the list of the painter's works visible in the churches and monasteries of Rome provided by his biographers. Equally doubtful is the chronology of the work, traditionally placed in around the seventh decade of the 16th century, with some reasonable exceptions (Strinati) according to which the panel dates to around mid-century. The *Entombment* is considered representative of the regressive tendencies evident in the career of the painter, susceptible to presumed spiritual pressures and adhering increasingly to the canons of the Counter-Reformation after the 1550s.

The lifeless body of Christ, held up by Joseph of Arimathea (or Nicodemus), is about to be placed in a sarcophagus in a classicizing style, perhaps in red porphyry, the variety of stone reserved for imperial tombs. Mary Magdalene helps the old man, supporting the weight of the Redeemer's legs, while the Virgin Mary, on the right, looks on sorrowfully. Barely visible against the dark background are the faces of two other figures and the tomb carved into the rock where, according to the account of the Gospels, the body of Jesus was laid. The affinities with Michelangelo's sculptural group of the Bandini *Pietà* (Florence, Museo dell'Opera del Duomo) are evident: this is the source for the unadorned composition and the dominant position of Christ's limp body, upright and facing the front. Buonarroti anticipated this formal solution in some drawings (for example Vienna, Albertina, inv. 102–103) and in the *Entombment* (London, National Gallery), an unfinished work destined for the Roman church of Sant'Agostino. All of these are models that Jacopino may have borne in mind. The painter thus foregrounds the symbolic and communicative meaning of the work, underlined by the gaze of Joseph of Arimathea (or Nicodemus), fixed on the viewer. He invites us to reflect on the sacrifice of Christ, "the stone the builders rejected" which through the Passion becomes the "cornerstone" (Psalm 117 [118], 22), just as the lower left portion of the slab destined to close the sarcophagus is a cornerstone, here a visual metaphor for the stone on which the new Church stands.

MC

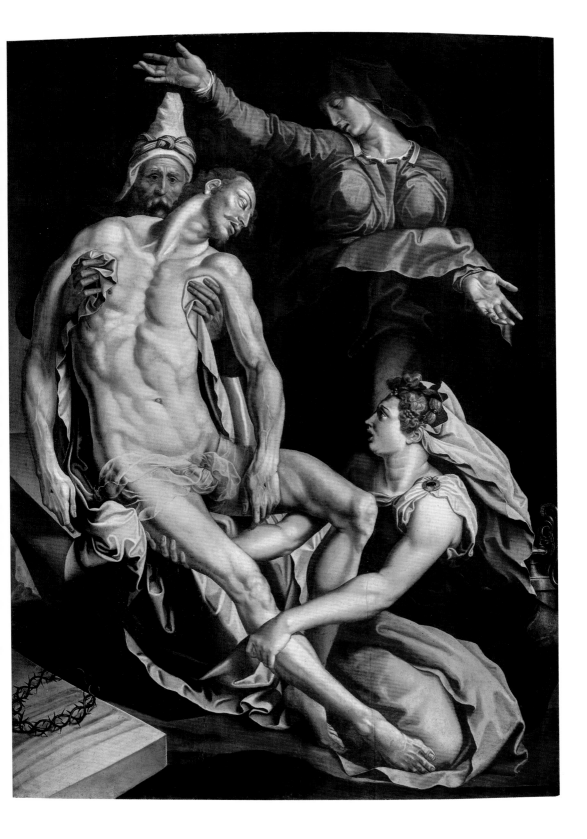

24 | Agnolo di Cosimo Tori, called Bronzino
(Florence, 1503–1572)

Portrait of Stefano IV Colonna
1546
oil on panel, 115.5 × 96.5 cm
Palazzo Barberini, inv. 1434 (purchased from the Colonna di Sciarra family, 1896)

Bibliography: G. Smith, *Bronzino's Portrait of Stefano Colonna: A Note on Its Florentine Provenance*, "Zeitschrift für Kunstgeschichte", 40, 1977, 3–4, pp. 265–269; P. Costamagna, *A New Portrait Drawing by Bronzino*, "Master Drawings", 48, 2010, 2, pp. 147–154; P. Costamagna, in *Bronzino. Pittore e poeta alla corte dei Medici*, cat. of the exhibition (Florence 2010–2011), ed. by C. Falciani, A. Natali, Florence 2010, pp. 266–267.

More than a portrait *in* armor, this painting by Bronzino is a portrait *of* a suit of armor, given the imposing prominence with which it dominates the image, the scrupulously analytical accuracy with which the painter has depicted it and the truly rhetorical eloquence with which the armor itself "recounts," as in a visual compendium, the life, role, deeds and identity of the sitter, the *miles*, the man of arms, the *condottiero*.

The mercenary soldier seen posing proudly here is Stefano IV Colonna of Palestrina (ca. 1490–1548), who had indeed made a career out of war, offering his military services to various lords during the Wars of Italy, from the imperial faction to the Pope, from the King of France to the Republic of Venice, to the Duke of Florence, Cosimo I de' Medici, who appointed him lieutenant general in 1541. It was in Florence that Colonna asked Bronzino, the official painter to the Medici court, to execute his portrait in 1546, shortly before his death and at a time when he was more inclined to frequent the circle of artists and scholars connected to the Florentine Academy than the fields of battle. The painting thus also has a commemorative function, intended to celebrate Colonna's past martial achievements and his military, personal and dynastic distinctions.

It is likely that the Barberini panel was the same portrait displayed at "the most magnificent obsequies" arranged by Cosimo I to pay tribute to his faithful commander in the Florentine basilica of San Lorenzo on 20 March 1548, asking the historian and writer Benedetto Varchi to compose a funerary oration in his honor. Indeed, like Varchi's posthumous eulogy, Bronzino's image is perfectly suited to a visual re-evocation of the virtues of a man who was "a soldier before he was a child," of the "steadfast column" heraldically rising behind the sitter and multiplied, like a marker of identity, in the sober but refined decoration of the armor. It has relief-like power, a sculptural solidity and an incisiveness of form that seem to respond to another, no less specific aesthetic need. In that same year, 1546, Benedetto Varchi had conducted his famous inquiry on which was the "noblest of the arts" among the most famous artists of the time and Bronzino himself, among others, had spoken out in favor of the superiority of painting, which could easily compete with the three-dimensional nature of sculpture.

After the death of Stefano Colonna, the painting was moved to Palestrina or to Rome, where it remained in Palazzo Sciarra Colonna until the end of the 19th century, before being purchased for the new collections of the Galleria Nazionale.

MC

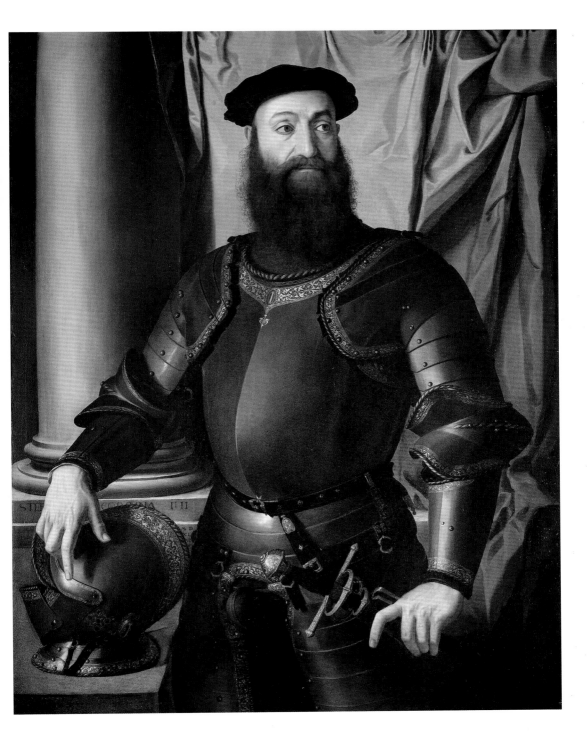

(Augsburg, 1497–London, 1543)

Portrait of Henry VIII

1540
oil on panel, 88.5 × 74.5 cm
Palazzo Barberini, inv. 878 (Torlonia donation, 1892)

Bibliography: J. Rowlands, *The Paintings of Hans Holbein the Younger*, Oxford 1985, p. 226
(with preceding bibliography); J. Rowlands, in *Dynasties: Painting in Tudor and Jacobean England, 1530–1630*, ed. by K. Hearn, London 1995, pp. 42–43.

The presence of an absence: this is the essence of a portrait of the sovereign and this is what Hans Holbein the Younger, a master portraitist, executes for Henry VIII of England. The purpose of the king's image is not only to depict the outward features and physical appearance of a specific individual, but also to make visible, to represent in the etymological and even legal sense of the word, the ritual icon of kingship and power, in accordance with a doctrine of sovereignty that has its roots in antiquity and is both political and religious. In the limpid, exceptional realism of the style of Holbein—court painter to the English Crown from 1536— Henry VIII found the perfect tool to imbue his image with this dual purpose. Already in 1534, date of the schism with the Roman papacy, the king of England had become the supreme head of the Anglican church and had organized a wide-ranging campaign of rhetorical and visual propaganda in which the multiplication and dissemination of his image through replicas, copies and derivatives of various types and qualities played a crucial role.

The Barberini panel, originally from the Torlonia collection, portrays the king in 1540 at the age of forty-nine, as indicated by the legend in the background, on the occasion of his fourth marriage, unfortunately neither successful nor long-lasting, to the German princess Anne of Cleves who was also portrayed by Holbein (the painting is now in the Louvre in Paris). However, the painting's obvious implicit prototype is the famous fresco—now lost— executed by Holbein in 1536 in the royal palace at Whitehall, in London. Here the king was

shown full-length with his father Henry VII, with the clear intent of asserting his claim to the throne, posing as the hero of the nation, as expressly stated by the plaque on the altar depicted at the center of the painting, benefactor of his country and of religion, "to whose staunch virtue the arrogance of the popes was forced to yield." Even in the confined space of the easel painting, the portrait in the Gallerie Nazionali retains the Whitehall fresco's imposing and solemn character as a state portrait, the steadfast and imposing figure who in his perfectly frontal pose gazes at the viewer without betraying any emotion, the meticulous description of the sumptuously luxurious garment.

Despite the evident quality of the drawing and the painting, some scholars have raised doubts that Holbein was solely responsible

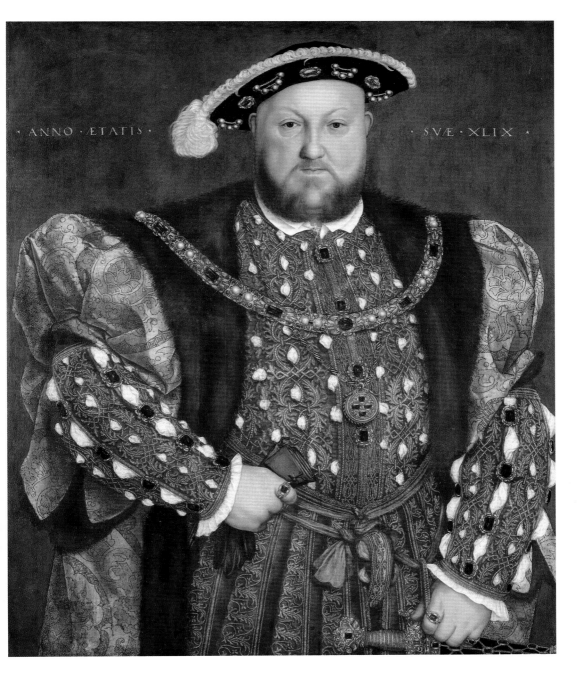

· ANNO · ÆTATIS · · SVÆ · XLIX ·

for the work, given an apparent lack of homogeneity in the rendering of certain details such as the jewels, preferring to consider the painting a copy after a lost original or a product of the circles of the German painter.

MC

26 | Hans Hoffmann

(Nuremberg, 1530–Prague, 1592)

The Hare

ca. 1585
watercolour and gouache on parchment, 57 × 49 cm
Galleria Corsini, inv. 224

Bibliography: F. Koreny, *Albrecht Dürer und die Tier- und Pflanzenstudien der Renaissance*, München 1985, p. 146; S. Alloisi, *Dürer e l'Italia*, cat. of the exhibition (Rome 2007) ed. by K. Hermann Fiore, Milan 2007, p. 376; K. Leonhard, *Hans Hoffmanns Hase*, in *Naturalismen. Kunst, Wissenschaft und Ästhetik*, ed. by R. Felfe, M. Saß, Berlin 2019, pp. 33–48.

Hoffmann's work derives from and quotes the famous painting by Albrecht Dürer on the same subject, signed and dated 1502, and now in Vienna (Graphische Sammlung, Albertina). However, the deliberate allusion to Dürer's prototype serves not only to recall the lasting vitality of an authoritative model, but also to offer a studied formal reinterpretation of it that responds to new cultural needs and a different context.

Probably executed when Hoffmann was already in Prague as court painter to Emperor Rudolf II, *The Hare* overcomes the analytically observational intent that still drove Dürer's study, aiming instead to construct a more "complete" work, of larger size, richer and more balanced in compositional terms, more attentive, even, to its ideal public destination. This is apparent even from the attitude of the animal itself, which now, compared to the natural indifference of the Albertina hare, seems to turn a knowing gaze on the viewer. A similar aesthetic need also underlies the decision to accompany the image with a series of plants and animals, depicted with the meticulous precision of the botanist and the entomologist. However, these are arranged as a counterpoint to the hare rather than forming a genuine setting for it—an impression that is all the more salient if we compare the painting with one of the other versions of the same subject, also executed by Hoffmann and now in the Getty Museum in Los Angeles.

The Corsini parchment is configured and, indeed, presented as a collector's item in two ways. On the one hand, as a naturalistic study, it belongs to a genre—which the painter himself helped to codify—in which the scientific image is freed from the merely illustrative and didactic function it has in treatises on natural history and aspires to the status of art object, an expression of skill that is not merely the technical mastery of mimesis, but also studied stylistic artistry. At the same time, the hare boasts and declares a noble and high-ranking pedigree as a descendant of Dürer's model, which thus becomes the progenitor of an entire lineage and of a recognized and specifically Germanic tradition. Not surprisingly, after the *Dürer Renaissance* of which Hoffmann was a protagonist at the end of the 16th century, the Nuremberg master's *Hare* was an object of interest for German Romantics up to Wölfflin and Heidegger.

Already a few decades after its creation, Hoffmann's painting must have been much coveted, so much so that the sculptor Pietro Tacca, who owned it in 1631, refused generous offers for it, saying that: "I know how to earn money, but if the hare escapes from me, I will never get it back."

MC

Mystic Marriage of St. Catherine of Alexandria and Saints

1524
oil on canvas, 98 × 115 cm
Palazzo Barberini, inv. 2610 (Scaretti purchase, 1982)

Bibliography: F. Cortesi Bosco, *Il coro intarsiato di Lotto e Capoferri per Santa Maria Maggiore in Bergamo*, Milan 1987, pp. 340–346; G. Altissimo, in *Lorenzo Lotto*, cat. of the exhibition (Rome 2011), ed. by G.C.F. Villa, Cinisello Balsamo 2011, pp. 180–183; E.M. Dal Pozzolo, in *Lorenzo Lotto. Portraits*, cat. of the exhibition (Madrid 2018, London 2018–2019), ed. by E.M. Dal Pozzolo, M. Falomir, M. Wivel, Madrid 2018, pp. 252–255 (with preceding bibliography).

In the intimate and cozy space of the painting, typically conceived for a domestic and private purpose, various saints huddle around the Virgin and Child, connected less by historical or hagiographical circumstances than by reasons of family devotion. Even the presence of St. Catherine, who has just received the ring from Christ as a pledge symbolizing their mystical union, is probably dictated by the occasion for which the painting was commissioned from the artist. The canvas was painted for the wealthy Cassotti family of Bergamo, for whom in 1523 Lotto had already painted the double portrait of the newlyweds Marsilio and Faustina, now in the Prado Museum in Madrid. It is therefore plausible that the mystical wedding of St. Catherine, intended expressly for the groom's chamber, served as a sort of ideal representation of marriage, in which the holy family presides over and blesses the fundamental institution of Christian union.

The image also suggests, or perhaps even prescribes, a model of conduct that the painter has carefully developed in visual terms. In the left-hand foreground, the scholar St. Jerome offers the Virgin the fruit of his erudite labors, the *Vulgate* edition of the Bible, while behind him the representatives of the militant Church, St. Sebastian and St. George, peer out discreetly; for the occasion the latter unusually wears a couple of rings. On the right, the elderly St. Nicholas

and St. Anthony the Abbot are absorbed in the reading of an office, a further reference to assiduous prayer and the contemplative life. Even Catherine's evident sentimental rapture—underlined by the curl that has escaped her hair to fall across her temple and by the unbuttoned collar of her bodice—is nonetheless metaphorically restrained by the knot of the precious pendant, which like a talisman recalls the true object of the holy martyr's "passion," and by the cameo engraved with the ascetic hieroglyph of spiritual love, of *amor sapientiae*, with the putto balancing on the plates of a pair of scales.

The painter devoted particular attention to the mystical bride and the details of her execution, and we can understand why, when calculating the cost of the painting "by the figure," Lotto himself estimated that the im-

age of St. Catherine was worth more than the others: 10 ducats compared to the 8 for St. Jerome or the 6 for St. George, for example, though predictably less than the 15 for the Virgin and Child. As a personal mark of his devotion to Mary, Lotto signed and dated the painting by placing his name immediately beneath the foot of the Virgin and in its shade.

MC

Christ and the Adulteress

ca. 1549
oil on canvas, 118.5 × 168 cm
Palazzo Barberini, inv. 1460 (donated by the Chigi family, 1902)

Bibliography: E. Weddigen, *L'"Adultera" del Tintoretto nella Galleria Nazionale di Roma*, "Arte Veneta", 24, 1970, pp. 81–92; R. Echols, *Giovanni Galizzi and the Problem of the Young Tintoretto*, "Artibus et Historiae", 31, 1995, pp. 69–110; E. Weddigen, *Myzelien zur Tintoretto-Forschung: Peripherie, Interpretation und Rekonstruktion*, München 2000, pp. 10–39; S. Engel, *Das Lieblingsbild der Venezianer. "Christus und die Ehebrecherin" in Kirche, Kunst und Staat des 16. Jahrhunderts*, Berlin 2012, pp. 98–110; R. Krischel, in *Tintoretto: A Star Was Born*, ed. by R. Krischel, München 2017, pp. 51, 120 (with preceding bibliography).

In a studiedly theatrical setting, the painter depicts the famous episode recounted in the Gospel of St. John, but focusing, in a way that is clearly not coincidental, on the final verses of the passage (8, 9–11). Jesus has already pronounced the fateful words: "Let any one of you who is without sin be the first to throw a stone at her," and indeed the pharisees and the scribes, embarrassed and confused, depart the scene and leave the adulteress alone, "in the middle" where they had brought her before Christ. The woman raises her hands, begging for mercy, but also to show that they are now "unbound," literally and metaphorically, as she is released from her sins.

The elaborate architectural setting, constructed around a visibly off-center vanishing point, helps to isolate the sinner's dialogue with Jesus, contrasting with the movement of her accusers scattered by the words of the Teacher, and simultaneously implies its judicial nature. Christ is seated on a sort of pillar in front of the colonnade, just as in the episode of his youthful dispute with the doctors. Indeed, the theme of the famous passage is less the woman's sin than that of the pharisees who maliciously place Jesus before an apparent legal dilemma, but only

"as a trap, in order to have a basis for accusing him" (John 8, 6). This also explains the contrast, and even the disproportion, between the size of the temple, the seat and symbol of the Pharisees' legalistic ethics, and the position of Christ. He is deliberately represented on a sort of altar, the apse surrounding which is formed by the twelve apostles: in other words, the new Church, the church *sub gratia* compared to the synagogue *sub lege.*

Despite the carefully calibrated perspectival framework, the painting presents numerous hesitations and poorly resolved aspects, especially in the figures, perhaps due in part to clumsy later alterations—suffice it to observe the left hand of Christ or the legs of the armed men on the far right. Indeed, more general stylistic considerations have suggested that the work should be ascribed, not to

the hand of Jacopo, but to that of one of his collaborators or followers, identified by some as the Bergamasque Giovanni Galizzi (Echols 1995).

The canvas in Palazzo Barberini is very probably the work mentioned by the biographer Carlo Ridolfi as being in the house of Vincenzo Zen, where it was paired with another painting, also attributed to Tintoretto, depicting the *Entry of Christ into Jerusalem*, now in the storerooms of the Galleria Palatina of Palazzo Pitti in Florence. The painting may also be that described in 1660 by Marco Boschini in the collection of Paolo del Sera and later purchased by Flavio Chigi in 1664. It was donated by Prince Mario Chigi to the Galleria Nazionale di Roma in 1902.

MDM

29 | Domínikos Theotokópoulos, called El Greco
(Crete, 1541–Toledo, 1614)

Adoration of the Shepherds
Baptism of Christ
1596–1600
oil on canvas, 111 × 47 cm
Palazzo Barberini, inv. 1474–1475 (purchased, 1908)

Bibliography: R.G. Mann, *El Greco and His Patrons*, Cambridge 1989, pp. 69–106; J. Álvarez Lopera, *El retablo del Colegio de Doña María de Aragón de El Greco*, Madrid 2000; J.M. Pita Andrade, A. Almagro Gorbea, *Sobre la reconstrucción del retablo del Colegio de doña María de Aragón*, in *Actas del congreso sobre el retablo del Colegio de Doña María de Aragón*, Madrid 2001, pp. 75–88; *El Greco. I due dipinti di Palazzo Barberini*, ed. by A. Negro, Rome 2009; M. Di Monte, in *Tutankhamon, Caravaggio, Van Gogh. La sera e i notturni dagli Egizi al Novecento*, cat. of the exhibition (Vicenza 2013), Treviso 2014, pp. 500–501.

The canvases, of identical size, are in all likelihood sketches or preparatory works for two of the six or seven paintings belonging to the monumental *retablo* executed by the Cretan painter to decorate the Colegio de doña María de Aragón, or Colegio de la Encarnación, in Madrid. This major project was commissioned from El Greco in 1596 and must have been an important undertaking requiring considerable effort, both for the size of the work and for the prestige of the place and the patrons, who paid the painter the truly enormous sum of about 63,000 *reales*. The polyptych was unfortunately dismantled in the Napoleonic period, between 1813 and 1814, and it is therefore not certain what it originally looked like or how exactly the canvases were arranged; various reconstruction hypotheses have been proposed.

It is likely that the structure presented three superimposed orders, with the *Annunciation* (or the *Incarnation*, to which the convent was dedicated) at the bottom center, flanked by the *Adoration of the Shepherds*, on the left, and the *Baptism of Christ*, on the right, while the *Resurrection*, *Crucifixion* and *Pentecost* were to be placed in the upper register. The execution of this majestic work took longer than expected and the painter sent the canvases from Toledo, where he lived, only in the summer of 1600. The definition of the complex iconographic program must also have been laborious. Centered on the life of Christ, it may have been inspired by the writings of the Augustinian friar Alonso de Orozco (1500–1591), buried at the foot of the altar; it cannot be ruled out that El Greco himself also availed himself for this purpose of the advice of his father Hernando de Rojas, Orozco's confessor, and his successor in charge of the College of the Incarnation.

The two Barberini canvases, acquired on the Sicilian antiques market and entering the collections of the Galleria Nazionale in 1908, anticipate even in their details the larger compositions intended for the Madrid *retablo*, now in the Muzeul Naţional de Artă in Bucharest (*Adoration of the Shepherds*) and in the Prado Museum in Madrid (*Baptism of Christ*). Here, thanks in part to the small scale of the sketches, El Greco's shimmering mature style is expressed in its most idiosyncratic form, with the characteristic, ostentatious elongation of the figures that exacerbates the vertical structure of the composition, stretched between two superimposed registers in accordance with the structural logic that informed the entire polyptych. Even more daring is the pictorial treatment of light and color, which according to El Greco—trained in the Venetian school of Titian, Tintoretto, and Bassano—was the most difficult aspect of painting.

MC

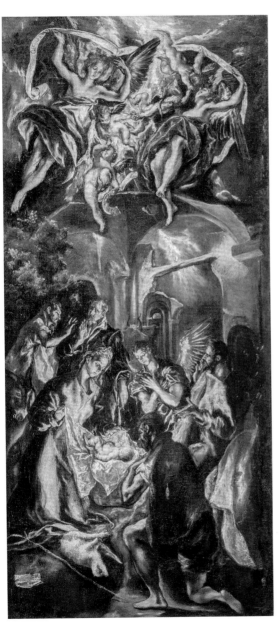
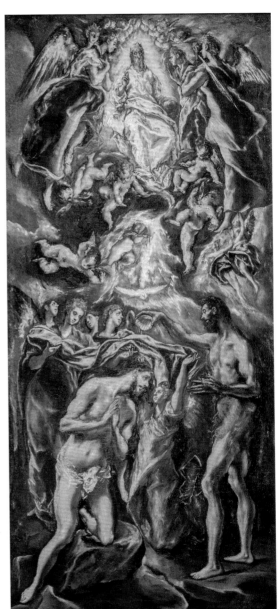

30 | **Jacopo da Ponte, called Bassano**
(Bassano del Grappa, ca. 1515–1592)

Adoration of the Shepherds
1560–1561
oil on canvas, 105 × 157 cm
Galleria Corsini, inv. 193

Bibliography: V. Romani, in *Jacopo Bassano. c. 1510–1592*, ed. by B.L. Brown, P. Marini, Bologna 1992, pp. 101–103; B. Aikema, *Jacopo Bassano and His Public: Moralizing Pictures in an Age of Reform, ca. 1535–1600*, Princeton 1996, pp. 83–84; P. Berdini, *The Religious Art of Jacopo Bassano. Painting as Visual Exegesis*, Cambridge 1997, pp. 103–107; L. Bortolotti, *La pittura religiosa nella provincia veneta: Jacopo Bassano in contesto*, "Venezia Cinquecento", 16, 1998, pp. 105–146 (especially 121–124); M. Di Monte, S. Pedone, A. Cosma, C. Santangelo, *Due* Adorazioni dei Pastori *di Jacopo Bassano a confronto*, "Venezia Cinquecento", 34, 2007, pp. 123–173.

Awoken by the angel's proclamation at the break of day, the shepherds travel to the poor hovel where Jesus was born and spontaneously adore him. They are the first chosen recipients of the good news. Here, more than in other canvases on the same subject, Bassano places a strong emphasis on the role of the shepherds, benevolently highlighting their extremely humble status as rustic and unlearned peasants—the *imperitia* and *rusticitas* of which St. Augustine speaks in his famous Epiphany sermon (200, 3); this is exactly what makes them worthy of the first manifestation of the incarnation and "thankful to heaven" as Sannazaro wrote in his *De Partu Virginis* (III, 136).

These keepers of flocks, who clearly anticipate the more aristocratic three kings of whom they represent the impoverished counterparts, are effusive in their instinctive gestures of obsequious devotion. The humblest of the three, in both his pose and his garments, is already kneeling, inadvertently turning toward the viewer the patched bottom of his breeches and bare, dirty feet. This does not indicate a lack of *decorum*, but rather invites the viewer to "reflect" on the meaning of his gesture, which became popular; Caravaggio—to mention

just a single famous example—recalled it in his *Madonna of Loreto*.

But the figures of the shepherds also serve to organize the composition of the image, tipping the focus of the action toward the left and creating a gap at the center that divides up the space and helps to underscore the scene's essential polarity. Not coincidentally, in the right-hand corner, the painter has inserted the antithetical figure of the young man, more heedless than irreverent, who turns his almost bare buttocks toward the manger and blows on a firebrand, unaware that a very different light has now come to illuminate the darkness, as we are also reminded by Joseph's unlit lamp. Underlining the urgent need for renewal, Bassano, with his customary interest in the symbolic world of animals, has also added the pair of swal-

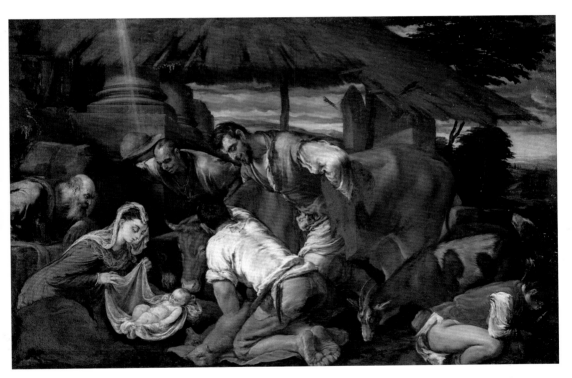

lows which, according to the Biblical saying, "observe the time of their migration" while the people of God "do not know the requirements of the Lord" (Jeremiah 8, 7).

Unfortunately, we know nothing of the painting's material history before 1750, when it was recorded in the inventories of the Corsini family. An *Adoration of the Shepherds* by Bassano, whose description corresponds fairly well to the Corsini painting, appears in Rome in 1643 in the bequest of the writer Lelio Guidiccioni, who left the canvas to Francesco and Antonio Barberini. In 1704, a "Nativity scene" of the same size as the Corsini painting again appears in the Barberini inventories, but it is difficult to say if this is indeed the same work and how it came to be in the collection of Clement XII.

MDM

The Bath of Bathsheba

1573–1574
oil on panel, 115 × 145 cm
Palazzo Barberini, inv. 1349

Bibliography: E. Pillsbury, in *Wadsworth Atheneum Paintings. II: Italy and Spain, Fourteenth through Nineteenth Century*, ed. by J. K. Cadogan Hartford 1991, p. 258; M. Bondioli Osio, *The Bath of Bathsheba by Jacopo Zucchi: The Adventurous Life of a Masterpiece*, in *Caravaggio and His Italian Followers: From the Collections of the Galleria Nazionale d'Arte Antica di Roma*, cat. of the exhibition (Hartford 1998), ed. by C. Strinati, R. Vodret, Venice 1998, pp. 17–20; C. Strinati, in *Villa Medici: il sogno di un cardinale. Collezioni e artisti di Ferdinando de' Medici*, cat. of the exhibition (Rome 1999–2000), ed. by O. Bonfait, M. Hochmann, Rome 1999, p. 274.

Zucchi's panel uses the biblical episode of Bathsheba's bath—drawn from 2 Samuel (11: 2–4)—as a pretext for a formal exercise on one of the favorite themes of Tuscan and central Italian Mannerism: the nude, in this case exclusively female. Sophisticated poses, multiple and even implausible viewpoints are all points scored in favor of the painter in the age-old dispute that sees him competing with the resources available to the sculptor. This famous dispute, known as the *paragone* or contest for primacy among the arts, was set out on paper by the Florentine scholar Benedetto Varchi in 1547. It is therefore unsurprising that the figure on the far left, in a serpentine contrapposto, is for example an exaggerated quotation of the bronze statuette of *Astronomy* by Giambologna (now in the Kunsthistorisches Museum in Vienna).

But the true theme of this spectacle is not only the sophisticated skill of anatomical drawing, but rather the motif of the gaze, or rather of the gazes: those depicted in the painting and the real gaze of the viewer. Indeed, while the buxom Bathsheba does not seem to realize that she is being spied upon, the two handmaids to the left of the protagonist, also naked, respond to the curiosity of the beholder with self-satisfied glances. And yet, on closer inspection, the voyeur realizes that he is not the only one observing the scene: in the upper left corner, just visible beyond the parapet of a colonnaded belvedere, the small figure of King David looks out, already enraptured by Bathsheba's fateful naked beauty. The viewer *of* the picture is reflected in the viewer *within* the picture, and his gaze takes on a more ambiguous meaning.

If that were not enough, the painter exasperates the game of mirroring, not without irony. In the corner opposite to that of David, at the bottom right, but in the foreground, Zucchi has created a curious moralized still life. Next to Bathsheba's slippers is a small mirror, just beneath the legs of the standing handmaid, who lifts her tunic while simultaneously pointing to the mirror itself. In his turn, the bronze satyr cast in the foot of the

luxurious chair on which Bathsheba sits seems to take considerable pleasure in the reflection. This detail thus crystallizes the central issue of the painting: the gaze—and thus the role—of the viewer, literally halfway between the lustful eye of the satyr and the no less indiscreet eye of the king.

MC

(Antwerp, 1554–Rome, 1626)

Feudal Estate of the Mattei Family

1601
oil on canvas, 155 × 220 cm
Palazzo Barberini, inv. 1982 (purchased from P. Donini Ferretti, 1939; formerly Mattei collection)

Bibliography: G. Panofsky-Sörgel, *Zur Geschichte des Palazzo Mattei di Giove*, "Römisches Jahrbuch für Kunstgeschichte", 11, 1967–1968, pp. 110, 167 and 173, no. xiv; F. Cappelletti, L. Testa, *Il trattenimento dei virtuosi. Le collezioni secentesche di quadri nei Palazzi Mattei di Roma*, Rome 1994, pp. 97–99; F. Cappelletti, in *Caravaggio e la collezione Mattei*, cat. of the exhibition (Rome 1995), ed. by R. Vodret Adamo, Milan 1995, pp. 128–133; Ead., *Paul Bril e la pittura di paesaggio a Roma, 1580–1630*, Rome 2006, pp. 253–256; Y. Primarosa, *La "buona stima" di Giovanni Baglione. Un carteggio e altri documenti sulla Cappella Borghese in Santa Maria Maggiore e sulla Tribuna di Poggio Mirteto*, "Storia dell'arte", 135, 2013, pp. 61–63.

In March 1601, Marquis Asdrubale Mattei commissioned several large overdoor paintings from Paul Bril to adorn the great reception hall of his Roman palace "alle Botteghe Oscure." This was a special set of landscapes (only four of which survive today), depicting the various fortified villages controlled by the Roman family from a bird's eye—and simultaneously strongly lowered—point of view: Rocca Sinibalda, Giove, Castel Belmonte, Antuni, Castel San Pietro and Poggio Mirteto.

Bril painted the series in Rome, after having travelled "in person to see the landscapes and make sketches of them" in order to create "beautiful" and as far as possible accurate views of the various feudal estates, scattered between Umbria and Lazio. Yet though their execution was verified in situ, the Mattei paintings—teeming with animals, flocks, hunters, and shepherds—maintain a fantastical and not entirely realistic air. This was in keeping with what was at the time the customary practice of many Flemish painters, who according to Giulio Mancini painted landscapes that "are more a theatrical spectacle than a view of the countryside" (G. Mancini, *Considerazioni sulla pittura* [1614–1630], ed. by A. Marucchi, L. Salerno, Rome 1956, I, p. 260).

This landscape, recorded in the Mattei inventory of 1604 among the "seven large paintings showing castles by Paolo Brillo," depicts Castel San Pietro in the foreground, previously rebuilt by the Orsini family on the site of an old medieval manor house. The work offers valuable and highly evocative—though not entirely reliable—evidence of the appearance of the fortress in the early 17th century. In the middle ground we see the village of Poggio Mirteto, the preferred residence of the Abbots of Farfa that developed in the second half of the 13th century around another fortified *castrum*. The imaginative view, the only one to predate the late 17th-century expansion of Poggio Mirteto, shows the small town near the "enfeoffed" Castel San Pietro, which—as Gaetano Moroni

reports—"lies atop a high breccia precipice on sloping ground, beyond the left bank of the Calentino river, near the Farfa river, in a picturesque location, with a baronial manor of fine design and remarkable solidity, [which] abounds in excellent waters" (G. Moroni, *Dizionario di erudizione storico-ecclesiastica ...*, Venice 1840–1879, LX, p. 48). The 19th-century scholar praised the "antiquity of the castle, of the church and of the fortress, built as the ancient Sabines did on the highest and steepest of precipices for the purpose of timely defence," just as it was painted in 1601 by Paul Bril.

YP

Portable tabernacle depicting the Pietà, St. Cecilia, St. Hermengild of Seville and scenes of martyrdom (interior); the Archangel Michael, the guardian angel, Christ and God the Father (exterior)

ca. 1603
oil on panel and on copper, ebony and gold, 43.8 × 31.2 cm (closed)
Palazzo Barberini, inv. 1025 (donated by the Torlonia family, 1892)

Bibliography: D. Posner, *Annibale Carracci: A Study in the Reform of Italian Painting Around 1590*, London 1971, n. 23, sc. 123s, p. 54; R. Zapperi, *Il Cardinal Odoardo Farnese principe e cardinale*, in *Les Carraches et les décors profane*, actes du colloque organisé par l'Ecole française de Rome (Rome 1986), Rome 1988, pp. 348–358; R. Vodret, in L. Mochi Onori, R. Vodret, *Capolavori della Galleria Nazionale d'Arte Antica Palazzo Barberini*, Rome 1998, pp. 63–64, no. 40; C. Mazzetti di Pietralata, in *Ritratto di una collezione: Pannini e la Galleria del cardinal Silvio Valenti Gonzaga*, ed. by R. Morselli, R. Vodret, Milan 2005, pp. 223–224, no. 32; B. Ghelfi, in *Roma al tempo di Caravaggio 1600-1630*, cat. of the exhibition (Rome 2011–2012), ed. by R. Vodret, Milan 2011, pp. 70–71, III.3.

This small portable altar, which updates the tradition of Flemish polyptychs, has a splendid *Pietà* at its center, with the white and intact body of Christ lying languidly on the shroud, without the marks of the Passion demanded by the Counter Reformation and in line with Renaissance iconography. His mother wraps him in a loving embrace, resting her face on that of the son, overcome by grief. John the Evangelist compassionately helps the Madonna, entrusted to him by Jesus just before his death. Mary Magdalen gives herself over to a gesture of despair. Two weeping putti meditate on the events and one points his index finger toward the crown of thorns, the symbol of Christ's Passion.

The two side compartments present depictions of St. Cecilia, with the chastity belt, her attribute of the church organ and the palm of martyrdom, and the king and saint Hermengild of Seville, the legendary son of a Visigoth king who as a Christian rebelled against his Arian father, by whom he was punished with decapitation. He also carries a palm, the symbol of mar-

tyrdom. Represented on the external doors are the Archangel Michael, trampling on the devil, and the guardian angel who carries the soul to safety, both symbolic images of redemption.

Based on documentary research, it is generally thought that the precious tabernacle belonged to Cardinal Odoardo Farnese (1573-1626), as demonstrated by the presence of St. Hermengild (canonized by Pope Sixtus V in 1585), particularly venerated by the churchman for personal and dynastic reasons. Thanks to his maternal descendance from Edward, king of England, Farnese hoped to succeed to the English throne, which went instead to James I Stuart in 1603. It has been suggested that, having lost all hope, the cardinal commissioned the portable altar from the artist after this date.

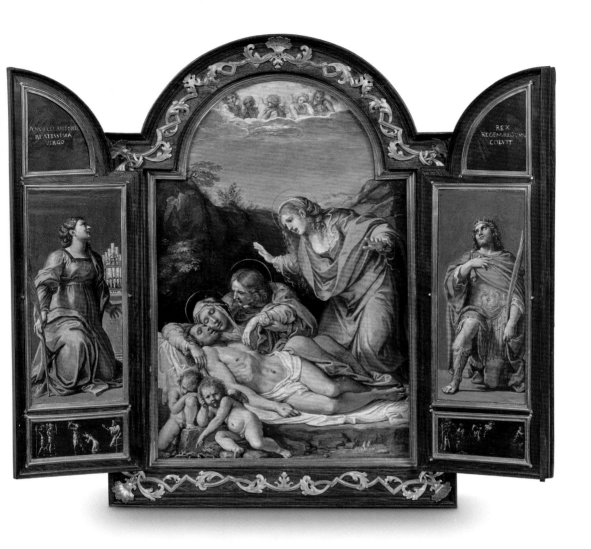

Odoardo's fondness for this precious object of private devotion is reflected in his will, in which he left the whole collection to his nephew, giving the tabernacle to Margherita Aldobrandini. After the marriage of Maria e Vittoria Farnese to Duke Francesco I, the work entered the collection of the Este family; it later came to belong to the Valenti Gonzaga and Torlonia collections before becoming part of Italy's national heritage in 1892.

The attribution of the work to Annibale, confirmed by the documents, has been met with some doubts by critics. However, the prestige of the commission and the high stylistic quality have led many scholars to accept its attribution to Carracci with certainty as regards the overall design and the execution of the central compartment, leaving to potential assistants, perhaps Innocenzo Tacconi, the execution of those at the sides.

TC

34 | Michelangelo Merisi, called Caravaggio
(Milan, 1571–Porto Ercole, 1610)

Judith and Holofernes
ca. 1598–1600 or 1602
oil on canvas, 145 × 195 cm
Palazzo Barberini, inv. 2533 (purchased from the Coppi family, 1971)

Bibliography: M. Marini, *Caravaggio, "pictor praestantissimus"*, Rome 2001, pp. 424–427; M.C. Terzaghi, *Caravaggio, Annibale Carracci, Guido Reni tra le ricevute del Banco Herrera & Costa*, Rome 2007, pp. 295–312; R. Vodret in Ead., *Caravaggio. Opere a Roma. Tecnica e stile*, ed. by G. Leone, M. Cardinali, M.B. De Ruggieri, G.S. Ghia, Milan 2016, II, pp. 270–310; G. Papi, *Riflessioni sui dipinti di Caravaggio per Ottavio Costa, sulle copie e sulla nuova "Giuditta" di Vermiglio*, in *Da Caravaggio. Il "San Giovanni Battista" Costa e le sue copie*, Empoli 2016, pp. 56–63; C. Terzaghi, *Caravaggio e Artemisia: la sfida dii Giuditta*, cat. of exhibition (Rome 2021), Rome 2021, pp. 110-114, no. II.5.

Judith is about to kill Holofernes to save the city of Bethulia and all the people of Israel. The decrepit face and frenzied eyes of her maid, ready to place the severed head in her sack, heighten the tension of the event while the girl, divinely inspired, seems almost impassive before her atrocious act: only her furrowed brow and palpitating breast suggest a hint of emotion, but not the exertion. At the high point of the action, the Assyrian general is caught between life and death. He is no longer alive, as suggested by his eyes rolled back into his head, but he is not yet dead. His desperate scream echoes through the night as his body contorts violently in a futile attempt to rise from the bed.

Caravaggio celebrated this macabre biblical episode in a paradigmatic image of powerful emotional impact, giving rise to a type of depiction of the throes of death that was to remain extremely popular throughout the 17th century, especially among the circles of his early followers (from Giovanni Baglione to Bartolomeo Manfredi, from Artemisia Gentileschi to Louis Finson, up to Jusepe de Ribera and beyond). This extraordinary painting, discovered by Pico Cellini and Roberto Longhi in 1951 and purchased by the Italian state in 1971, was

commissioned by the Genoese Ottavio Costa (1554–1639), who in 1579 had established an important bank in Rome together with the Spaniard Juan Enríquez de Herrera. As well as being a refined collector, Costa was one of the wealthiest businessmen in the Papal capital and administered huge deposits and profitable Curial offices.

Mentioned in Costa's two wills (1632 and 1639) and in Baglione's *Lives* (1642), the *Judith* must have been the most important work in the banker's collection of paintings; he kept it carefully hidden—both to surprise his guests and to protect it—behind a taffeta curtain resembling that depicted by Caravaggio in the upper part of the painting (the *Victorious Cupid* now in Berlin, executed by the painter in 1602 for Marquis Vincenzo Giustiniani, was originally displayed in the same way).

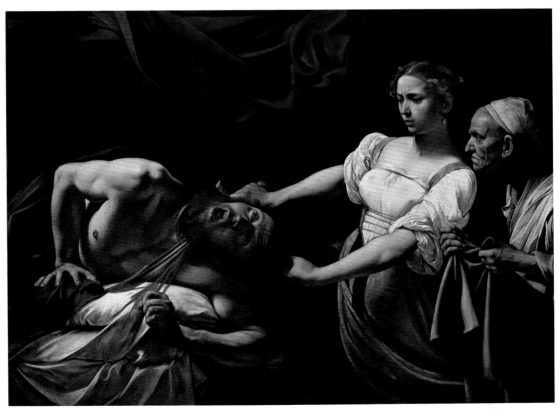

Some scholars date the painting to the two-year period 1598–1600, four or five years after the artist's arrival in Rome, while others moved toward a date in around 1602 after Gianni Papi, in 2016, connected the execution of the canvas to an important document published in 2007 by Maria Cristina Terzaghi: an autograph note in which Caravaggio stated that he had received twenty *scudi* from Ottavio Costa on 21 May 1602, "on account, for a picture I am painting for him." This generic mention had previously been referred on various occasions to another masterpiece by the artist owned by the banker: the *St. John the Baptist* now in Kansas City.

St. John the Baptist in the Desert

1604–1606
oil on canvas, 97 × 131.5 cm
Galleria Corsini, inv. 433

Bibliography: S. Alloisi, *Panigarola e Caravaggio: temi predicatori e pittura religiosa* in *Caravaggio. Nuove riflessioni*, Rome 1989 [but 1990], pp. 15–46; G. Leone, *Il San Giovanni Battista nel deserto di Caravaggio nella Galleria Nazionale d'Arte Antica in Palazzo Corsini a Roma* in *Caravaggio e Mattia Preti a Taverna. Un confronto possibile*, cat. of the exhibition (Taverna 2015), ed. by G. Leone, G. Valentino, Rome 2015, pp. 17–32; R. Vodret, *Il San Giovanni Battista Corsini: novità dalla diagnostica*, ibid., pp. 33–43; M. Di Monte, entry in *Dentro Caravaggio*, cat. of the exhibition (Milan 2018), ed. by R. Vodret, Milan 2018, pp. 124–127.

Caravaggio tackled the theme of St. John in the desert on several occasions, in keeping with the preachings of the Counter-Reformation Church on the validity of the sacraments and particularly baptism. The saint is always depicted by the Lombard painter as a prophet barely older than an adolescent, mostly naked, seated on a stone or log in the solitude of a desert. Ours is a beardless Baptist, young but no longer a child, shirtless, in full light, covered only by a white cloth and an ample red cloak, with the cross-shaped staff leaning at his side and without the traditional camel skin; he intently observes something outside the painted space with an intense gaze, veiled by the shadow cast by the mass of hair. The young hermit is caught at the moment of his vocation, depicted from so close up that the figure barely fits within the space of the image. Caravaggio thus breaks down the barrier between real and painted space, drawing the viewer into the scene. The prophet's mission is highlighted by the empty bowl with which John poured the water of baptism, but also used to collect the wild honey he ate, and some stones, symbolizing the life of prayer and penance.

Diagnostic tests have revealed that the painting was rapidly executed with full-bodied and confident brushstrokes and a preparation of the canvas very similar to that of the paintings

attributed with certainty to Caravaggio, with a reddish-brown hue left visible in some areas of the face and skin. This is a compositional technique in which the graphic rendering results from a combination of incisions defining the spatial positioning of the head, the left arm and parts of the drapery, dark brushstrokes for the outlines and light-colored strokes with ample amounts of lead white for the most brightly lit areas, like the knee that seems to emerge from the canvas, marking the preferred viewing angle. Caravaggio's first version included a lamb behind John's shoulders with its muzzle at face height; the painter completed the figure of the animal before executing that of the saint, and later decided—for unknown reasons—to conceal the lamb beneath the vegetation. The inclu-

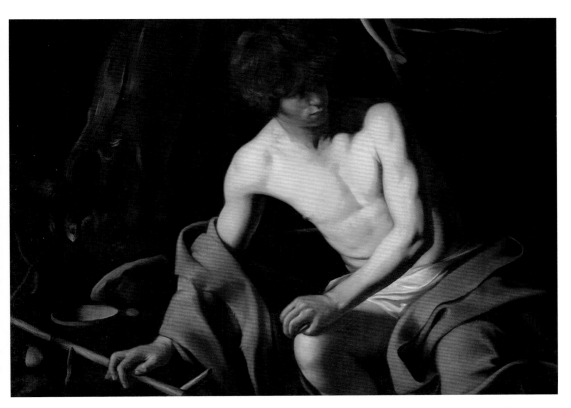

sion of the animal also clarifies the position of the saint, whose posture now appears unstable and almost enigmatic.

The painting appears for the first time in the Corsini inventories, presumably having entered the family collections after the marriage of Prince Bartolomeo Corsini to Maria Vittoria Felice Colonna Barberini (1758). The canvas can be identified in the inventory of 1784 in the prince's apartment on the second floor of the palace in Via della Lungara; it then appears in subsequent inventories, again in the second-floor gallery in 1808, while from 1812 onwards the work is exhibited in the picture gallery on the *piano nobile*, the historical location of the collection proper, and probably in the same room as in the current museum display.

PN

St. Francis in Meditation

ca. 1606
oil on canvas, 128.2 × 97.4 cm
Palazzo Barberini, inv. 5130 (on loan from Carpineto Romano, church of San Pietro)

Bibliography: M.V. Brugnoli, *Un "San Francesco" da attribuire al Caravaggio e la sua copia*, "Bollettino d'arte", 53, 1968, pp. 11–15; A. Zuccari, *San Felice e i luoghi d'arte cappuccini dal convento di San Bonaventura ai tuguri dipinti dal Caravaggio*, in *San Felice da Cantalice*, ed. by G. Maceroni, A.M. Tassi, Rieti 1990, pp. 175–199; M. Marini, *Caravaggio, "pictor praestantissimus"*, Rome 2001, p. 564; R. Vodret, in Ead., *Caravaggio. Opere a Roma. Tecnica e stile*, ed. by G. Leone, M. Cardinali, M.B. De Ruggieri, G.S. Ghia, Milan 2016, II, pp. 624–626; G. Berra, *Le copie del "San Francesco in meditazione sulla morte" del Caravaggio*, in *Originali, repliche, copie. Uno sguardo diverso sui grandi maestri*, ed. by P. Di Loreto, Rome 2018, pp. 117–125 (with complete bibliography).

An oblique shaft of light breaks through the half-light of the hermitage and illuminates Francis' right profile, leaving his chest, his hand with the stigmata and the left side of his face in partial shade. The saint, absorbed in prayer and devout meditation on the transience of worldly things, draws his attention away from the crucifix to focus on the skull, an attribute of the penitent hermit. The sparseness of the composition accentuates the solemnity of the poor man of Assisi's mystical reflection, connected to the theme of the *imitatio Christi*.

The strong contrasts of light and the close-up depiction underscore the heavy folds of the coarse and threadbare woollen habit that Francis "had made himself, reproducing the image of the cross to keep all the seductions of the devil at bay; he had made it very rough to crucify the flesh and all his vices and sins, and so poor and coarse as to make it impossible for anyone to envy it" (*Fonti Francescane*, 356–357).

The painting comes from the church of San Pietro at Carpineto Romano, founded in around 1609 by Cardinal Pietro Aldobrandini, a nephew of Pope Clement VIII. It was probably this family, which had acquired the feudal estate of Carpineto in 1597 from the counts of Segni and Valmontone, which commissioned the painting in around 1606. Indeed, the style of the work is in keeping with Caravaggio's production of this period, and the events of the artist's life also support this hypothesis. In the summer of 1606, the painter sought refuge in the Colonna family's lands south of Rome to escape the death sentence hanging over him after his murder of Ranuccio Tomassoni.

From 1968, when it was made known by Maria Vittoria Brugnoli, the painting was linked to the finest of its many copies: that kept in Rome in the church of the Immacolata Concezione, until then believed to be the original. That Caravaggio himself painted the work in Palazzo Barberini is suggested by the more accurate rendering of some details (the description of the cincture, the tears, and patches on the habit) and by various *pentimenti*, missing in the various known copies and that concern the hand holding the skull—initially in a slightly different position—and, above all, the saint's hood. The latter was originally painted with a point, in reference to the habit of the Capuchins. This change to the shape of the hood, visible even to the naked eye, should perhaps be interpreted as a later correction necessitated by the work's original destination: a church assigned to the Reformed Friars Minor, initially entrusted to the Capuchin order.

YP

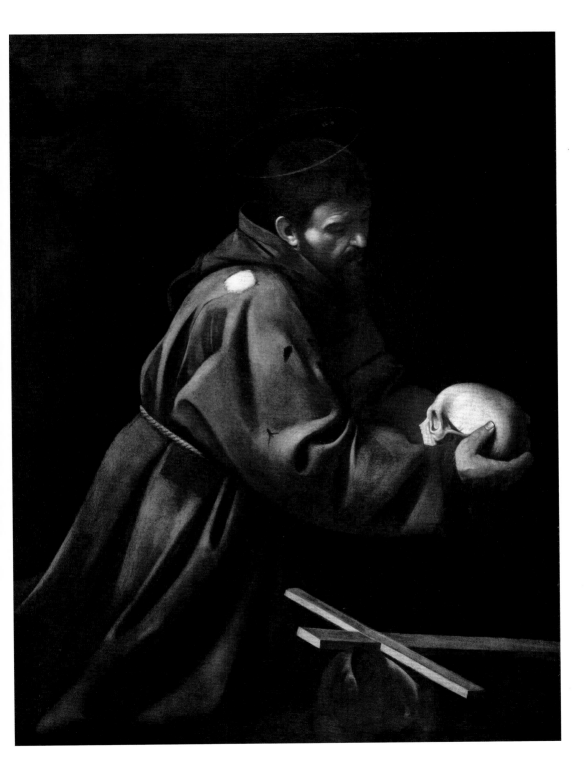

(Milan, 1571–Porto Ercole, 1610)

Narcissus

ca. 1597–1598
oil on canvas, 113 × 97 cm
Palazzo Barberini, inv. 1569 (donated by B. Kwhoshinsky, 1916)

Bibliography: S. Bann, *The True Vine: On Visual Representation and the Western Tradition*, Cambridge 1986, pp. 127–156; A. Posèq, *The Allegorical Content of Caravaggio's Narcissus*, "Source", 10, 3, 1991, pp. 21–31; G. Papi, in Id., *Spadarino*, Soncino 2003, pp. 155–160; J. Koering, *Au miroir de Narcise: la peinture de Caravage?*, in *Poiesis. Über das Tun in der Kunst*, ed. by A. Beyer, D. Gamboni, Berlin 2014, pp. 95–108; G. Careri, *Caravaggio. La fabbrica dello spettatore*, Milan 2017, pp. 66–72.

The Palazzo Barberini *Narcissus* has become the quintessential illustration of the famous story told by Ovid in the *Metamorphoses* (III, 402-510) and the representative image of its unfortunate protagonist, the "hopeless lover"—as Petrarch calls him– who falls helplessly in love with his own image reflected in a pool of water. The painting's visual appeal and its traditional attribution to Caravaggio have ensured its extraordinary popularity and the existence of a vast critical literature. This, alongside the lack of documentary evidence on its chronology, paternity, and original purpose, has helped to feed a long debate on its attribution starting from 1913, when Roberto Longhi identified the canvas as an original by Caravaggio in the house of the art historian Paolo d'Ancona. The dispute has divided and continues to divide scholars between those who support its attribution to Merisi and those who have suggested a variety of other names and dates—in particular that of the Caravaggesque painter Giovanni Antonio Galli, called Spadarino (1585–1652), who has hitherto garnered the most agreement.

However, the figurative and semantic peculiarities of the image remain more important than the attributive conjectures; these make the Barberini painting an unprecedented interpretation of the myth, and not just between the 16th and 17th centuries, for its density, intensity, and sparseness. Dressed in modern garments and set in a context that the painter has stripped of any anecdotal or environmental connotations, the youthful Narcissus is not a mere illustration of the ancient fable, with its moralistic undertones, but seems to allude to and embody a sort of concentrated visual reflection on a theme of contemporary relevance: the presumed direct and "natural" mimetic representation of the world. The problem is thus the status of the painted image itself. Indeed, it is unlikely that the painter would have been unaware of the famous passage from Leon Battista Alberti's *De pictura* (II), which symbolically makes Narcissus the inventor of painting and that is in keeping with the Caravaggesque painting: "What would you call painting other than something that resembles embracing the surface of the pool by means of art?"

Literally at the center of the canvas is the "fine veil" that separates the object from its illusory likeness, a mere moment before Narcissus' own hand, touching it in the attempt to embrace it, causes it to vanish. The mirror motif, so important in the theoretical writings and artistic literature of the 16th and 17th centuries, denotes a model but also a boundary beyond which illusion becomes self-deception. Thus, by staging the mirror of painting, the painting depicts itself and leaves the viewer in the uncertain position of the young man enthralled by his own image. "It is our task—wrote Philostratus in the *Imagines*, in a famous ekphrasis dedicated to Narcissus—to explain how the image is made."

MDM

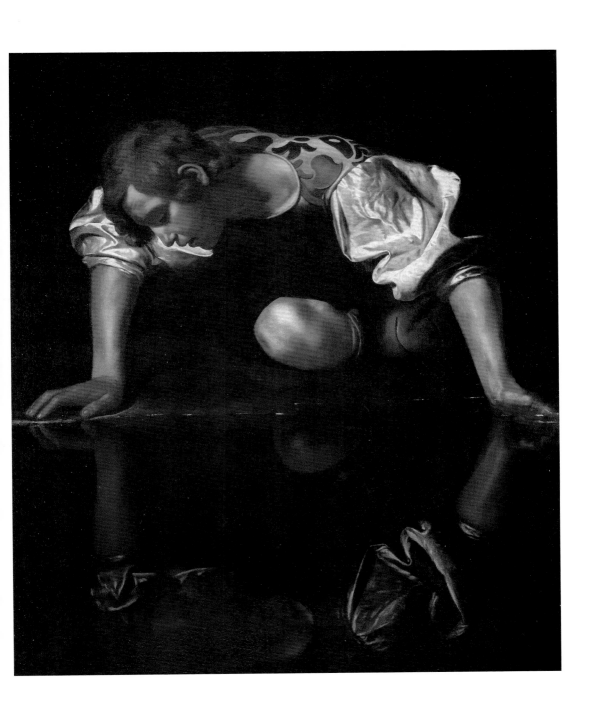

38 | **Giovanni Baglione**
(Rome, *post* 1566–1643)

Sacred and Profane Love
1602
oil on canvas, 240 × 143 cm
Palazzo Barberini, inv. 1268 (purchased from Monte di Pietà, 1895)

Bibliography: G. Magnanimi, in *Antologia di restauri. 50 opere d'arte restaurate dal 1974 al 1981*, cat. of the exhibition (Rome 1982), Rome 1982, pp. 70–71; H. Röttgen, "*Quel diavolo è Caravaggio*". *Giovanni Baglione e la sua denuncia satirica dell'Amor Terreno*, "Storia dell'arte", 79, 1993, pp. 326–341; M.C. Cola, in *Immagini degli dei. Mitologia e collezionismo tra '500 e '600*, cat. of the exhibition (Lecce 1996–1997), Lecce 1996, pp. 189–191; R. Vodret, *Giovanni Baglione, nuovi elementi per le due versioni dell'Amor sacro e Amor profano*, in *Caravaggio nel IV centenario della cappella Contarelli*, ed. by C. Volpi, Città di Castello 2002, pp. 291–302; M. Nicolaci, in *Roma al tempo di Caravaggio 1600-1630*, cat. of the exhibition (Rome 2011–2012), ed. by R. Vodret, Milan 2011, pp. 144–146 (with preceding bibliography).

In his autobiography, published in 1642, Baglione recalled that he had executed "two paintings of two Divine Loves with Profane Love, the World, the Devil and the Flesh beneath their feet" for Cardinal Benedetto Giustiniani. The two works are mentioned in the inventories of the Giustiniani collection and remained together until the 19th century, when one was sold in Paris and eventually came to belong to the Gemäldegalerie in Berlin. The other entered the collections of the Monte di Pietà, from where it passed to the Gallerie Nazionali in 1895. Sent for storage to the Italian embassy in Berlin in 1908 and believed to be lost during the Second World War, it was found by a stroke of luck in a private collection and returned in 1969.

As the artist notes, the painting shows Divine Love about to shoot Profane Love—the youthful cupid fallen to the ground and already disarmed—with an arrow, while on the left the defeated devil turns toward the viewer with a wild-eyed scowl. The theme, inspired by classical literature, was extremely popular in early 17th-century painting and particularly appreciated by the Giustiniani family, which already owned Caravaggio's so-called *Victorious Cupid* (now in Berlin), which was an explicit reference point for Baglione's canvas. Confirmation of this comes from an important witness statement given during the trial for slander brought by Baglione himself against Caravaggio, Orazio Gentileschi and other artists in 1603. On this occasion, Gentileschi recalled that Baglione had executed the painting as a response to the work by Caravaggio and to his lost *St. Michael*. However, the critiques of his depiction of Divine Love as an "armed adult man" instead of a "nude child" forced the painter to execute a second, emended version.

The painting now in Berlin, in which the armor is present, has generally been considered the first version, but diagnostic tests carried out on the Rome canvas, which is also the only one to be signed, have revealed numerous pentimenti, rarely present in copies. As such, it is currently impossible to determine with certainty which of the two paintings came first; they are in any case clear evidence of the competition among painters in Rome at the time, with Baglione proposing a subject and style very similar to those of Caravaggio in order to supplant him in the relationship with the powerful Giustiniani family. This rivalry was not lacking in reciprocal criticisms and accusations, to the extent that some scholars have seen the painting—fairly implausibly—as an attempt to condemn Caravaggio's homosexuality by depicting him in the guise of the devil, while his friend Cecco del Caravaggio lent his countenance to Profane Love.

AC

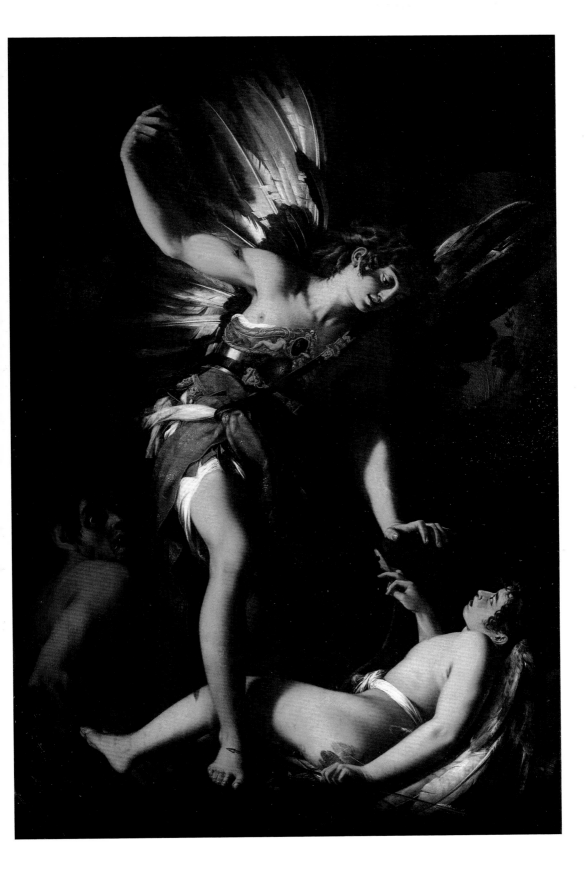

Madonna and Child

ca. 1610
oil on canvas, 113 × 91 cm
Galleria Corsini, inv. 107

Bibliography: R. Longhi, *Gentileschi, padre e figlia*, "L'Arte", xix, 1916, pp. 245–314; R.W. Bissell, *Orazio Gentileschi and the Poetic Tradition in Caravaggesque Painting*, London 1981, pp. 144 and 204; K. Christiansen, in *Orazio e Artemisia Gentileschi*, cat. of the exhibition (Rome-New York-Saint Louis 2001), ed. by K. Christiansen, J.W. Mann, Milan 2001, pp. 56–58; M. Francucci, in *Roma al tempo di Caravaggio, 1600–1630*, cat. of the exhibition (Rome 2011), ed. by R. Vodret, Milan 2011, ii, pp. 148–149; G. Papi, *"Mary Magdalene in Ecstasy" and the "Madonna of the Svezzamento": Two Masterpieces by Artemisia*, in *Artemisia Gentileschi in a Changing Light*, ed. by S. Barker, London 2017, pp. 147–166.

The image, isolated against a vibrant dark background, glows with the light falling on the flesh of mother and son, and reflected, muted and translucent, on the drapery of their garments. The two figures, captured in the tender immediacy of an eternal and instinctive gesture, disregard the viewer's gaze, avoiding the ritual solemnity that had hitherto characterized representations of the Madonna and Child. Were it not for the golden outline of the halo, the Virgin could be any ordinary girl, dressed in accordance with the Roman or Tuscan fashions of the early 17th century, with her hair gathered in a chignon and her sleeves attached to her bodice with ribbons (so that the same dress could be worn in both summer and winter). The artist updated the old iconography of the *Madonna lactans*, emphasising the unusually advanced age of the child and the tender embrace—wholly human and earthly—between the two protagonists. Their unspoken dialogue, made up of intense looks and very human affections, is reminiscent of illustrious prototypes by Caravaggio, such as his *Madonna of Loreto* (1604–1605) or his *Madonna dei Palafrenieri* (1606); not coincidentally, when the painting entered the Corsini collection in the early 18th century it was thought to be an important original by the great Lombard master. It remained under this name until 1916, when Roberto Longhi assigned it to Orazio, father of the equally famous Artemisia Gentileschi. More recently, Gianni Papi has attributed the painting to the latter, offering an innovative interpretation of Artemisia's early Roman production under the guidance of Gentileschi *senior*. However, the extreme naturalism of the scene, the strong chiaroscuro effects of the light and the unconventional character of the composition undeniably suggest the style of Orazio, though it is worth noting some dissimilarities with another *Madonna and Child* now in Bucharest, which he signed and dated 1609.

The serene domestic intimacy characterizing the atmosphere of this painting and several other works by Gentileschi seems at odds with the hot-tempered and highly litigious temperament of both artists. For example, in 1615 the Florentine ambassador Piero Guicciardini reported to the Medici court that Orazio "lives so carelessly and is in his habits and temperament such that it is impossible to get along with him or cope with him, and having him around causes a thousand difficulties". In a similar vein, the biography dedicated to him by his colleague and rival Giovanni Baglione recalls that if "Gentileschi had been of a more pleasant disposition, his abilities would have been considerable, but his nature was more bestial than human [...] and he offended everyone with his satirical tongue."

YP

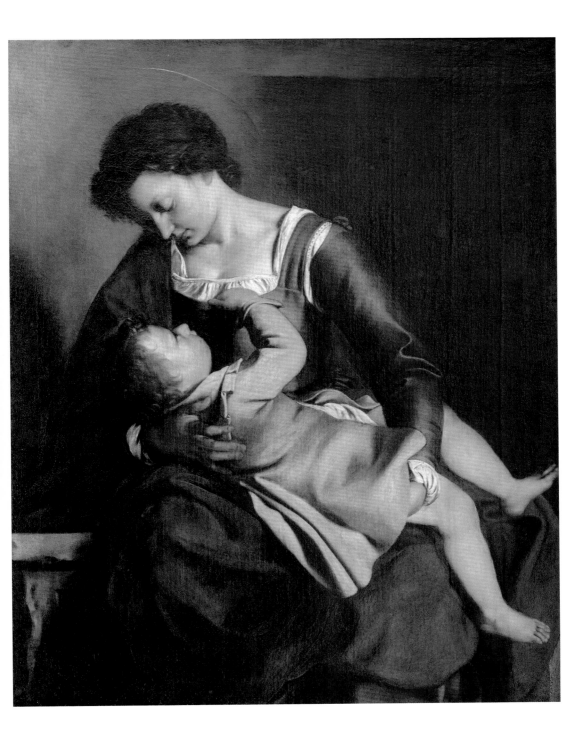

40 | **Orazio Gentileschi**
(Pisa, 1563–London, 1639)

St. Francis Supported by an Angel
ca. 1612
oil on canvas, 133 × 98 cm
Palazzo Barberini, inv. 1276 (purchased from Monte di Pietà, 1895)

Bibliography: R. Longhi, *Gentileschi, padre e figlia*, "L'Arte", XIX, 1916, pp. 245–314; R.W. Bissell, *Orazio Gentileschi and the Poetic Tradition in Caravaggesque Painting*, London 1981, pp. 14–17, 19, 140–141 and 144; R. Vodret, in *Caravaggio e i suoi*, cat. of the exhibition (Rome 1999), ed. by C. Strinati, Naples 1999, pp. 38–41; K. Christiansen, in *Orazio e Artemisia Gentileschi*, cat. of the exhibition (Rome-New York-Saint Louis 2001), ed. by K. Christiansen, J.W. Mann, Milan 2001, pp. 110–112.

An angel supports Francis, debilitated by his mystical ecstasy and the pain of the stigmata. The poor man of Assisi, presented as an *alter Christus*, faints into the arms of the winged youth as Jesus did into those of the Virgin. The painter drew inspiration from the traditional iconography of the *Pietà* and depictions of Christ during the Passion or as the *Ecce Homo* to celebrate Francis in an image that was simultaneously devout and powerful in its emotional impact.

The work, characterized by the use of a very fine crystalline paint, is one of Orazio Gentileschi's first Caravaggesque masterpieces, the finest of the various versions that the artist devoted to this theme. Gentileschi, acclaimed by Roberto Longhi as "the most marvellous tailor and weaver ever to work among painters," portrayed the saint's sculpturesque body with sharp precision, dwelling "with impulsive self-satisfaction on an incidental detail that nonetheless seeks to take on a greater meaning, like the weave of the thick cincture" (Longhi 1916). Indeed, the artist developed the composition from life, using posed models, a working method that he had learned in the early years of the 17th century directly from Caravaggio. His encounter with the Lombard master radically changed Gentileschi's way of painting; by this time, he was almost forty and had been active in Rome for over two decades as a follower of late Mannerism. The friendship between the two painters must have been fairly close, since for some time they even exchanged their props, including the "Capuchin's habit" and the "pair of wings" of an angel that Orazio claimed to have "lent" to Caravaggio in 1603. Gentileschi may have reused these same stage costumes in the execution of this work.

At the bottom, on a rock, a Latin inscription in gold lettering reads: "Pray for Orazio Griffi, priest of God, founder of this orator and chapel." The work's patron was a priest and papal cantor from Varese, a member of the Roman congregation of San Girolamo della Carità, which he had entered in 1609. Orazio Griffi was buried in this church with a formal ceremony in 1624, after a life devoted to study and to directing the musical oratories of the Vallicella and of San Girolamo. The latter space for performances of sacred music, destroyed by a fire in 1631, was rebuilt from its foundations some years later. Gentileschi's painting, left by Griffi to the confraternity, was thus dispersed shortly afterwards on the Roman art market.

YP

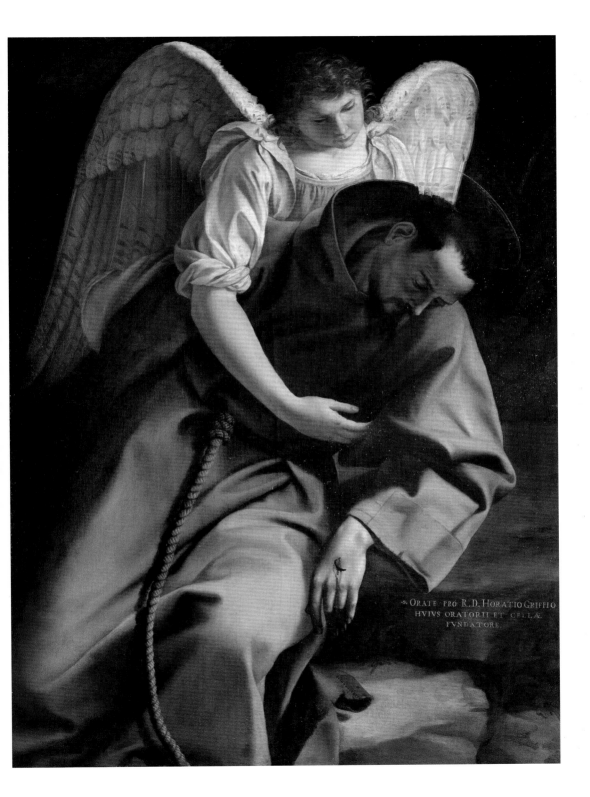

ORATE PRO R.D. HORATIO GRIFFIO
HVIVS ORATORII ET CELLÆ
FVNDATORE

41 | Orazio Borgianni
(Rome, 1574–1616)

Holy Family with St. Elizabeth, the Young St. John the Baptist and an Angel
ca. 1609–1610
oil on canvas, 257 × 202 cm
Palazzo Barberini, inv. 5005 (from the convent of San Silvestro in Capite, 1922)

Bibliography: R. Longhi, *Scritti giovanili 1912–1922*, Florence 1961, pp. 219–221; G. Papi, *Orazio Borgianni*, Soncino 1993, pp. 111–112; M. Gallo, in *Roma al tempo di Caravaggio 1600–1630*, cat. of the exhibition (Rome 2011–2012), ed. by R. Vodret, Milan 2011, II, pp. 126–129; G. Papi, in *Orazio Borgianni. Un genio inquieto nella Roma di Caravaggio*, cat. of the exhibition (Rome 2020), Milan 2020, pp. 90–93.

The divine harmonies played by the angel—as seductive as that painted by Caravaggio in the Doria Pamphilj Gallery's *Rest During the Flight into Egypt*—celebrate the mystical dialogue between the baby Jesus and the young Baptist, tussling over the dove of the Holy Spirit in an ostensibly childish game. The former is blessed by the latter, preparing for, and acknowledging his future vocation as a baptizer, alluded to by the cross of intertwined reeds, the traditional camel skin, and the half-concealed cartouche with the inscription "[Ecce Agnus] Dei."

The altarpiece comes from the convent of the Poor Clares of San Silvestro in Capite, expropriated in 1871 by the Italian State to be turned into the headquarters of the Ministry of Public Works, together with the administrative offices of the Royal Post and Telegraphs; it was discovered here in 1916 by Roberto Longhi, who arranged for it to be moved to the museum of Palazzo Corsini.

The high point of Borgianni's second Roman period (1605–1616), the work is strangely ignored by the early sources and guidebooks that describe this important Roman church, probably because it was installed in the enclosed area of the convent. The basket full of textiles on the lower right, which Longhi considered "the finest still life of 17th-century Italy and one of the finest of 17th-century Europe," is a virtuoso touch in a pure Caravaggesque mold,

perhaps even proto-Baroque in the thready and vibrant texture of the paint. In the same wicker crib, we see the swaddling clothes of infancy and the wrappings of the shroud, so that the cradle of birth already prefigures the sepulchre of the resurrection. The artist also reworked some paradigmatic *Holy Families* painted in the early 16th century by Raphael and Giulio Romano, translating them into a Caravaggesque style with strong neo-Venetian elements originating with Tintoretto and Bassano. This is confirmed by the insert with the red curtain on the right, the contrasting lighting that strikes the figures and the pauperistic overtones of the scene, enhanced by a dark and vibrant background that occupies over a third of the composition.

YP

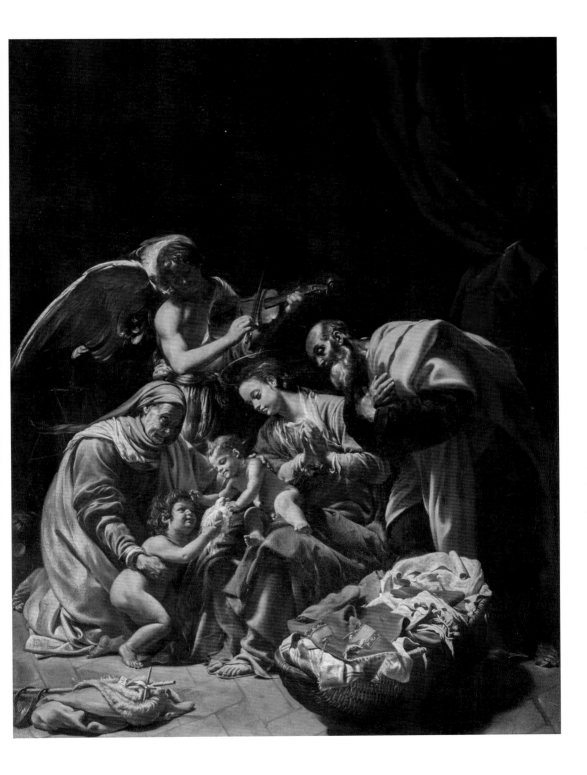

42 | **Carlo Saraceni**
(Venice, 1579–1620)

The Virgin and St. Anne Teach Jesus About the Holy Spirit
ca. 1611–1612
oil on canvas, 180 × 155 cm
Palazzo Barberini, inv. 5006

Bibliography: A. Ottani Cavina, *Carlo Saraceni*, Milan 1968, p. 114; R. Vodret, in *Caravaggio e i suoi*, cat. of the exhibition (Rome 1999), ed. by C. Strinati, Naples 1999, pp. 42–43; M. Gallo, in *Carlo Saraceni (1579-1620), un Veneziano tra Roma e l'Europa*, cat. of the exhibition (Rome 2013), ed. by M.G. Aurigemma, Rome 2013, pp. 228–231 (with preceding bibliography); G. Papi, in *Orazio Borgianni. Un genio inquieto nella Roma di Caravaggio*, cat. of the exhibition (Rome 2020), ed. by G. Papi, Milano 2020, pp. 148-149, no. 28.

St. Anne holds a young dove, about to give it to Jesus, as Mary gently directs the Child's attention toward the face of his grandmother, who wears the mantle and turban of a peasant woman. The mystical trio, linked to the old iconography of the St. Anne Trinity, invites the viewer to meditate on the redemptive meaning of Christ's birth, on his relationship to the Holy Spirit and, more generally, on the fragility of the human condition, shown by the artist in all its stages: from Christ's carefree childhood, to the youth of Mary and the old age of Anne, now close to death. Time, frozen in a perfect moment, is as if suspended in a charmed atmosphere that seems to foreshadow a magical enchantment.

Carlo Saraceni painted this altarpiece in Rome in around the spring of 1611, when his patron, Monsignor Orazio Lancellotti (1571–1620), obtained permission to have the little church of San Simeone Profeta, incorporated into Palazzo Lancellotti ai Coronari, restored at his own expense. The canvas, mentioned in the 17th-century sources and in numerous guidebooks to Rome, was only purchased by the Galleria Nazionale in 1929, when the little church that hosted it, located in the vicinity of San Salvatore in Lauro, was partially demolished.

By the end of the first decade of the 17th century, the Venetian painter was fully integrated into the Roman art world after his move to the city in around 1598. At this time Saraceni had established a lucrative workshop in Via di Ripetta, frequented by numerous collaborators and students, both Italian and foreign. The intimate and domestic tone of this scene, in which the sacred and divine are shown in an everyday setting, reflects the painter's assimilation of the novelties introduced to Rome by Caravaggio. Indeed, from the style of the great Lombard master Saraceni also borrowed the dark background with its ample drapery, and the very detailed rendering of Anne's face. The artist was also positively influenced by the art of his friend Orazio Borgianni, who executed an altarpiece depicting the same subject, again in Palazzo Barberini.

YP

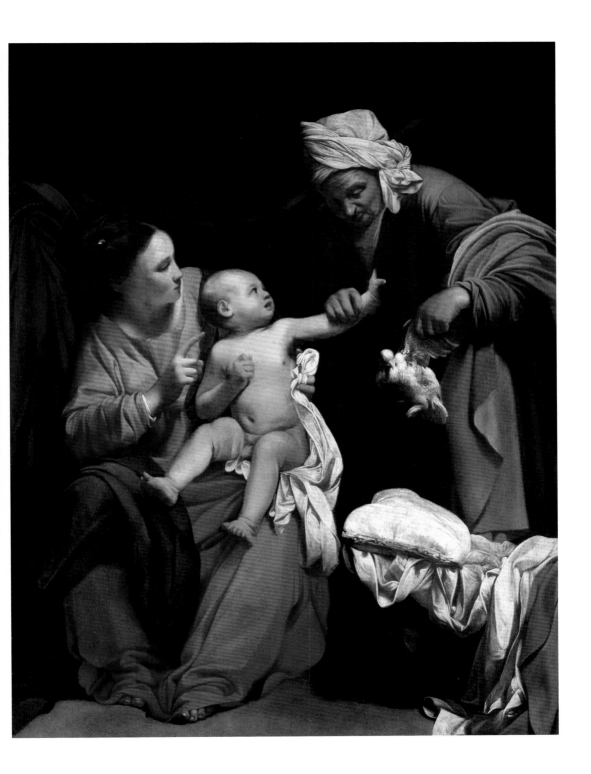

43 | Jusepe de Ribera
(Jàtiva, 1591–Naples, 1652)

The Denial of St. Peter
ca. 1615–1616
oil on canvas, 163 × 233 cm
Galleria Corsini, inv. 438

Bibliography: R. Longhi, *Ultimi studi su Caravaggio e la sua cerchia*, "Proporzioni", I, 1943, p. 58 no. 80; G. Papi, *Jusepe de Ribera a Roma e il Maestro del Giudizio di Salomone*, "Paragone", 44, 2002, pp. 21–43; Id., in *Roma al tempo di Caravaggio 1600–1630*, cat. of the exhibition (Rome 2011–2012), ed. by R. Vodret, Milan 2011, pp. 254–255.

This episode, recounted in the synoptic Gospels (Mk 14, 66–72; Mt 26, 69–75; Lk 22, 56–62) and, with some variations, by John (18, 15–27), refers to the moment at which Peter denied Christ when accused by a servant girl and some guards.

Previously included by Roberto Longhi in a group of works by the so-called Master of the Judgement of Solomon after the painting of this name in the Borghese Gallery, the painting was attributed by Gianni Papi to the early Roman period of the Spaniard Jusepe de Ribera. The artist, influenced to some extent by the work on a similar subject painted by Caravaggio (New York, Metropolitan Museum of Art), enlarged the composition horizontally, relegating the literal quotation of Peter's gesture when questioned in front of the palace of Caiaphas to the far right-hand side.

The scene includes a roughly made table with several guards intent on playing dice (an immediate reference to the counter in the Contarelli chapel *Calling of St. Matthew* in San Luigi dei Francesi), with a decrepit old man at the center wearing an odd plumed hat and denouncing Peter. This is the so-called slave of Ripa Grande drawn from life, a character actor who appears frequently in the paintings of the Spaniard and other artists active in Rome at the time (from Guido Reni to Orazio Borgianni, from Cecco del Caravaggio to Giovanni Lanfranco). Like Caravaggio's originals, the Corsini canvas played a normative role with-

in the Caravaggesque movement—especially for Bartolomeo Manfredi, Valentin de Boulogne and Nicolas Tournier— even influencing some second-generation naturalists like Bartolomeo Mendozzi or Mattia Preti. These painters undoubtedly admired Ribera's masterful fusion of sacred history with a tavern scene to create a large painting characterized by an updated staging and a strong theatrical component.

The first owners of the painting, which dates to around 1615–1616, shortly before Ribera left for Naples, were the Spanish diplomat Pietro Cussida († 1622)—owner of an *Apostolado* by Ribera, a series depicting the five senses and "a large painting with St. Peter when he denied Christ"—and the Roman banker Carlo de Rossi, whose inventory of assets, drawn up in 1683, includes a "large

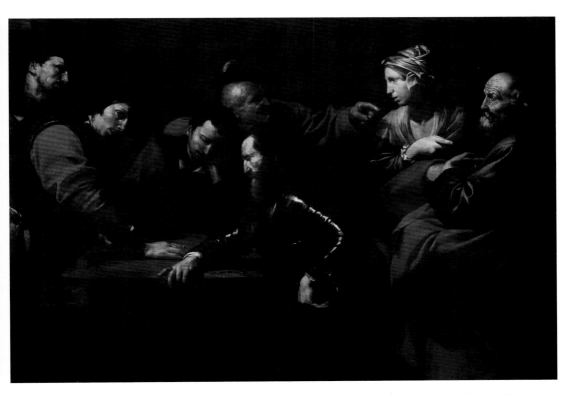

canvas painting, measuring 10 by 8 palms, on which is painted a denial of St. Peter with many half-figures of soldiers by the hand of Spagnoletto, and some say of Caravaccio." The work later entered the collection of Cardinal Lorenzo Corsini, the future Pope Clement XII, and from 1750 was displayed in the gallery of the palace in Via della Lungara.

YP

44 | Giovanni Serodine
(Ascona, 1600–Rome, 1630)

St. Peter and St. Paul Led to Martyrdom
1625
oil on canvas, 144 × 220 cm
Palazzo Barberini, inv. 1968 (purchased from P. Donini Ferretti, 1939; formerly Mattei collection).

Bibliography: R. Longhi, *Giovanni Serodine*, "Paragone", 7, 1950, p. 20; F. Cappelletti, in *Caravaggio e la collezione Mattei*, cat. of the exhibition (Rome 1995), ed. by R. Vodret Adamo, Milan 1995, p. 162; R. Vodret, in *Caravaggio e i suoi*, cat. of the exhibition (Rome 1999), ed. by C. Strinati, Naples 1999, p. 86.

There are partings that strengthen bonds instead of breaking them. This is true of St. Peter and St. Paul, linked by the hagiographical tradition in both martyrdom and the festival that to this day celebrates them together in the month of June. The Caravaggesque painter Giovanni Serodine offers a very modern interpretation of their leave-taking, executing a painting on the topic of friendship that seems to have come straight out of a 19th-century *Salon*. The image, emotionally highly charged and of excellent quality, developed some famous models by Orazio Borgianni and Caravaggio, like the *Taking of Christ* now in Dublin, originally from the Mattei collection.

The two saints clasp hands tightly and look deep into one another's eyes in an endless moment, frozen in time, before each is dragged away to his own martyrdom. Peter is pulled away by an executioner as he blesses his companion, approached by two glowering armed men: an older man with a grotesque face brandishing a cudgel and a sword, and a younger soldier with a slightly melancholy expression who seems to anticipate the eccentric Baroque musketeers of Salvator Rosa. To the left, a bugler vaguely reminiscent of Guercino announces the start of the macabre spectacle, creating a dynamic play of diagonal and broken lines with the shield and raised arms of his fellow soldiers. The dramatic tension of the narrative is further heightened by the artist's use of rapid, dense, thread-like brushstrokes, rich in ac-

cumulations of paint, to construct the figures, which almost blend into the vibrant mobility of the setting.

Serodine executed the painting in 1625, together with *The Tribute Money* now in Edinburgh and the *Jesus among the Doctors* in the Louvre, on commission from Marquis Asdrubale Mattei, the younger brother of the Ciriaco who had hosted Caravaggio in 1601. The first payments were made to the painter on 31 January 1625—the last date to 13 January of the following year—for the three canvases ordered by Marquis Mattei for the extraordinary picture gallery of his Roman palace, located in the Sant'Angelo district. For this enterprise, alongside his faithful artist from Ticino, the aristocrat summoned other talented "young men who have created something of quality and made a name for

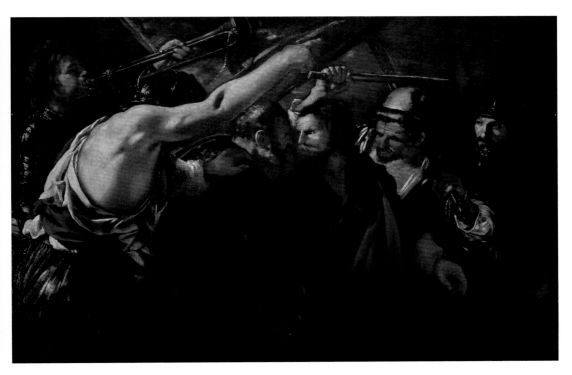

themselves": Antiveduto Gramatica, Orazio Riminaldi, Alessandro Turchi, Valentin de Bou-
logne and Pietro da Cortona.

45 | Simon Vouet

(Paris, 1590–1649)

The Fortune Teller

1617
oil on canvas, 95 × 135 cm
Palazzo Barberini, inv. 1041 (Torlonia donation, 1892)
On the back: AEGIPTIA. VULGO. ZINGARA. FATVI. CERDONIS. DIVINATRIX. A. SIMEO. VOET. AD VIVVM. DEPICTA.
MCDXVII (an Egyptian woman commonly [called] a gypsy telling the fortunes of the foolish
craftsman, painted from life by Simon Vouet, 1617)

Bibliography: R. Vodret, in *Caravaggio and His Italian Followers from the Collections of Gal-
leria Nazionale d'Arte Antica di Roma*, cat. of the exhibition (Hartford, 1998), ed. by C. Strina-
ti, R. Vodret, Venice 1998, pp. 80–83, no. 9; R. Vodret, in *I segreti di un collezionista. Le straor-
dinarie raccolte di Cassiano dal Pozzo 1588–1657*, cat. of the exhibition (Rome 2000), ed. by
F. Solinas, Rome 2000, p. 66; L. Calenne, in *Roma al tempo di Caravaggio, 1600–1630*, cat. of
the exhibition (Rome 2011–2012), ed. by R. Vodret, Milan 2011, II, pp. 264–265; A. Brejon de
Lavergnée, in *I bassifondi del barocco. La Roma del vizio e della miseria*, cat. of the exhibition
(Rome 2014–2015), ed. by F. Cappelletti, A. Lemoine, Milan 2014, pp. 194–196.

The long inscription in capital letters, which appeared on the back of the original canvas dur-
ing restoration work in 1996–1997, made it possible to attribute the painting to the French
painter and date it to 1617; it is thus the earliest documented work that he executed in Rome.
The inscription links the painting to Cavalier Cassiano dal Pozzo, a refined collector in the
circles of the Barberini family who was one of the most loyal protectors of the young Vouet.

Inspired, though not slavishly, by Caravaggio's famous model of the *Fortune Teller* (Rome,
Musei Capitolini), Vouet adopts a simple compositional approach centered on three half-length
figures emerging from the dark background. A gypsy is depicted in the act of reading the
hand of a naive craftsman who has fallen in love with her, while an older accomplice (absent
from Merisi's painting) robs the victim. He makes the old gesture of mockery with the thumb
protruding between the folded index and middle fingers, very widespread in Tuscan popular
culture and even mentioned in the *Divine Comedy*. This burlesque hint of insult, referring to

the dupe's foolishness, seems to be the key to
interpreting the image, as the old inscription
on the back of the picture suggests.

The work and its Caravaggesque prototype
are connected to the wide circulation of literary
and theatrical texts on the theme of gypsies,
very widespread in Rome in the first quarter
of the 17th century and becoming an object
of curiosity and entertainment for important
patrons, including Francesco Maria del Mon-
te and Cassiano dal Pozzo, the first owner of
this painting. The representation of the figures
"ad vivum," from life, closely linked to Cara-
vaggio's style, and the colorful gestures of the
characters are thus interpreted along the lines
of theatrical farce, and seem to be inspired by
commedia dell'arte and street theatre, serving as
a pretext for a condemnation of human vices.

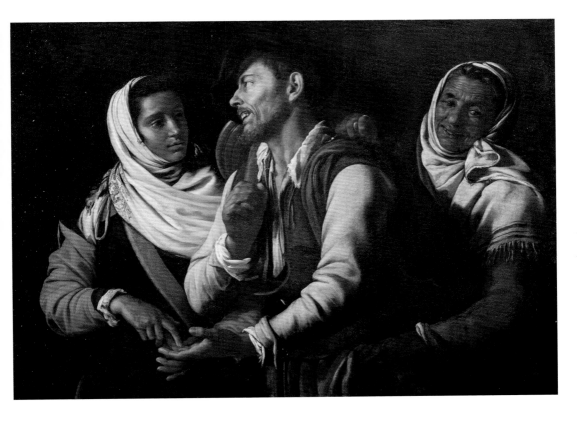

The existence of at least three other versions of the same subject that can be linked to Vouet suggests that the painter was among the first to specialize in the representation of this particular iconographical theme, which at the time was much appreciated in the art market, in Rome and elsewhere.

TC

46 | Simon Vouet
(Paris, 1590–1649)

Herodias with the Head of the Baptist
ca. 1620–1625
oil on canvas, 112 × 82 cm
Galleria Corsini, inv. 45

Bibliography: J. Thuillier, in *Vouet*, cat. of the exhibition (Rome 1990), ed. by J. Thuillier, Paris 1990, p. 130, no. 1; D. Jacquot, in *Simon Vouet. Les annés italiennes, 1613/1627*, cat. of the exhibition (Nantes 2008), ed. by B. Chavanne, D. Jacquot, A. Collange, Paris 2008, p. 145, no. 36 (with complete bibliography).

Herodias looks at us proudly, a knowing smile on her face. In her hands is the plate holding the severed head of St. John the Baptist, which she has just received from Salome. According to the Gospels, Herod Antipas had the saint arrested because he was guilty of publicly criticizing his union with Herodias, who had previously been married to his brother (Mt. 14, 1–12). The Jewish princess thus decided to take advantage of her husband's interest in her daughter Salome by persuading him to have the Baptist condemned to death.

Simon Vouet concentrated on staging the contrast between the macabre trophy and Herodias' impassive face, looking straight at the viewer in a stylized attitude and maintaining a cold and detached air. All this takes place in a petrified, almost unreal atmosphere underscored by the gloomy background. The artist has also attenuated the morbid realism that characterized the most radical expressions of the Caravaggesque tradition in favor of a more pleasant, and, so to speak, reassuring representation: no drop of blood sullies the girl's luxurious garment, no contortions mar the expression of the severed head lying on the plate, turned so that the severed neck faces away from the viewer.

The work was executed in around 1620–1625, at the very beginning of the Francophile reign of Urban VIII, when Vouet was at the peak of his Roman career. The Parisian painter was one of the few French artists, with his colleagues Valentin de Boulogne and Nicolas Poussin, to be honored with the commission of a work for St. Peter's Basilica. On the strength of this and other important achievements, the artist returned to his home country in the summer of 1627 to be greeted with full honors as the *premier peintre du roi*. Vouet's sudden departure thus left free reign to his lucrative and much-frequented workshop: a formidable creative hub located in the Campo Marzio district in what is now Via Frattina, where Claude Mellin, Jacques de Létin, Charles Mellin and various other young French painters ensured the dissemination of the master's highly original style, characterized by a tempered Caravaggism and an unmistakable decorative and theatrical elegance.

YP

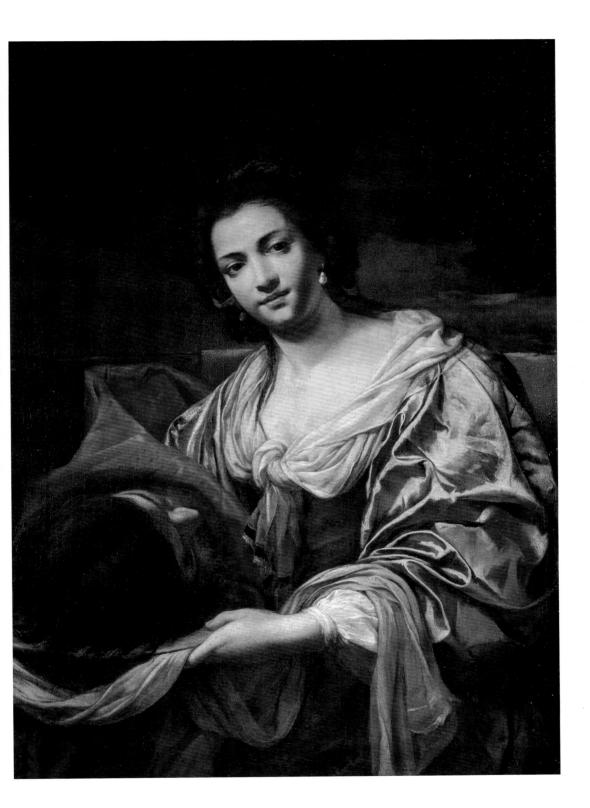

47 | Valentin de Boulogne
(Coulommiers-en-Brie, 1591–Rome, 1632)

Expulsion of the Merchants from the Temple
ca. 1618
oil on canvas, 195 × 260 cm
Palazzo Barberini, inv. 1261 (Monte di Pietà purchase, 1895)

Bibliography: *I Caravaggeschi francesi*, cat. of the exhibition (Rome 1973–1974), ed. by A. Brejon de Lavergnée, J.P. Cuzin, Rome 1973, pp. 132–134, no. 38; M. Mojana, *Valentin de Boulogne*, Milan 1989, pp. 68–69; R. Vodret, in *Caravaggio e i suoi. Percorsi caravaggeschi in Palazzo Barberini*, cat. of the exhibition (Rome 1999), ed. by C. Strinati, R. Vodret, Rome 1999, p. 122, no. 48; A. Lemoine, in *Valentin de Boulogne. Réinventer Caravage*, cat. of the exhibition (New York-Paris 2017), ed. by K. Christiansen, A. Lemoine, Paris 2017, pp. 136–138, no. 186; S. Hoppe, in *Utrecht, Caravaggio and Europe*, cat. of the exhibition (Utrecht-Munich 2019), ed. by B. Ebert, L.M. Helmus, Munich 2018, pp. 184–185.

This vast work is one of the most ambitious paintings executed by Valentin in his early Roman years. The doctrinal intent of the reference to the Gospel episode is clear, an obvious metaphor for the moralizing action of the Counter-Reformation Church. The Gospels stress the wrath of Christ when he realized that the sacred temple was becoming a flourishing market, complete with money changers and vendors of animals to offer as sacrifices. The Messiah's reaction was striking and resolute, as John relates: "So he made a whip out of cords and drove all from the temple courts, both sheep and oxen; he scattered the coins of the money changers and overturned their tables" (John 2:15).

In the wake of Caravaggio's *Martyrdom of St. Matthew* and the early Caravaggesque works of Ribera and Manfredi, the French artist transfers the biblical episode into the contemporary world, attempting to emotionally engage the viewer in the heart of the drama unfolding before their eyes. Drawing on Merisi's teachings and blending them with the Venetian 16th-century tradition, Valentin devises an asymmetrical and tumultuous composition, masterfully orchestrated through the superimposition of different moving

figures, with numerous realistic details taken directly from everyday life. The climax of the drama, shifted to the left, is encapsulated in the violent contrast between the isolated and stern Christ, wielding his whip, and the victim, who fearfully protects his face with his raised arm. In the opposite corner the crowd congregates, while the center is deliberately left empty and dark.

Directly impelled by Caravaggio's revolutionary work, the French painter emphasizes the excited expression of the faces, especially those on the right, strongly illuminated, and adopts warm and full-bodied tones with a pronounced use of chiaroscuro contrasts to create powerful dramatic effects. On the basis of these stylistic features, critics have proposed a very early date for the work, around 1618.

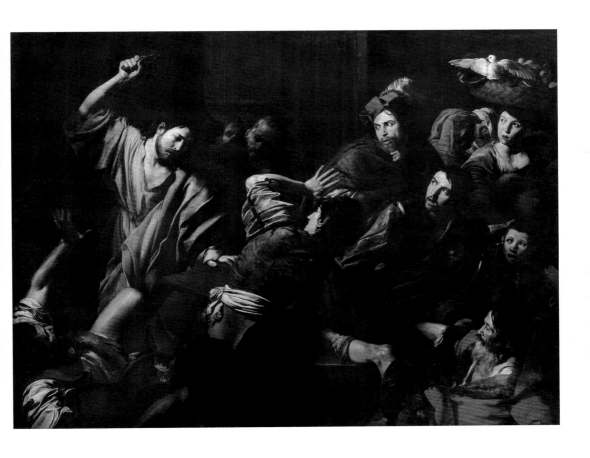

The painting, in the Spanish royal collections before passing through the Fesch collection and the Monte di Pietà, entered the Galleria Nazionale in 1895.

TC

48 | Hendrick ter Brugghen
(The Hague 1588–Utrecht 1629)

Concert (Duet)
1629
oil on canvas 90 × 127 cm
signed on the left, in the background: *HTBrugghen fecit 1629*
Palazzo Barberini, inv. 2334

Bibliography: W. Stechow, *Zu zwei Bildern des Henrick Terbrugghen*, "Oud Holland", 45, 1928, pp. 277–281; B. Nicolson, *Hendrick Terbrugghen*, London 1958, pp. 91–92; R. Vodret, in *Caravaggio e i suoi: percorsi caraveggeschi in Palazzo Barberini*, ed. by C. Strinati, R. Vodret, Naples 1999, p. 132; L. J. Slatkes, W. Franits, *The Paintings of Hendrick ter Brugghen (1588-1629): Catalogue raisonné*, Amsterdam 2007, pp. 211–212.

Ter Brugghen was among the principal exponents of the so-called Utrecht Caravaggisti, a group of Dutch painters strongly influenced by Caravaggio's stylistic innovations. He lived in Italy and specifically in Milan and Rome, perhaps in around 1607, where he was able to directly observe the naturalistic style of Merisi and his followers. Many of his compositions are dedicated to musical themes treated in a highly realistic and witty way. The *Duet* in the Gallerie Nazionali, discovered by chance by the German scholar Wolfgang Stechow in the shop of a Florentine antiquarian in 1928, is a typical invention of this kind, one of the most successful in its equilibrium and quality of execution; it is signed and dated 1629, the year of the painter's untimely death.

As is often the case in the work of Ter Brugghen and in the Dutch genre painting of the 17th century more generally, the motif of the concert is charged with multiple semantic and metaphorical meanings. The pair has not yet begun to play: the young man, who has already taken up the viola, seems to explicitly invite the woman to accompany him on her instrument, a ten-stringed lute, very commonly used in the early decades of the 17th century. Both look outwards with knowing smiles to the left and right, as if seeking the encouragement of the bystanders; a private moment thus becomes a more openly inclusive occasion, engaging the viewer.

The gesture of the violinist, just brushing against his companion's breast; the provocative transparency of her skimpy dress; the perfect and certainly not fortuitous crossing of arms and hands: everything suggests that the painter intended to create an image full of erotic undertones. Instrumental concord and musical harmony thus become a metaphor for the *voluptas* that presides over secular music, in accordance with a symbolism very widespread in the Dutch culture of the time, literary, figurative, and popular.

Emblematic in this sense is the motif of the female lute player, which often lends itself, in both texts and images, to an unequivocally licentious interpretation, as in the anon-

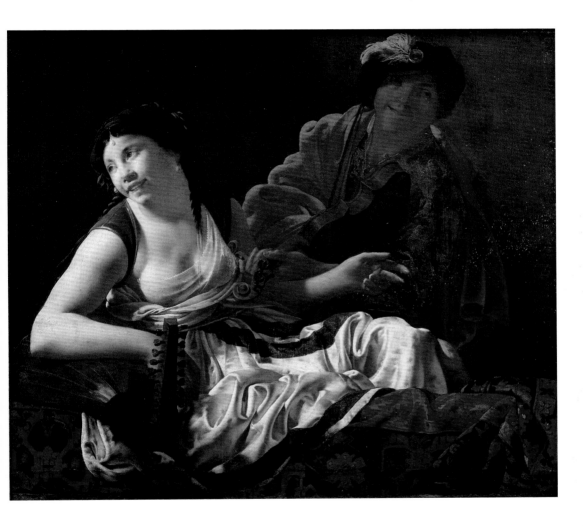

ymous but popular libretto *Incogniti scriptoris nova poemata* (or *Enigmata sive Emblemata Amatoria*, 1624, pp. 75–77), a collection of "énigmes joyeuses pour le bons esprits," in which the description of the voluptuous performer grappling with her instrument verges on intentional double entendre. Against the background of the refined synesthetic parallelism between poetry, music and painting, the picture itself thus becomes an object of lively and pleasurable entertainment, at least, of course, for viewers of wit.

MDM

49 | Pieter Paul Rubens
(Siegen, 1577–Antwerp, 1640)

St. Sebastian Healed by the Angels
ca. 1602–1604
oil on canvas, 155.5 × 119.5 cm
Galleria Corsini, inv. 388

Bibliography: G. Magnanimi, *Indagini su un dipinto di Rubens*, "Ricerche di Storia dell'arte", 8, 1978–1979, pp. 119–126; D. Bodart, in *Pietro Paolo Rubens (1577–1640)*, cat. of the exhibition (Padova-Rome 1990), ed. by D. Bodart, Roma 1990, p. 48, no. 7; R. Morselli, in *San Sebastiano. Bellezza e integrità nell'arte tra Quattrocento e Seicento*, cat. of the exhibition (San Secondo di Pinerolo 2014–2015), Milan 2014, pp. 86–89, no. 18; T. Carratù, in *Barocco a Roma. La meraviglia delle arti*, cat. of the exhibition (Rome 2015), ed. by M.G. Bernardini, M. Bussagli, Milan 2015, pp. 352–353, no. 2; C. Paolini, in *Rubens e la nascita del Barocco*, cat. of the exhibition (Milan 2016–2017), ed. by A. Lo Bianco, Venice 2016, p. 152, no. 25.

This extraordinary painting depicts the liberation of the young martyr by four angels in place of the pious Irene. According to the legendary *Passio*, at the time of Diocletian Sebastian served as tribune of the prestigious first praetorian cohort, stationed in Rome to protect the emperor. After converting to Christianity, his position enabled him to support Christians and spread the new faith among military officers, and he was therefore sentenced to death by the emperor: tied to a stake, he was shot by dozens of arrows and left to be eaten by wild animals. The execution took place on the Palatine Hill, probably on the *Gradus Helagabali*, the steps of Elagabalus, part of the temple over which a church was later erected in Sebastian's honor. When recovering his body for burial, his widow Irene realized that the young martyr was not dead and, thanks to her care, he was miraculously healed and continued to proclaim his faith. Diocletian then ordered him to be flogged in the hippodrome on the Palatine. His body was thrown into the Cloaca Maxima to prevent Christians from recovering and burying it. Finally, the matron Lucina managed to find him and bury him in the catacombs on the Appian Way.

The saint's seductive and languid body, depicted on a slight diagonal, dominates the scene, surrounded by four graceful flying angels. Those on the top right are intent on covering the powerful limbs with a sheet; the angel below unties the bindings around his feet, while the fourth on the opposite side pulls an arrow from his pierced chest. In the left-hand foreground a shining breastplate rests on the ground, an allusion to Sebastian's role as a Christian soldier. This iconographical element was borrowed from Titian and was used by Rubens on other occasions.

The powerful and sculptural nude, on the other hand, betrays the artist's fascination with ancient sculpture and with Michelangelo, whose masterpieces he studied and copied during his two stays in Rome (1601–1603 and 1606–1608).

The canvas has a troubled conservation history: in the past it was glued to a wooden board from which it was detached during the most recent restoration and diagnostic study (1977), which showed that some parts were unfinished and that others presented a noticeable difference in style. Consequently, some scholars have suggested assigning the work to Rubens' first stay in Rome: he left it unfinished and then completed it a few years later.

TC

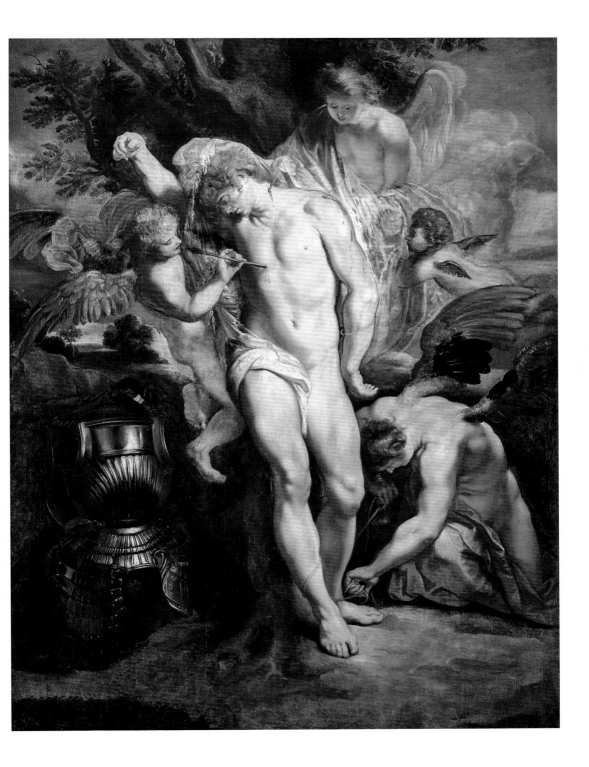

Madonna of the Straw

ca. 1625–1627
oil on canvas, 110 × 87 cm
Galleria Corsini, inv. 111

Bibliography: E. Larsen, *The Paintings of Anthony Van Dyck*, Freren 1988, II, p. 180; S. Alloisi, in *Imago Mariae. Tesori d'arte della civiltà cristiana*, cat. of the exhibition (Rome 1988), Rome 1988, pp. 150–151; S.J. Barnes, *Van Dyck: A Complete Catalogue of the Paintings*, New Haven 2004, p. 151; C. Fiore, in *Madonna. Tesouros dos Museus do Vaticano*, cat. of the exhibition (Lisbon 2017), Lisbon 2017, pp. 36, 252–254; S. Tarissi, in *Catalogo delle Gallerie Nazionali di Arte Antica*, in press (with preceding bibliography).

At the center of the canvas, Mary carefully wraps the sleeping Child in a white cloth. The presence of the donkey, the straw and the manger clearly signal that this is an unusual version of the Nativity in which Joseph and the ox are completely absent. The painter has concentrated all of the viewer's attention on the relationship between Mary and her son, choosing to depict the moment at which the Madonna nurses or more accurately has just finished nursing the Child. This is the so-called Nursing Madonna, a very widespread iconography in popular devotion, but at the same time opposed by the Church after the Council of Trent as it might lead to inappropriate images of Mary. For exactly this reason, in the painting Van Dyck hints but does not show, leaving the dress lowered over the right breast but nonetheless well-concealed behind the head of the sleeping child.

Again, through the details, the painter also stages what is known as a "prolepsis of the Passion," in other words the symbolic allusion to the end of Christ's story. This is a work created for private devotion in which the elements depicted were also intended to make the viewer reflect on the mystery of Christ's incarnation. For example, Mary's pensive and melancholy face indicates awareness of her son's destiny, just as the Child sleeping on the white sheet prefigures his death and entombment. The dark cloud that bursts into the hut—in which the heads of two cherubs can just be made out, eliminated in the final version of the painting—and the straw that gives the picture its name, a traditional Eucharistic symbol linked to the death and resurrection of Christ, allude to the same concept; the stems, not coincidentally, form a cross in the foreground.

Van Dyck executed the work during the last years of his stay in Genoa, which ended when he returned to Antwerp in 1627, as a gift for the brothers Cornelis and Lucas de Wael who had supported him while he lived in the city. By the end of the century, however, the painting must have left Italy, as we find it in Antwerp in 1691, in the collection of a certain Jean Baptiste Anthoine. Cardinal Neri Maria Corsini brought it back from Flanders in 1753, paying the large sum of 250 *scudi* for it. The cardinal's appreciation for the work is also attested by its placement in the most important gallery of his apartment and by the engraving that he had made of it after a drawing by Domenico Campiglia to increase its fame.

AC

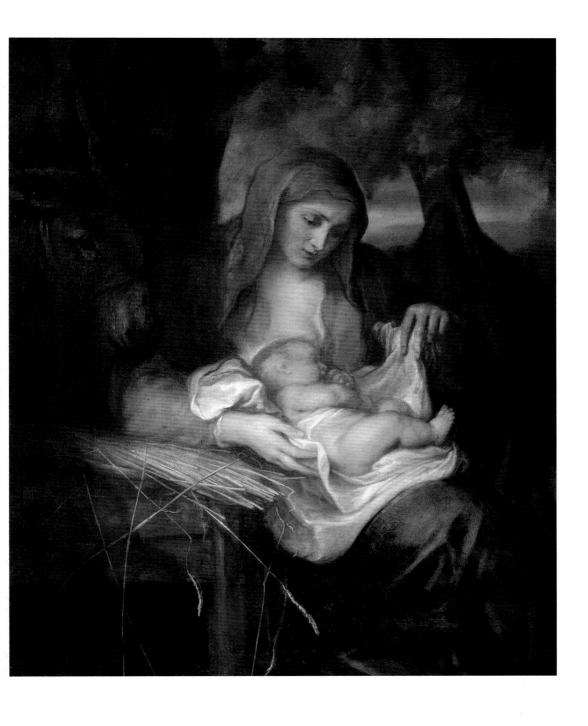

Venus Discovers the Body of Adonis

1637
oil on canvas, 179 × 262 cm
Galleria Corsini, inv. 233

Bibliography: C. Felton, W.B. Jordan, in *Jusepe de Ribera lo Spagnoletto 1592-1652*, cat. of the exhibition (Forth Worth 1982), ed. by C. Felton, W. B. Jordan, Forth Worth 1982, pp. 177–181; A. Costamagna, in *Antologia di restauri. 50 opere d'arte restaurate dal 1974 al 1981*, cat. of the exhibition (Rome 1982), Rome 1982, pp. 79–80; D.M. Pagano, in *Jusepe de Ribera 1591-1625*, cat. of the exhibition (Naples 1992), Naples 1992, pp. 211–213; N. Spinosa, *Ribera. L'opera completa*, Naples 2006, p. 329 (with preceding bibliography); F. Zalabra, in *Ovidio. Amori, miti e altre storie*, cat. of the exhibition (Rome 2018), ed. by F. Ghedini, Naples 2018, p. 269.

In the *Metamorphoses* (x, 525–560; 708–739), Ovid recounts that Venus, after wounding herself with one of Cupid's arrows, fell in love with Adonis, a handsome young man born from the incestuous relationship between Myrrha and her father Cinyras. However, Adonis preferred the adventures of hunting to the love of Venus until one day, failing to heed the goddess's warnings, he was attacked by a boar which mortally wounded him in the thigh. Seeing him on the ground, Venus immediately went to him and, in despair, turned him into an anemone to give him new life.

Ribera chooses to depict the final moment of the myth. The goddess rushes from the heavens toward her beloved, identified by her most typical attributes: the doves and the white roses that, according to tradition, turned red when Venus was injured as she ran toward Adonis. On the right, the young man's lifeless body is watched over by his faithful dog, while his spear lies abandoned on the ground. The painting is constructed on the diagonal and thus seems to visually separate the space of death from that of life, which meet only at the point where the foot of Venus overlaps with those of the young man. However, the painting presents some

substantial differences with respect to the Ovidian source, starting with Adonis' wound, located not on the thigh but on his side. This reference reveals the true source of the work, the version of the myth published in 1623 by Giovanni Battista Marino in his poem *Adone*. Here, the Neapolitan poet recovers the old medieval tradition that associated the figure of Adonis with that of Christ, emphasizing the "horrible wound in the flank" resulting from the "cruel muzzle" that "tried to kiss his side" (Marino, *Adone*, cantos XVIII, XIX).

Proudly signed and dated "Jusepe de Ribera español valenciano f [ecit] 1637" beneath the spear, the painting must have been executed for an important and cultured patron, perhaps to be identified as the then viceroy of Naples, Manuel de Acevedo y Zúñiga, count of Monterrey, who remained in the city until

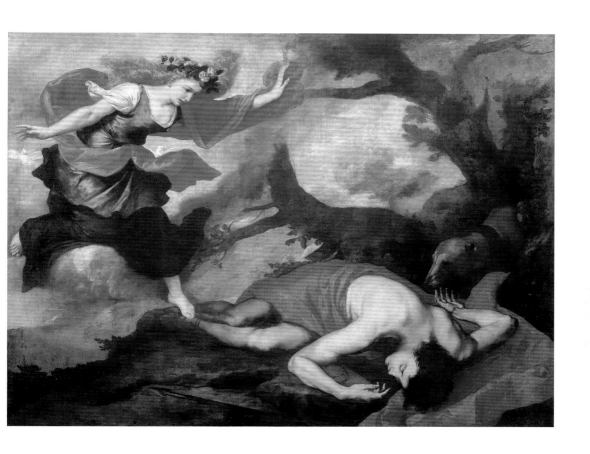

1637 and whose collection included a *Venus and Adone* by Ribera of the same size as that in the Corsini collection. On the count's death in 1656, the work was sold by his heirs and in the 18th century was purchased by Cardinal Neri Maria Corsini for a few *scudi*, with an attribution to Luca Giordano. The painting finally found a place in the gallery only in 1812, correctly attributed to Ribera.

AC

(Bologna, 1575–Rome, 1642)

Salome with the Head of the Baptist

ca. 1638–1639
oil on canvas, 134 × 97 cm
Galleria Corsini, inv. 191

Bibliography: S. Pepper, *Guido Reni. A Complete Catalogue of His Works with an Intro-ductory Text*, Oxford 1984, p. 281; C. Casiali Pedrelli, in *Guido Reni 1575–1642*, cat. of the exhibition (Bologna 1988), ed. by S.L. Caroselli, Bologna 1988, p. 160; F. Giannini, in *Guido Cagnacci. Protagonista del Seicento tra Caravaggio e Reni*, cat. of the exhibition (Forlì 2008), ed. by D. Benati, A. Paolucci, Cinisello Balsamo 2008, pp. 196–197; G. Leone, in *Da Guercino a Caravaggio*, cat. of the exhibition (Rome 2014–2015), ed. by A. Coliva, M. Gregori, S. Androsov, Rome 2014, p. 164 (with preceding bibliography).

The figure of Salome emerges from an indistinct grey background carrying the severed head of John the Baptist on a platter to be delivered to her mother Herodias. According to the Gospel of Matthew (14: 1–12), Herod Antipas, the tetrarch of Galilee, had the saint arrested for his sermons publicly criticizing his marriage to Herodias, formerly his brother's wife, but lacked the courage to have him executed. During a banquet in honor of Herodias, however, Salome performed a sensual dance that so pleased Herod that he promised to grant the girl anything she might wish. On her mother's prompting, Salome asked for "the head of John the Baptist on a platter," thus signing the saint's death warrant.

Guido Reni's version focuses on the contrast between the event narrated—a girl carrying a severed head on a platter—and the face of Salome, who looks directly at the viewer while simultaneously maintaining a frosty and impersonal distance. This distance is accentuated by Reni's skillful pictorial technique, bringing out Salome's rich robes and headdress from the canvas with long full-bodied brushstrokes that further distance the girl's face.

The work is probably that mentioned in a document dated 13 December 1639, recalling the purchase by Cardinal Francesco Barberini of "a picture with a gilded frame 6 and 4½ palms high with Herodias by the hand of Guido Reni," obtained thanks to the intervention of Monsignor Fausto Poli, head of the Barberini family's household staff, and costing the substantial sum of 170 *scudi*. The measurements coincide perfectly with those of the painting in the Galleria Corsini, which also presents a strong stylistic resemblance to the works created by Guido Reni in the late 1630s. However, the painting cannot have remained in the Barberini collection for long: it is not listed in the later inventories and Cardinal Francesco himself commissioned a copy of it already in 1640. The painting probably passed to Cardinal Alessandro Bichi, a close associate of the Barberini family, whose inventory includes a "Herodias with the head on the platter." Its provenance from the Bichi house is also attested by a note in the inventory of the Corsini collection of 1750, according to which the work was donated to Pope Clement XII by Monsignor Girolamo Bardi. Placed by Cardinal Neri Maria Corsini in his study in the Lungara palace, it immediately became one of the most admired paintings in the collection, as evidenced by the numerous copies and the mentions of it in guidebooks to Rome between the 18th and 19th centuries.

AC

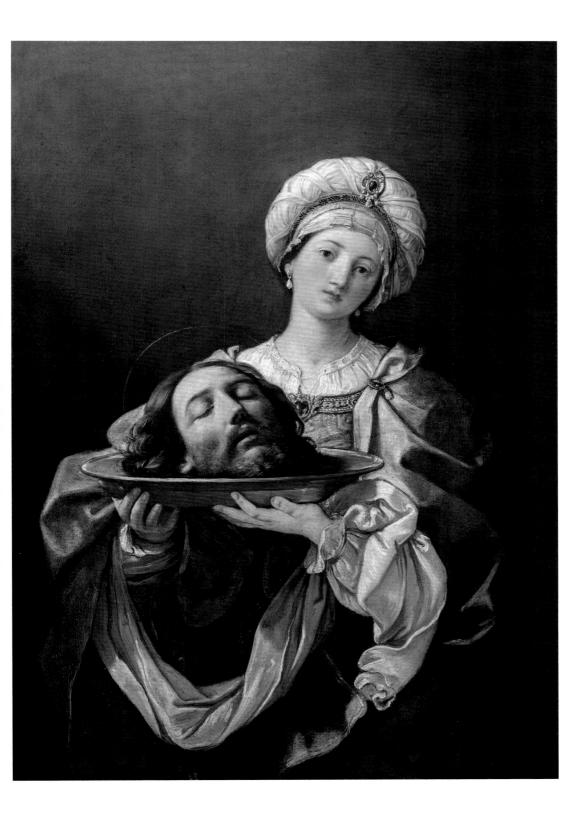

53 | Guido Reni
(Bologna, 1575–Rome, 1642)

Penitent Magdalene
ca. 1631–1632
oil on canvas, 234 × 151 cm
Palazzo Barberini, inv. 1437 (Sciarra collection, 1897)

Bibliography: S. Pepper, *Guido Reni: A Complete Catalogue of His Works with an Introductory Text*, Oxford 1984, p. 267; A. Mazza, in *Guido Reni 1575–1642*, cat. of the exhibition (Bologna 1988), Bologna 1988, p. 142; A. Emiliani, in *L'Idea del bello. Viaggio per Roma nel Seicento con Giovan Pietro Bellori*, cat. of the exhibition (Rome 2000), ed. by E. Borea, C. Gasparri, L. Arcangeli, Rome 2000, I, p. 53; T. Carratù, in *Titian to Tiepolo: Three Centuries of Italian Art*, cat. of the exhibition (Canberra-Melbourne 2002), ed. by G. Algranti, J. Anderson, Florence 2002, p. 140; R. Vodret, in L. Mochi Onori, R. Vodret, *Galleria Nazionale: Palazzo Barberini. I dipinti catalogo sistematico*, Rome 2008, p. 324.

This work was executed by Guido Reni for Cardinal Antonio Santacroce a few years before 1633. In the latter year, the Bolognese Emanuele Vizzani published a long description praising the painting, which must therefore have been purchased or commissioned by the cardinal while he was legate in Bologna between 1631 and 1634. On his death in 1641, his brother Valerio donated the canvas to Cardinal Francesco Barberini, perhaps following the instructions provided in the will of Antonio Santacroce himself, who owed his appointment as cardinal in 1629 and much of his ecclesiastical career to the Barberini family. The work is a copy—though a full-length one—of another *Penitent Magdalene* (now in a private collection), executed by Guido Reni in 1627 and given by the painter to Cardinal Francesco Barberini, who had expressed enthusiasm after seeing it in his studio.

Passed to the Sciarra family when the Barberini collection was divided up among the heirs in 1812, the painting was purchased in 1891 by the Corsini family for their palace in Florence and was only later acquired by the Italian state, entering the collections of the Gallerie Nazionali.

The image depicts the Magdalene in a cave, leaning gracefully against a rock as she raises her gaze to the heavens in an ecstatic attitude. This is a very common iconography for paintings, taking up an old hagiographic tradition according to which, after the death of Jesus, the saint travelled to Marseilles with Lazarus and her sister Martha. Here she retired to a solitary hermitage where angels visited her daily, carrying her up to heaven to taste the joys of Paradise. The Magdalene is thus surrounded by the typical marks of hermit life such as the skull,—a symbol of penance and meditation on death—the cross, and the bitter roots that the saint ate, as Carlo Emanuele Vizzani writes, "so that temperance would take root in solitude and, by restraining the appetites of the senses, feed the soul with celestial contentments."

Compared to the heightened sensuality that normally characterizes images of Mary Magdalene, described by the sources as a repentant former prostitute, here Guido Reni has depicted a composed and controlled ecstasy, in which the monumentality of the figure—not coincidentally fully covered by a tunic and an ample cloak—and the rendering of the emotions perfectly embody the ideal of classical beauty. This is a characteristic feature of the painter's style that made Bernini exclaim, in front of another *Magdalene* by Guido Reni: "[these] are paintings from Paradise."

AC

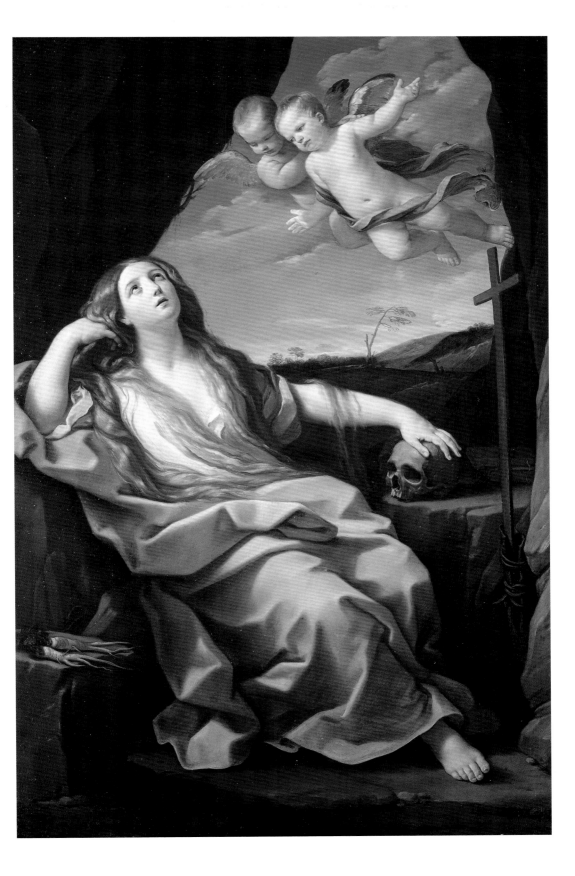

54 | **Charles Mellin**

(Nancy, ca. 1598–Rome, 1649)

Penitent Magdalene

ca. 1627
oil on canvas, 241 × 171 cm
Palazzo Barberini, inv. 2328 (purchased from the Barberini family, 1952)

Bibliography: E. Schleier, *Nuove proposte per Simon Vouet, Charles Mellin e Giovanni Battista Muti*, in *Poussin et Rome*, ed. by O. Bonfait, C.L. Frommel, proceedings of the conference (Rome 1994), Paris 1996, pp. 153–167; P. Malgouyres, *Vouet, Mellin et compagnie... Sur les traces de Charles Mellin dans l'atelier romain de Simon Vouet*, "Jahrbuch der Berliner Museen", 41, 1999, pp. 89–97; P. Malgouyres, in *Charles Mellin, un Lorrain entre Rome et Naples*, cat. of the exhibition (Caen-Nancy, 2007), ed. by P. Malgouyres, Paris 2007, pp. 76–79, 272; Y. Primarosa, *Nuove proposte per Charles Mellin, pittore e disegnatore lorenese a Roma*, "Bollettino d'arte", 97, 2012, pp. 53–76.

Mary Magdalene lies in her hermitage, taking up the whole diagonal of the painting, with her head resting on her left hand as she awaits the mystical vision; her right hand points to a skull, symbolizing the vanity of earthly things. At the top right is an ointment jar, the attribute of the sinner saint.

The description of the plants in the rocky landscape, the rendering of the chipped stones and of some anatomical details (the feet, legs, and hands) point unmistakably to the early Roman masterpieces of Charles Mellin: the *Venus at her Bath* in Berlin, the *St. Francis in Meditation* in a private collection, the *Achilles Recognized at the Court of Lycomedes* in Turin, the *Painting Drawing Love* in Bordeaux and the *Allegory of Peace and the Arts* also illustrated here.

The early works of the painter from Lorraine, the most successful and talented of Simon Vouet's numerous collaborators, have only recently been distinguished from those of the Parisian artist, who lived in Rome from March 1613 and returned to France in the summer of 1627. Unlike many of his fellow countrymen, "Charles of Lorraine" spent his whole life in Italy, continuing the style of Vouet's style by executing altarpieces and vast religious and secular compositions in Rome, Naples and Montecassino. After his arrival in the Papal capital in around 1620, when he is recorded at Nancy as a painter "presently in Rome," Mellin is attested from 1622 as affiliated with the Roman parish church of Sant'Andrea delle Fratte. All trace of the artist seems to be lost until Easter of 1625, when he is registered in the "street of the Maronites near the College" in the company of Jacques de Létin (1597–1661), a painter from Troyes. Nonetheless, considering the close affinities between Mellin's early manner and the style of Vouet, there is no reason to doubt that the "painter Carlo" recorded in the 1623 census in the house of the Parisian was in fact the painter from Lorraine, who a few months later helped him execute several of the seventeen fresco panels in the ambitious chapel of San Lorenzo in Lucina commissioned by Paolo Alaleoni (1553–1643), Urban VIII's master of ceremonies.

Monsù Simone's return to Paris in 1627 was a crucial event in Charles's professional development and coincided with his establishment on the Roman stage. Indeed, only in 1627–1630 did Mellin fully develop the stylistic register evident in this painting, diluting the teachings of the Frenchman with heterogeneous influences drawn from the painting of Giovanni Lanfranco, Annibale Carracci, Guido Reni, Domenichino and Artemisia Gentileschi.

YP

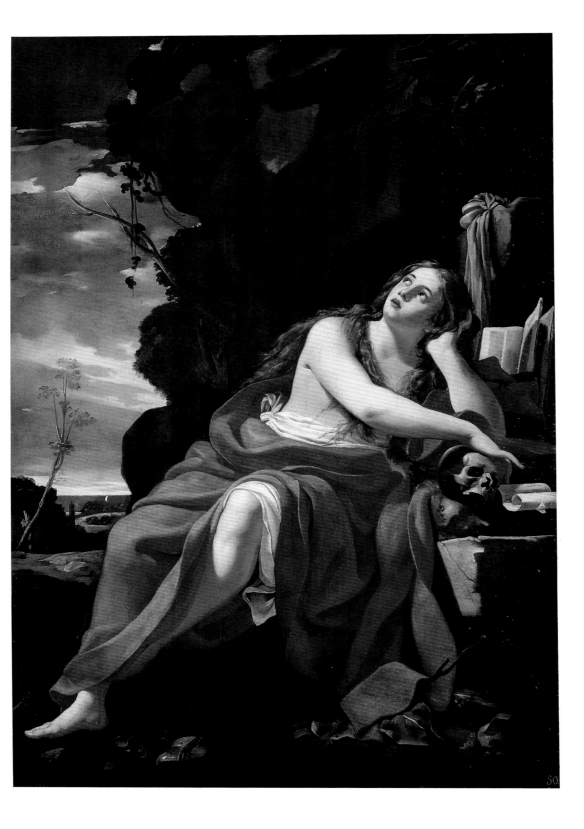

55 | **Guido Cagnacci**

(Santarcangelo di Romagna, 1601–Vienna, 1663)

Penitent Magdalene

1622–1627
oil on canvas, 86 × 72 cm
Palazzo Barberini, inv. 898 (1892, Torlonia donation)

Bibliography: G. Papi, *Qualche riflessione sul primo tempo di Guido Cagnacci*, "Antichità viva", 27, 3/4, 1988, pp. 19–25; Id., *La "Maddalena penitente" di Guido Cagnacci a Palazzo Barberini*, "Paragone", 39–40 (519/521), 1993, pp. 95–98; D. Benati in *Guido Cagnacci. Protagonista del Seicento tra Caravaggio e Reni*, cat. of the exhibition (Forlì 2008), ed. by D. Benati, A. Paolucci, Cinisello Balsamo 2008, p. 154; G. Papi in *Orazio Borgianni. Un genio inquieto nella Roma di Caravaggio*, cat. of the exhibition (Rome 2020), ed. by G. Papi, Milan 2020, pp. 136–137, no. 22.

The *Magdalene* is one of Cagnacci's best-known works for its unrestrained sensuality and iconographic audacity. A naked woman, worn out by pain and exhausted from the torture that she has inflicted on herself with the iron chain she holds in her hand, falls backwards as if unconscious, letting her auburn hair drop to her shoulders and clutching the skull on which she has been meditating. Without hyperbole, the saint offers up to close contemplation her smooth and vibrant body—with the breast shown provocatively from below—the vase and the cross set on the ground, testimonies to her sin and repentance, while the sky, of a deep and intense blue, appears on the left. This is a scandalously erotic image, full of emotional stimuli, in which the sacred and the profane, mystical ecstasy, the suffering of the flesh and the passion of the senses are blended in a highly emotive and theatrical painting. The only source of light, which falls from the left, fully illuminates her face, casts shadows against the hand and skull, and leaves the dark background, the rock, and the wall against which the Magdalene leans in total obscurity. The play of light emphasizes the explosive energy of the nude, depicted with a revolutionary sense of truth and simplicity, and freezes the timeless action.

Identified by Gianni Papi as early as 1988 after an improbable attribution to Francesco Trevisani, this masterpiece is a youthful work by the painter from Romagna, executed while he was living in Rome or shortly thereafter. The hypothesis that it was executed in Rome, where Cagnacci is documented between 1621 and 1622 at the house of Guercino in Via del Babuino, as well as its provenance from the Torlonia collection, is justified by the strong realism of the scene. The painting is also an early homage to Guercino's painting technique with daubs of color and Orazio Borgianni's naturalism, full of luminous matter, offering a personal interpretation of Caravaggio's teachings for the brazen realism with which he treats the theme of the female nude.

PN

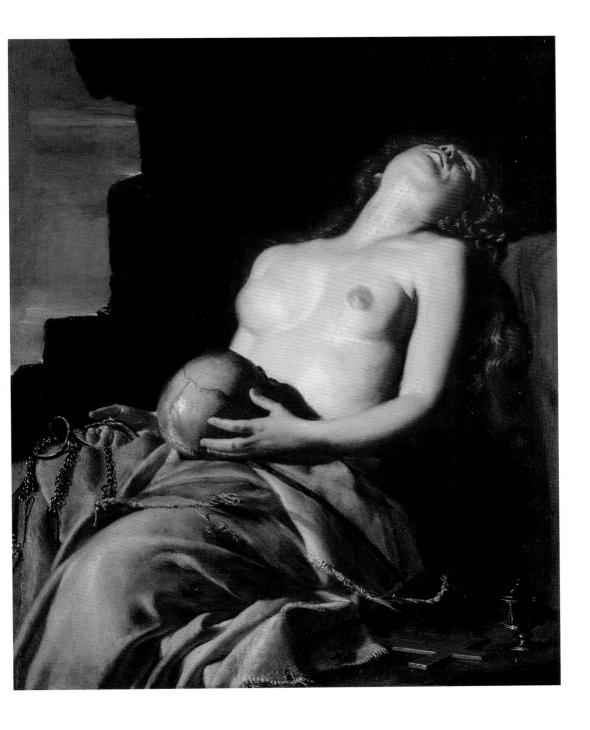

56 | Francesco Furini
(Florence 1603–1643)

Judith and Holofernes
1630–1635
oil on canvas, 116 × 151 cm
Palazzo Barberini, inv. 2010 (Dusmet bequest, 1948)

Bibliography: R. Maffeis, in *Francesco Furini, un'altra bellezza*, cat. of the exhibition (Florence 2007–2008), Florence 2007, pp. 176–177; G. Cantelli, *Francesco Furini e i furiniani*, Pontedera 2010, p. 109 (with preceding bibliography).

The heavy vermillion curtains of Holofernes' tent frame the scene like the wings of a theatre and reveal the outcome of the bloody drama that has just unfolded. The naked body of the Assyrian general lies sprawled on the blood-soaked sheets; the severed head has rolled to the ground and the triumphant Judith, still wielding her scimitar, gestures at the horrible trophy with her left hand to her maidservant Abra, who enters cautiously with the sack in which to hide Holofernes' severed head.

Furini interprets the biblical passage (*Judith* 13, 1–10) with a peculiar theatrical inflection that departs from the text in some respects. The protagonist does not creep stealthily out of the tent but dominates the center of the scene, with a grim look and imperious gesture, illuminated by a beam of light that cuts diagonally across the space and casts sharp shadows: more a theatrical expedient than a natural phenomenon. The image is constructed on the basis of finely calibrated similarities and contrasts: thus, the woman's arm is echoed by Holofernes' livid and inert limb next to his arm guard, gleaming but now ghostly in its emptiness.

The highly theatrical presentation—not uncommon in 17th-century images of Judith—might suggest that the execution of the painting was directly influenced by a contemporary stage play. This is particularly true since in Florence the biblical heroine was not only a traditional symbol of "sanctimonia" (sanctity), but also, like David, embodied the "power" of the political ideal of civic patriotism. However, here the painter aims to represent Judith in a different

light, more ambiguous and only ostensibly contradictory. The young widow from Betulia is seated on the victim's bed, partially unclothed and with a prominently displayed bare leg that exactly marks the central axis of the painting. Immediately beneath her naked foot, right next to Holofernes' head, a pair of elegant unlaced shoes are less a detail of her costume than a precise reference to the biblical text (16, 9): "Her sandal captured his eyes, her beauty captured his heart, and the sword sliced through his neck." Like the famous Judith (now in Palazzo Pitti) painted by his fellow Florentine Cristofano Allori twenty years earlier, Furini's Judith is above all the terrifying seductress, albeit with a higher purpose.

The Barberini canvas, which entered the Gallerie Nazionali with the bequest of the

Marquise Dusmet (1948), comes from the collection of the Marquis Giulio Vitelli, Furini's "great protector," and is almost perfectly identical, on a smaller scale, to the painting now owned by the Ente Cassa di Risparmio di Firenze, for which it was considered a sort of model, although it might also be a copy.

MC

Et in Arcadia ego
ca. 1618
oil on canvas, 78 × 89 cm
Inscription: «ET IN ARCADIA EGO»
Palazzo Barberini, inv. 1440 (Barberini collection)

Bibliography: D. Mahon, in *Giovanni Francesco Barbieri il Guercino 1591–1666*, cat. of the exhibition (Bologna and Cento 1991), ed. by D. Mahon, Bologna 1991, pp. 94–98, no. 32; M.C. Cola, in *Immagini degli dei. Mitologia e collezionismo tra '500 e '600*, cat. of the exhibition (Lecce 1996–1997), ed. by C. Ceri Via, Milan 1996, pp. 102–104, no. 1; M. Pulini, in *Guercino. Poesia e sentimento nella pittura del '600*, cat. of the exhibition (Milan 2003–2004), ed. by D. Mahon, M. Pulini, V. Sgarbi, Novara 2003, pp. 150–151, no. 27; R. Vodret, in *Guercino (1591–1666). Capolavori da Cento e da Roma*, cat. of the exhibition (Rome 2011–2012), ed. by R. Vodret, F. Gozzi, Florence 2011, pp. 31–49, 51–63, no. 16, 100–102; A. Lo Bianco, in *Et In Arcadia ego. Guercino, 1591–1666*, cat. of the exhibition (Fermo 2012), Perugia 2012, pp. 10–18.

The painting, one of the most fascinating and mysterious of the Baroque, is an early work by Guercino, executed around 1618 when the painter was still influenced by 16th-century Venetian and Ferrarese painting. We do not know the patron for whom he executed the canvas, perhaps Maffeo Barberini, the future Pope Urban VIII, or his nephew Cardinal Antonio Barberini, in whose inventory it is mentioned for the first time in 1644. Certainly, patrons and collectors were struck by the sorrowful and poetic atmosphere that pervades the work. In a wooded landscape, two young shepherds in contemporary garments look out at the scene, directing our gaze toward the decaying skull set on a wall worn away by time. Around it are a mouse, a blowfly, a caterpillar, a lizard and a goldfinch, standing out against a lunar landscape that is the true protagonist of the painting alongside the shepherds with their melancholy and haunted expressions. The theme is the contrast between the youth of the shepherds and the inevitable march of time that consumes all. The enigmatic painting is closely related to the *Apollo and Marsyas* in the Palatine Gallery in Florence, executed by Guercino for the Grand Duke of Tuscany Cosimo II. In the Florentine painting, the same figures of shepherds appear as spectators of the atrocious flaying of Marsyas. From that idea, Guercino created an original image that blends three pictorial genres: landscape painting, still life and the moral theme of *vanitas* as a reflection on the fragility of the human condition. Death speaks to us through the famous motto *Et in Arcadia ego*, "I too (death) am in Arcadia," which first appears in painting here.

A mythical place evoked by Theocritus and Virgil, sung about in the 16th century by Sannazaro, Tasso and Guarini, and reaching the height of its popularity at the end of the 17th century with the academy of writers

founded in Rome by Queen Christina of Sweden, Arcadia had always been a symbol of a lost golden age of humanity when perfect harmony reigned between man and nature. With his very personal painting style of light touches and daubs, a vibrant chromatic and material range and shifting flashes of light, Guercino transforms the image into a poetic concept. Full of expressive and emotional power, it captivates the viewer with the theatricality of the composition and the seductively mysterious landscape. This was the invention of Baroque painting.

PN

Saul and David

1646
oil on canvas, 147 × 220 cm
Palazzo Barberini, inv. 1549 (donated by the Ministero Real Casa, 1915)

Bibliography: L. Salerno, *I dipinti del Guercino*, Rome 1988, p. 303; D. Stone, *Guercino. Catalogo completo*, Florence 1991, pp. 221–222; *Il libro dei conti del Guercino. 1629–1666*, ed. by B. Ghelfi, Bologna 1997, p. 130; R. Vodret, in *Guercino (1591–1666). Capolavori da Cento e da Roma*, ed. by R. Vodret, F. Gozzi, Florence 2011, pp. 138–140 (with preceding bibliography).

The painting illustrates, with theatrical emphasis and didactic clarity, the Biblical episode recounted in the first Book of Samuel (18, 10), in which King Saul, in thrall to an evil spirit and jealous of David's military victories after his glorious defeat of Goliath, attempts to stab the valiant young man as he tries to placate the sovereign's anger by playing the harp. Taking a typical approach recurrent in his works, Guercino depicts the clash from very close up to better underline the contrast and the disparity between the two opposing figures: Saul, imposing with his crown and armor as he brandishes the lance, and the defenseless and slender David, armed only with his harp, with which he had nonetheless alleviated the king's distress. The scene is given a further dynamic impulse by the amplification of gestures and movements, together with the subdivision of the background, deliberately asymmetrical and sparse, and with the direction of the light.

The work, for which 175 *scudi* were paid in June 1646, was commissioned by the Florentine cardinal Lelio Falconieri (1585–1648). The choice of subject and its interpretation should be connected to another canvas executed by Guercino, again for Falconieri, which, though slightly smaller, must have formed a sort of ideal companion piece to the Barberini painting. The second work—now in a private collection in California—depicts *Samson revealing to Delilah the Secret of his Own superhuman Strength* (Judges 16, 17–18). The unusual subject is thus associated with the image of the irate Saul and, just as this painting stigmatizes the envy that leads to a violent abuse of power, the latter denounces the corruption of money that entails indiscretion and treachery. Both *exempla* must have been congenial to Falconieri who, particularly during his time as Papal Legate in Bologna from 1644 to 1648, had striven to be seen as an impartial, moderate, and incorruptible judge, as he is remembered at least by his official biographers and his epitaph in San Giovanni dei Fiorentini: "incorruptible, prudent and above all of proven justness."

At the same time, the painter might even have seen himself in the familiar motif of envy and rivalry, which was certainly com-

mon among the artists of the period and often expressly evoked through the example of Saul and David; as cardinal Sforza Pallavicino noted, "the makers of the world's illustrious works, be they works of art, or feats of arms, or prudent deliberations or the discoveries of the intellect, certainly love being imitated and followed, but not surpassed" (*Arte della perfezion cristiana*, 1665, p. 364).

MDM

59 | Ginevra Cantofoli (?)
(Bologna, 1618–1672)

Woman with a Turban (presumed portrait of Beatrice Cenci)
ca. 1650
oil on canvas, 64.5 × 49 cm
Palazzo Barberini, inv. 1944 (purchased from the Barberini family, 1934)

Bibliography: B. Groseclose, *A Portrait Not by Guido Reni of a Girl Who Is Not Beatrice Cenci*, "Studies in Eighteenth-Century Culture", 11, 1982, pp. 107–132; R. Vodret, *Un volto per un mito. Il "ritratto di Beatrice" di Guido Reni*, in *Beatrice Cenci, la storia, il mito*, ed. by M. Bevilacqua, E. Mori, Rome 1999, pp. 131–140; B. Jack, *Beatrice's Spell: The Enduring Legend of Beatrice Cenci*, London 2004; M. Pulini, *Ginevra Cantofoli: la nuova nascita di una pittrice nella Bologna del Seicento*, Bologna 2006, pp. 20–24, 84–87.

"In this face of Cenci there is more than we have ever seen in any other human face." Thus, Goethe confided to his friend Johann Georg Zimmermann in 1777, suggesting that the portrait might have served as the supreme ornament for a work like the treatise on physiognomy that the Swiss scholar Johann Kaspar Lavater was writing at the time.

The face of which Goethe spoke was that of Beatrice Cenci, the unfortunate Roman noblewoman executed for parricide in front of Castel Sant'Angelo in 1599, and who, according to a tradition well-attested in the 18th century, had her portrait painted by Guido Reni on the eve of her execution. In fact, more than one presumed portrait of the young Cenci was known in Rome already in the late 17th century– for example, local guides pointed to one in the Casino del Bel Respiro at Villa Pamphilj—but the painting attributed to Reni was to achieve an absolutely exceptional renown.

Before passing to the Barberini family in 1818, the painting was in the collection of the Colonna family, in whose inventories it appeared no earlier than 1783, with a hypothetical identification ("Portrait believed to be of Cenci"), but even before this date the image must have been fairly popular thanks to a series of copies, particularly those executed by the German painter Friedrich Gotthard Naumann. It is from one of these that the engraving commissioned by Lavater, on Goethe's advice, from Johann Heinrich Lips was drawn in 1777 to illustrate the heartfelt pages dedicated to Beatrice in his *Physiognomische Fragmente* (Leipzig 1778, ɪᴠ, pp. 124–126).

Naturally, the portrait's popularity was not due solely to the facial features of the angelic figure, and if Lavater himself could write in good faith that the young woman seemed "incapable of any malevolent designs" it was because he had in mind the tragic events that Muratori had restored to the limelight in the *Annali d'Italia* (Milan 1749, x, pp. 565–567), presenting Beatrice as a victim first of the "disordered desires" of her father and later of the pitiless intransigence of the Pope. This helped to feed the fervid Romantic imagination, which throughout the following century celebrated the unfortunate heroine in the famous pages of Hawthorne, Melville, Dickens, Stendhal, Shelley and many other writers and painters, and turned the portrait into a true object of veneration and pilgrimage.

In fact, doubts over the subject of the work and the artist responsible for it were not lacking, starting from the historical plausibility of the idea that a woman condemned to death under such circumstances might be portrayed by a painter. Today the attribution to Reni is almost unanimously rejected and the most recent hypothesis is that the anonymous portrait of a woman, perhaps as a sybil, can be ascribed to the Bolognese painter Ginevra Cantofoli.

MDM

60 | Domenico Zampieri, called Domenichino
(Bologna, 1581–1641)

Virgin and Child with St. John the Evangelist and St. Petronius
1625–1629
oil on canvas, 420 × 267 cm
Palazzo Barberini, inv. 5074 (on loan from the Pinacoteca di Brera, Milan)

Bibliography: R. Spear, *Domenichino*, New Haven-London 1982, pp. 269–270; D. Benati, in *Pinacoteca di Brera: scuola emiliana*, Milan 1991, pp. 158–159; R. Vodret, *La pala della chiesa dei Santi Giovanni Evangelista e Petronio dei Bolognesi*, in *Domenichino 1581–1641*, cat. of the exhibition (Rome 1996–1997), Milan 1996, pp. 298–310; M. Di Monte, in *Il Museo universale dal sogno di Napoleone a Canova*, cat. of the exhibition (Rome 2016–2017), ed. by V. Curzi, C. Brook, C. Parisi Presicce, Milan 2016, pp. 256–257; R. Vodret, *La pala del Domenichino*, in *La Chiesa dei Bolognesi a Roma. Santi Giovanni evangelista e Petronio*, ed. by F. Buranelli, F. Capanni, Rome 2017, pp. 83–90 (with preceding bibliography).

On 15 June 1625, Domenichino made the Bolognese Confraternity in Rome an offer to execute the altarpiece for their church, dedicated to St. John the Evangelist and St. Petronius, for the extremely modest sum of 200 *scudi*. The proposal was accepted, but despite numerous reminders from the brothers the painter only delivered the work in November 1629. Its long gestation, attested by the numerous preparatory drawings and by various pentimenti brought to light by X-rays, is in keeping with Domenichino's torturous working method, compounded in this case by the importance of a work destined for the church of his native city and thus visible to his Bolognese colleagues working in Rome, with whom he had clashed numerous times.

For the occasion, Domenichino took up a compositional scheme typical of the Renaissance, with the Virgin and Child on a throne surrounded by angels playing musical instruments. The choice of instruments (cornett, violin, viola, and harp), however, illustrates the painter's in-depth musical knowledge; this was the first time a trio sonata, a musical form popular in the 17th century specifically in Bologna, had been depicted in a painting. Below, St. John the Evangelist, the titular saint of the church, is portrayed with an eagle, a book, and a chalice with serpents, alluding to a failed attempt to poison him in Ephesus. St. Petronius, the patron saint of Bologna, wears his bishop's robes and is placed near the symbol of the city sculpted on the pedestal.

The altarpiece attracted numerous criticisms, chief among them the vicious critique of the sculptor Alessandro Algardi who complained of the "old and tired invention," the compositional problems and the figures with "unnatural" legs and "rigid hands." The judgement clearly reflects the distance between Domenichino and the other Bolognese artists of his time and their reciprocal incomprehension.

Interest was only shown in the work from the mid-18th century thanks to the painter Anton Raphael Mengs, who tried unsuccessfully to purchase it for the museum of Dresden in 1757, offering the substantial sum of 5000 *scudi*. In 1799, following the French occupation of the city, the work was taken to the Vatican gallery and only after many attempts was it returned to the church in 1805. However, its stay here was short. In 1812, the altarpiece was again removed and sent to Milan to compensate the Pinacoteca di Brera for the loss of numerous works destined by Napoleon for the collections of the Louvre. Despite the protests, the painting remained in Milan until 1953, when it was returned to Rome and its new home in Palazzo Barberini, in the rooms of the Officers' Club (the work has been on display to the public from 1992).

AC

61 | Nicolas Poussin
(Les Andelys, 1594-Rome, 1665)

Triumph of the Poet Ovid
1624–1625
oil on canvas, 148 × 176 cm
Galleria Corsini, inv. 478

Bibliography: H. Bardon, *Deux tableaux sur des thèmes archéologiques*, "Revue Archéologique", 1, 1960, pp. 168–181; J. Thuillier, *Nicolas Poussin*, Paris 1994, pp. 106–107, 243; P. Rosenberg, *Vouet et Poussin*, in *Simon Vouet: les années italiennes 1613-1627*, ed. by D. Jacquot, A. Collange, Paris 2008, pp. 81–89; L. Pericolo, *"Smoderato piacer termina in doglia". Sul* Trionfo d'Ovidio *della Galleria Corsini, attribuito a Nicolas Poussin*, "Annali dell'Università di Ferrara", 4, 2003, pp. 263–292; S. Pedone, in *Barocco a Roma. La meraviglia delle arti*, ed. by M.G. Bernardini, M. Bussagli, Milan 2015, pp. 370–371.

More than a genuine triumph, the painting is an allegorical celebration of the theme of love through the dominant, but ambiguous, metaphor of play. In a secluded and idyllic clearing, a group of Cupids take advantage of the fact that Venus is sleeping to give full rein to their own playful liveliness, watched over by the poet Ovid—obviously present here as the author of the *Ars amatoria* and the *Amores*, whose titles can be read on the spines of the books against which he leans. Indeed, the spirit in which the power of the amorous drive is represented is at least in some senses Ovidian: vital and pervasive, yet for this very reason often uncontrollable.

This interpretation is all the more pertinent here if we consider that scholars have rightly identified in the features of the Latin poet a hidden portrait of the new Ovid, the poet Gian Battista Marino (1596–1625), a friend and admirer of Poussin, who paid tribute to him in this way. In the poetry of Marino, too, the theme of lovers' play is a frequent presence, often with overtones that stress the changeability of sentiments in thrall to an amorous passion. Not coincidentally, in poems such as *L'amore incostante*—which the poet had dedicated to Marcello Sacchetti, the protector in Rome of Marino himself and of Poussin—we find an abundant

use of metaphors such as bonds, knots, lures, arrows and so forth that can easily be associated with the pastimes enjoyed by the Cupids in the painter's Ovidian garden. Particularly significant in this regard is the pair in the foreground, engaged in the game known as *gioco del bracciale*, the ball that the two are throwing back and forth is none other than the celestial sphere, a motif that may have been drawn from the collection of emblems published by Daniël Heinsius in 1613 (*Ambacht van Cupido*), where an identical scene is tellingly entitled *Pila mundus Amorum est* (The world is the globe of Cupids).

We do not know for what purpose the painting was executed, though the two myrtle wreaths held in the poet's hand might suggest a work intended to celebrate a marriage, perhaps painted in Rome in around 1624–1625.

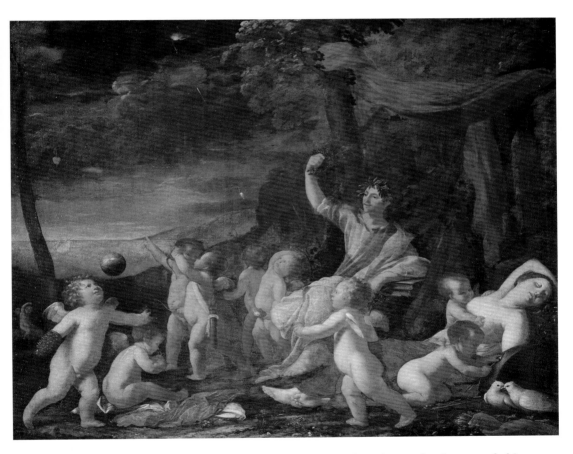

Nonetheless, the unusual and erudite invention devised by the painter, who thus reveals his philosophical leanings toward Neostoicism, suggests that we should not trust appearances and invites us to guard against an unbridled abandonment to the passions, as the snares of evil are always lying in wait. Indeed, on closer inspection, we see, almost hidden from view but identifiable behind a tree trunk at the back right, the figure of a faun with devilish features who is watching the carefree group unseen. As Poussin himself warned, things should not be observed in a hurry, "mais avec temps, jugement et intelligence."

MDM

62 | Giovanni Lanfranco
(Parma, 1582–Rome, 1647)

St. Peter Healing St. Agatha in Prison
1613–1614
oil on canvas, 93 × 114 cm
Galleria Corsini, inv. 211

Bibliography: S. Alloisi, *Guida alla Galleria Corsini*, Rome 2000, p. 87; E. Schleier, in *Giovanni Lanfranco. Un pittore barocco tra Parma, Roma e Napoli*, cat. of the exhibition (Parma-Naples-Rome 2001-2002), ed. by E. Schleier, Milan 2001, p. 110, n. 8; *Effetto notte. Sant'Agata risanata. Due dipinti di Lanfranco a confronto*, cat. of the exhibition (Rome 2011), ed. by T. Carratù, A. Negro, Rome 2011; T. Carratù, in *Roma. Seicento verso il Barocco*, cat. of the exhibition (Beijing 2014–2015), ed. by G. Leone, D. Porro Rome 2014, p. 132.

According to the sources, the young and beautiful Sicilian heroine Agatha was martyred during the persecutions of Decius or Diocletian. The *Passio Sanctae Agatae* describes her courageous espousal of the Christian faith: persecuted by the governor Quintianus for refusing to worship the pagan gods, she took a vow of perpetual virginity and consecrated herself to God. For this reason, she was subjected to numerous forms of torture, including having her breasts cut off, from which she was healed in prison by the miraculous intervention of St. Peter. The healing takes place at night: the apostle applies an ointment to the bleeding wound on the breast accompanied by a young angel, who illuminates the dark prison cell with the light of a torch.

The painting thus celebrates the miracle of the *curatio mamillarum*, focusing on the moment at which the apostle reaches out his hand to the saint's bleeding wound, which immediately heals, while the youthful angel hands him the small bowl with the ointment.

Inspired by Caravaggio, Lanfranco uses the theatrical expedient of the single beam of light entering the picture diagonally from the high window of the prison, making the figures stand out strongly against the darkness; this is accompanied by other lighting effects such as the dim ray of moonlight, the gleam of the lighted torch and the mystical glow emanating from the saint's virginal body.

At the same time, the drama of the moment is attenuated by the magically timeless, lyrical, and intimate nocturnal atmosphere, suggested by the calm gestures and idealized faces of the figures who betray a sentimental approach to the rendering of the event, far removed from the violent and dramatic realism typical of Caravaggio's paintings.

Thanks to the restoration and diagnostic studies conducted in 2011, it was possible to definitively establish the authenticity of the painting in the Gallerie Nazionali in Rome and its inventive precedence over the similar version in Parma (Galleria Nazionale), thus reversing the prevailing opinion of many scholars who in the past considered it a good copy or a second version of the original in Parma.

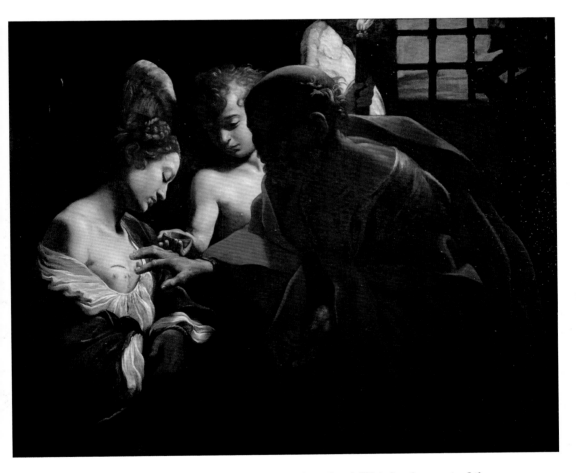

From a stylistic point of view, the chromatic fluidity, the skillful development of the composition and lighting and the poetic interpretation of the scene, alongside the power and sensitive coloring of the Corsini *St. Agatha*, are reminiscent of the frescoes in Palazzo Mattei and the canvases in the Bongiovanni chapel in Sant'Agostino in Rome, justifying a date in 1613–1614, slightly earlier than these works.

TC

63 | **Giovanni Lanfranco**

(Parma, 1582–Rome, 1647)

Venus Playing the Harp (Music)

1630–1634
oil on canvas, 214 × 150 cm
Palazzo Barberini, inv. 2411 (1959, acquired from the Barberini collection)

Bibliography: E. Schleier, *Disegni di Giovanni Lanfranco*, cat. of the exhibition (Florence 1983), Florence 1983, pp. 162–163; F. Trincheri Camiz, *Una "Erminia", una "Venere" e una "Cleopatra" di Giovanni Lanfranco in un documento inedito*, "Bollettino d'Arte", 67, 1991, pp. 165–168; L. Mochi Onori, in *Giovanni Lanfranco e la famiglia Barberini*, in *Giovanni Lanfranco. Un pittore barocco tra Parma, Roma e Napoli*, cat. of the exhibition (Parma-Naples-Rome 2001–2002), ed. by E. Schleier, Milan 2001, pp. 79–82 e p. 266, no. 77.

Lanfranco's painting known as *La Musica* is first mentioned in the will of the virtuoso harpist Marco Marazzoli (1602–1662), where it is described as a Venus playing the harp. The composer, nicknamed Marco of the harp, was one of Cardinal Antonio Barberini's court musicians and a friend of Lanfranco: both were born in Parma and the painter's daughter was also a singer and harpist. The painting was executed before Lanfranco's departure for Naples in 1634 and after Marazzoli's arrival in Rome (around 1629). On his death, the latter wished to express his friendship and gratitude to the papal family by giving them the three works by Lanfranco he owned. The musician's testamentary bequest was divided up between Cardinal Antonio jr., a cultured music lover and owner of the harp depicted in this canvas, who received the *Music*, Prince Maffeo, who was given the *Cleopatra*, and Cardinal Carlo, who received *Erminia Among the Shepherds*. From this point on, the three paintings are always documented in the Barberini inventories. The work in question is thus a double celebration of music and painting, as well as a tribute to the Barberini patrons. In this painting, Venus plays the famous harp commissioned by the Barberini family in around 1620 and used by the musician, who returned it to the papal family upon his death. The harp, now in the Museo degli strumenti musicali in Rome, is exceptional both for the decoration of the sumptuously carved pillar adorned with cherubs holding up the coat of arms, and from the musical point of view as it is of a rare type with three rows of strings.

The painting explicitly references the pleasure of the senses, in particular sight, hearing and touch. The goddess, depicted in a highly sensual way, moves in a theatrical atmosphere. Wrapped in a bright red drapery, her breasts are uncovered and her lips parted in song; in the act of plucking the harp with all her fingers (contrary to the Spanish custom which used only two fingers), she rests her bare right foot on a dainty slipper with a high cork sole while two cupids accompany her attentively with their song. Musical works and theatrical performances were an important component of the cultural life of the Barberini family. Before the construction of the theatre next to the palace by Pietro da Cortona (destroyed around 1930), these were held in the so-called Sala delle Comedie, the current Sala dei Marmi of the palace.

PN

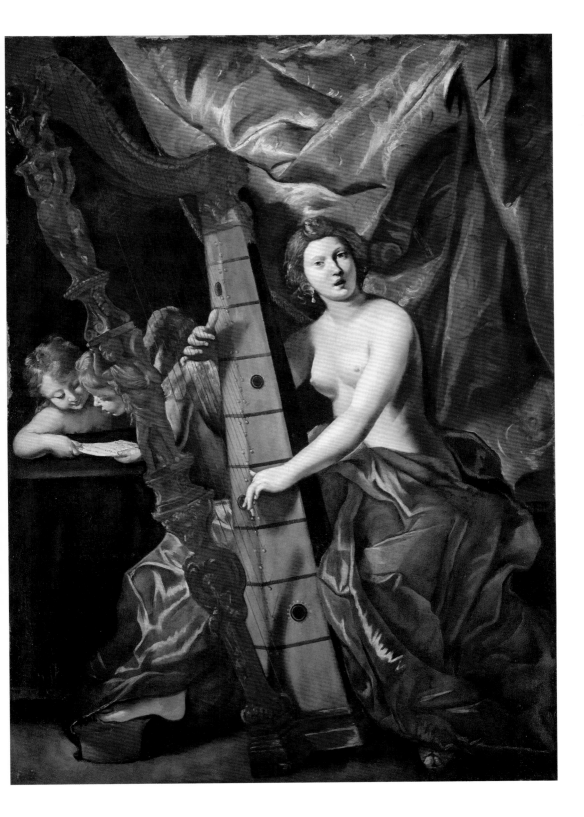

64 | Brother of the Cavalier Muti (Charles Mellin and Prospero Muti Papazzurri?)
(Nancy, ca. 1598–Rome, 1649; Rome, 1602–1653)

Allegory of Peace and the Arts Under the Barberini Papacy
1627
oil on canvas, 350 × 254 cm
Palazzo Barberini, inv. 2329 (purchased from the Barberini family, 1952)

Bibliography: E. Schleier, *Charles Mellin and the Marchesi Muti*, "The Burlington Maga-zine", 118, 1976, pp. 837–844; J. Thuiller, *Charles Mellin très excellent peintre*, in *Les Fon-dations nationales dans la Rome pontificale* ("Collection de l'École française de Rome"), 52, 1981, p. 604; Ph. Malgouyres, in *Charles Mellin, un Lorraine entre Rome et Naples*, cat. of the exhibition (Paris 2007), ed. by Ph. Malgouyres, Paris 2007, pp. 71–74 and 261; Y. Pri-marosa, *Giovanni Battista Muti Papazzurri (1604–1653) e Charles Mellin. Un "nobile dilet-tante" e un pittore lorenese alla corte dei Barberini*, "Storia dell'arte", 127, 2010, pp. 41–92.

In 1627, the sons of the Roman aristocrat Vincenzo Muti Papazzurri (1577–1633) gave Cardi-nal Francesco Barberini this extraordinary allegorical painting celebrating the glories of the papacy of Urban VIII. In September of that year, the inventories of the Pope's cardinal neph-ew record the acquisition of a "large painting made by the brother of the Cavalier Muti, 16 palms high and 12 palms wide with five large figures, in praise of peace." The author of the work mentioned in the document is a brother of the Cavalier Giovan Battista Muti Papazzurri (1604–1653), probably Monsignor Prospero (1602–1653), who became canon of St. Peter's in 1629 (Primarosa 2010). This amateur painter, previously wrongly identified as Marcantonio Muti, was likely responsible for devising the subject of the painting—with its sophisticated literary allusions—and for executing some parts of it under the careful guidance of its true author: the painter Charles Mellin from Lorraine, who is recorded as living from 1629 to 1631 at Palazzo Muti Papazzurri in Piazza Santi Apostoli.

Various paintings are attributed to the brush of the "Cavalier Muti" or that of his "brother" in the Barberini inventories. The expressions "made by" or "in the hand of" used to describe these works would seem to dispel any doubts as to the identity of their authors; yet, consid-ering the high quality of this painting and the stylistic heterogeneity of the other canvases hitherto identified, some uncertainties remain since it is not possible to ascribe their execu-tion wholly to the intermittent artistic activity of the two aristocrats.

The painting extols the everlasting glory of the Barberini family, working on behalf of peace and the arts: as Peace subjugates the instruments of War, we see the triumph of Music who plays the theorbo, Poetry crowned with laurel holding the trumpet of Fame, and Painting busy creating the image of Eternity. Below, the Barberini bees buzz around the legs of the easel while a fly—alluding to the illusory nature of painting—rests on the edge of the painted canvas. The depiction of Peace burning weapons—based on Dosso Dossi's *Circe* (or *Melissa*) in the Borghese collection—and the references to the Muses and to Apollo (the sculpture with the lyre at the top right) celebrate Barberini Rome as a sort of new Christian Parnassus. The work is thus a special tribute to the so-called "marvelous conjuncture" supported by the rul-ing Pope, a sort of manifesto of that memorable *speculum aureum* of the arts and sciences that marked the early years of Urban VIII's reign.

YP

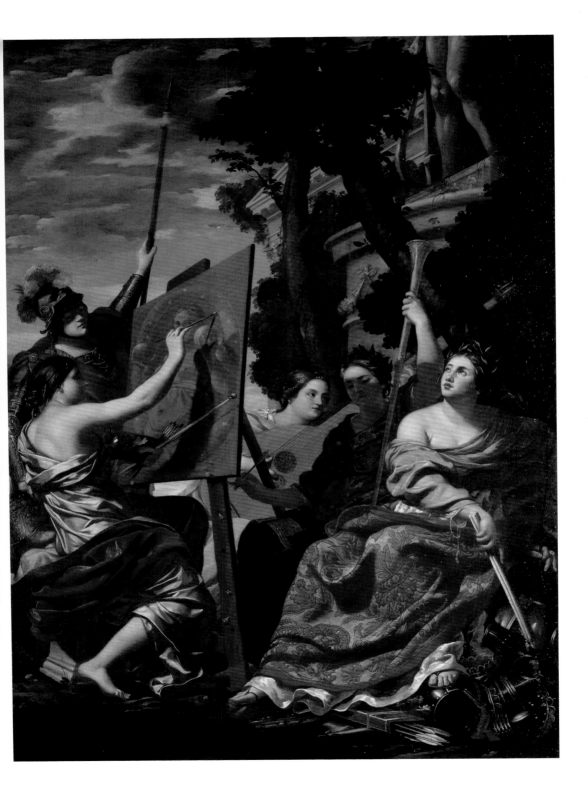

65 | Gian Lorenzo Bernini

(Naples, 1598–Rome 1680)

Portrait of Urban VIII Barberini

1632–1633
marble, h. 102 cm
Palazzo Barberini, inv. 5084 (collection of the Barberini heirs; acquired in 1969)

Bibliography: A. Bacchi, C. Hess, *Creating a New Likeness: Bernini's Transformation of the Portrait Bust*, in *Bernini and the Birth of Baroque Portrait Sculpture*, cat. of the exhibition (Los Angeles-Ottawa 2008–2009), ed. by A. Bacchi, C. Hess, J. Montagu, Los Angeles 2008, pp. 30–36; A. Bacchi, in *I marmi vivi: Bernini e la nascita del ritratto barocco*, cat. of the exhibition (Florence 2009), ed. by A. Bacchi, T. Montanari, B. Paolozzi Strozzi, D. Zikos, Florence 2009, pp. 246–248, no. 10; F. Petrucci, *I busti: dalla maturità all'addio della scultura*, in *Bernini*, cat. of the exhibition (Rome 2017–2018), ed. by A. Bacchi, A. Coliva, Milan 2017, pp. 306–308.

"It is a great fortune for you, O Cavaliere, to see Cardinal Maffeo Barberini become pope, but our fortune is even greater to have Cavalier Bernino living in our pontificate." With this remark, attributed to Pope Urban VIII, Filippo Baldinucci summarized the relationship of intimacy and mutual admiration that bound the sculptor to the pontiff. Bernini's biographer listed three marble portraits of Urban VIII by the artist's hand in Palazzo Barberini and this bust is identified as that also celebrated by Girolamo Tezi in the *Aedes Barberinae* (1642) as the "truly divine effigy of Pope Urban" and listed in the Barberini inventory of 1644. Gian Lorenzo is thought to have executed the portrait in the summer of 1632, while the pope was on holiday in Castel Gandolfo. Over the ten years of his pontificate, Bernini had carefully observed Urban's face and thus sculpted the effigy "with ease, with speed and without seeing the subject," making use of the painted portraits and sketches in which he had studied his features. The biographer revealed that Bernini "when portraying someone did not wish for him to stand still, but for him to move around and talk: because in this way [...] he saw all of his beauty and depicted him as he was." This practice was in line with the new Baroque aesthetic, according to which art is a celebration of the energy inherent in nature. The result was a new type of portrait sculpture that goes beyond traditional models aimed at communicating the pope's solemn and rhetorical formal role to create a "speaking likeness," so realistic as to make viewers feel that they are actually in the presence of the pope about to deliver a blessing. Urban VIII wears the camauro and a mozzetta slightly raised on the right shoulder; the eyes, whose irises and pupils are sculpted to capture the light, and express serenity and awareness; the lips seem about to part, the beard is unshaved and a button on the mozzetta is not fully fastened; the face is furrowed with barely suggested wrinkles, the cheeks are full and the head slightly turned. The informal pose, the rumpled drapery, the carefully studied staging of the light: all these elements allow the sculptor to replicate the pope's appearance with unsurpassed skill and clarity, but also to fix his movements and state of mind in stone, creating a naturalistic and anti-rhetorical portrait of the pope-poet, lively and intimate at the same time. This was the most perceptive bust of Urban VIII executed by Gian Lorenzo, in which "magnanimity and circumspection, imperiousness and melancholy mysteriously mingle in the gaze of Maffeo" (Bacchi), that intellectual pope who was a leading figure in 17th-century politics, formerly a friend of Galileo, and who ended his long reign in 1644 with the dramatic break between scientific research and Catholic orthodoxy.

PN

66 | Gregorio and Mattia Preti
(Taverna, 1603–Rome, 1672; Taverna, 1613–La Valletta, 1699)

Allegory of the Five Senses
1641–1646
oil on canvas, 174.5 × 363 cm
Palazzo Barberini, inv. 4660 (formerly Circolo ufficiali delle Forze Armate, gift from a member in the 1950s; donated to the GNAA by the Ministry of Defence on 23 June 2016).

Bibliography: J.T. Spike, *Gregorio Preti. I dipinti, i documenti*, Florence 2003, pp. 58–59; G. Leone, in *Gregorio Preti calabrese (1603-1672), un problema aperto*, cat. of the exhibition (Cosenza 2004), Cinisello Balsamo 2004, pp. 154–155; L. Calenne, *Le 'tenebre oneste' di Mattia Preti. Un simposio di amici di Galileo nell'"Allegoria dei cinque sensi" della collezione Barberini*, Rome 2016; Y. Primarosa, *Il talento e il mestiere. Nuova luce sull'"Allegoria dei cinque sensi" di Mattia e Gregorio Preti*, in *Il trionfo dei sensi. Nuova luce su Mattia e Gregorio Preti*, cat. of the exhibition (Rome 2019), ed. by Yuri Primarosa, Rome 2019, pp. 11–34 and 126–127 (with complete bibliography).

A painter, aged about forty, turns toward us with aristocratic magnanimity, as if inviting us to join in the cheerful drinking party taking place behind him: he is the Calabrian Gregorio Preti, brother of the more famous Mattia, who also collaborated on the execution of the work. The provenance of the painting from the Barberini collection is attested by the family's 17th-century inventories, which record "a horizontal painting with various portraits: an instrumentalist, a singer, a gambler, a drinker and someone cheating a companion, about 14 palms long and 8 palms high [...] by Mattia from Calabria." This document, dated 1686, is the first to attribute the work to Mattia alone, at a point when the latter had already for some time been more famous than his older brother. The 17th-century "connoisseurs" failed to notice the reference to the five senses underlying the allegorical scene: the lively musical performance on the left alludes to hearing, while the pipe smoker at the center recalls smell; the innkeeper and the drinkers illustrate the attributes of taste while the palm-reading scene alludes to touch. Finally, sight is celebrated by the brushes and palette of Gregorio Preti himself.

Gregorio executed his own self-portrait and the five figures at the center of the painting almost entirely single-handed: the foreshortened elderly drinker, the innkeeper, the waitress, the pipe smoker and the standing card player. Mattia worked on the seated boy playing a betting game, dressed in a tunic decorated with large slashes, and in part on the execution of the areas at the sides. Starting from the left, we can attribute to him the little monkey, the rather damaged lute player (perhaps executed in collaboration with Gregorio), the guitar player, the singer playing the virginal (perhaps also executed with his brother) and the inspired—but much

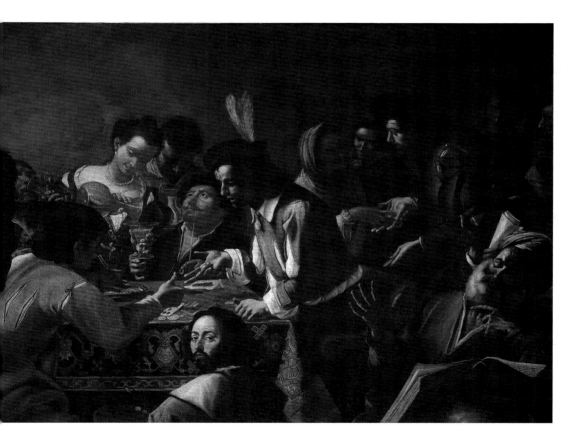

restored–violinist. Gregorio must also have participated in the painting of the harpist, as his stiff and simplified brush strokes seem to depart from the softer *ductus* of Mattia. On the right-hand side, by contrast, we can identify the manner of Preti *iunior* in the gypsy woman and in the imprudent gentleman whose palm she is reading. Finally, Gregorio must have worked (with Mattia?) on the execution of the two philosophers on the far right: Heraclitus and Democritus. The latter, holding a large book resting on a globe, believed that there were two distinct forms of knowledge: an authentic form resulting from the intellect and an inauthentic form deriving from the senses. The philosopher thus laughs at the vanity of worldly things, like the monkey on the top left, an allusion to the stupidity of the human race. By contrast, Heraclitus appears glum and scowling, as the philosopher of becoming unable to take his eyes off the tragic fragility that destroys all things. The laughter and tears of the two ancient thinkers, symbolically contrasted, warn us of the limitations of knowledge attained through the senses, inviting us to go beyond the appearances created by empirical reality.

(Taverna, 1613–La Valletta, 1699)

The Tribute Money
ca. 1638–1642
oil on canvas, 123 × 173 cm
Galleria Corsini, inv. 117

Bibliography: J.T. Spike, *Mattia Preti. Catalogo completo dei dipinti*, Florence 1999, pp. 256–257; S. Alloisi, in *Mattia Preti tra Roma, Napoli e Malta*, cat. of the exhibition (Naples 1999), ed. by M. Utili, Naples 1999, pp. 94–95; A. Cosma, in *Il cammino di Pietro*, cat. of the exhibition (Rome 2013), ed. by A. Geretti, S. Castri, Milan 2013, pp. 64–65; G. Leone, in *Mattia Preti. Un giovane nella Roma dopo Caravaggio*, cat. of the exhibition (Rome 2015–2016), ed. by G. Leone, Soveria Mannelli 2016, pp. 91–93 (with preceding bibliography).

The work depicts an episode recounted in the Gospel of Matthew (17, 24–27), in which a tax collector asks Peter, who has arrived in Capernaum with the apostles, if Jesus will pay the tax for the temple in compliance with Jewish law. Christ then orders Peter: "Go to the lake and throw out your line. Take the first fish you catch; open its mouth and you will find a silver coin. Take it and give it to them for my tax and yours." The story highlights Peter's pre-eminent role and indeed figurative representations of this episode, particularly common in 17th-century painting, always make him a leading figure by depicting him intent on taking the coin from the fish or in conversation with Christ. By contrast, Mattia Preti, chooses the moment when the tribute is paid, adopting a horizontal composition with half-length figures directly inspired by the models of Caravaggio and the interpretation of his style by his early Roman followers such as Bartolomeo Manfredi or the young Ribera.

The whole composition is thus organized around the tax collector's table on which the fish is prominently displayed in the foreground, ensuring that the story is recognizable. Through the gesture and gaze of Christ, the painter guides the viewer toward the center of the scene, while the light entering from the left emphasizes the protagonists and the most important

details: the tax collector with the elegant plumed hat and ruff, an evident reference to the Caravaggesque updating of sacred scenes; Peter's gesture as he pays the tax; the astonishment of the apostle in the foreground, staring fixedly at the fish as he puts his hand into its belly; and finally the figure of Christ, the focal point of the entire composition.

The strong Caravaggesque overtones of the work, mediated by the influence of Guercino's paintings, date it to between the end of the fourth and the beginning of the fifth decade of the 17th century, when the Calabrian painter looked with increasing attention to the Bolognese artist. Unfortunately, however, we have no information on the origins of the work, which appears for the first time in 1679 in the inventory of the properties of Cardinal Neri Maria Corsini *senior* in the villa of

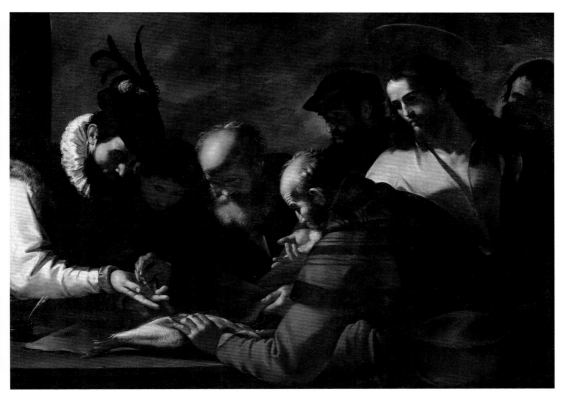

San Pancrazio on the Janiculum. The document notes that the painting previously belonged to Stefano di Castro, the cardinal's secretary and head of his household staff, who donated his collection to the Corsini family upon his death. Having probably remained in the villa on the Janiculum, the canvas was only put on display in the painting gallery in the 19th century, when—significantly—it was attributed to Caravaggio.

AC

(Taverna, 1613–Valletta, 1699)

Flight from Troy

ca. 1640–1645
oil on canvas, 186 × 153 cm
Palazzo Barberini, inv. 1154

Bibliography: R. Longhi, "L'Arte", 15, 1916, p. 371; J.T. Spike, *Mattia Preti. Catalogo completo dei dipinti*, Florence 1999, p. 253; G. Leone, in V. Sgarbi, *Mattia Preti*, Soveria Mannelli 2013, p. 68; R. Vodret, in *Mattia Preti. Un giovane nella Roma dopo Caravaggio*, cat. of the exhibition (Rome 2015–2016), ed. by G. Leone, Soveria Mannelli 2016, pp. 39–41; L. Calenne, in *Il trionfo dei sensi. Nuova luce su Mattia e Gregorio Preti*, cat. of the exhibition (Rome 2019), ed. by Y. Primarosa, Rome 2019, pp. 160–165 (with preceding bibliography).

The canvas depicts the nocturnal flight of Aeneas from Troy, now fallen and conquered by the Greeks as narrated by Virgil in the second book of the *Aeneid*. Against the backdrop of the burning city, the hero carries on his shoulders his old father Anchises, who holds in his hand the statuette of the Penates, the spirits who protected the family. In front of him is the young Ascanius, running ahead of his father as if urging him to flee, while Creusa can be glimpsed in the dim light, turning back to remind us that she will lose her way during the night and be unable to embark with the others.

The subject was particularly popular between the late 16th and mid-17th century, thanks to the episode's connections with the foundation of Rome—after landing in Latium with his father, Ascanius founded Alba Longa, the city in which Romulus and Remus were born. The choice of this topic thus allowed patrons to celebrate the city's illustrious lineage and legitimize its greatness. During the early decades of the 17th century, moreover, the medieval revival of the links between Aeneas, the supremacy of Rome and that of the pope led to renewed interest in the subject, giving rise to masterpieces such as the marble version created by Bernini for Scipione Borghese. Indeed, the parallels with Bernini's sculpture are one of the main features of the painting by Preti, who models his figures like monumental statues, placing them on a carved threshold that functions almost like a base and against an enormous fluted column. At the same time, however, Preti contrasts the fixed pose of Aeneas, leaning steadily on his spear, with the dynamism of Ascanius, clearly inspired by another of Bernini's sculptures, the Borghese *Apollo and Daphne*. In his free use of different models, Preti thus demonstrates the ability to supersede the allusions to naturalism and to the works of Caravaggio that had characterized the initial phase of his career in Rome alongside his brother Gregorio.

The painting therefore fits easily into that series of large-scale works created by the painter in Rome in the first half of the 1640s, such as the *St. Catherine* executed for the Barberini family and now in Dayton, or the *St. Pantaleon Healing the Sick* now in a private collection but originally in the Roman church of the same name. Although its size and high quality imply that the *Flight from Troy* also had an important patron, the work is not mentioned by any of the sources; the first reference to it is in the inventory of the Torlonia collection of 1819, where it was attributed to the French painter Simon Vouet. Only after the collection passed to the Italian state, in 1892, was it correctly assigned to Mattia Preti by Roberto Longhi.

AC

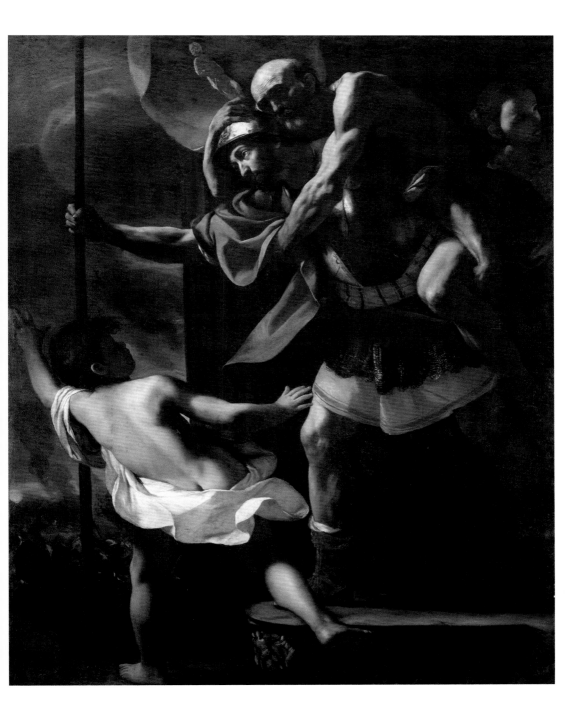

The Parting of St. Peter and St. Paul on the Road to Martyrdom

1645–1650
oil on canvas, 102 × 127.5 cm
Palazzo Barberini, inv. 1485 (purchased from I. Diodati, 1909)

Bibliography: F. Hermanin, *Gli acquisti della Galleria Nazionale d'Arte Antica in Roma. I qua-dri d'arte meridionale*, "Bollettino d'arte", IV, 1910, pp. 225–235; A.T. Lurie, *Bernardo Cavallino: Adoration of the Shepherds*, "The Bulletin of the Cleveland Museum of Art", 56, 4, 1969, pp. 136–150; A. Percy, in *Bernardo Cavallino of Naples. 1616–1656*, cat. of the exhibition (Cleveland-Forth Worth 1984-1985), ed. by A.T. Lurie, A. Percy, Cleveland 1984, pp. 156–157; R. Vodret, in *Caravaggio e i suoi. Percorsi caravaggeschi da Palazzo Barberini*, ed. by C. Strinati, R. Vodret, Rome 1999, p. 108; N. Spinosa, *Grazia e tenerezza in posa. Bernardo Cavallino e il suo tempo. 1616–1656*, Rome 2013, pp. 338–339.

Since its purchase by the Italian state on the Neapolitan antique market in 1909, the painting has unanimously been attributed to Bernardo Cavallino and equally unanimously, but erroneously, its subject identified as the scene in which the centurion Cornelius is baptized by St. Peter, drawn from the Acts of the Apostles (10, 25–48). In fact, Cavallino's painting depicts the parting of St. Peter and St. Paul, at the precise moment when the roads of the two apostles, led to martyrdom together from the Mamertine prison, divided on the Via Ostiense. This episode is frequently mentioned in the hagiographical sources, from the *Legenda aurea* to the annals of Baronio, and a small church had even been erected at the presumed location of their final embrace. Also known as the Chapel of the Separation it was rebuilt already in 1568 by the Arciconfraternita della Trinità dei Pellegrini e Convalescenti before being definitively demolished in the early 20th century.

The painter places us before this crossroads, marked by the bifurcation in the road. The crowded procession of soldiers and onlookers halts for a moment and the dapper officer leading it, in an overly affected pose on the right, allows the two condemned men to exchange a final farewell. At the same time, the soldier on horseback, boldly outlined on the opposite side, is already point-

ing out the way and the imminence of their martyrdom. Peter, though his wrists are bound, blesses his companion, who bows his head in reverence with hands clasped, already almost prostrate beneath the sword that the executioner immediately behind him carries over his shoulder. According to the apocryphal account ascribed to Dionysius the Areopagite, Paul was believed to have said to Peter: "Pax tibi, fundamentum Ecclesiarum", to which the latter replied: "Vade in pace Praedicator bonorum".

The solemn and moving occasion is captured with composed elegance and an extraordinarily sober use of drawing, lighting and coloring techniques. Peter's right hand occupies the geometrical center of the canvas and the figures in the foreground are highlighted by the rhythmic alternation of light and shade. Acting as a counterpoint is the level position-

ing of the faces of the onlookers in the middle ground, characterized by an astutely concise but realistic execution; some turn a silent and perplexed gaze on the viewer, forming a composition that almost seems reminiscent of Velázquez. The didactic and exemplary nature of the image, as is usually the case with scenes of martyrdom, is underscored on the right by a bearded man who calls two perhaps overly distracted children to attention next to the fluted column set on a corner stone, a possible allusion to Peter's primacy as the "foundation of the churches," expressly acknowledged by Paul.

MDM

70 | **Salvator Rosa**
(Naples, 1615–Rome, 1673)

The Torment of Prometheus
ca. 1645–1650
oil on canvas, 224 × 179 cm
Galleria Corsini, inv. 484

Bibliography: L. Salerno, *L'opera completa di Salvator Rosa*, Milan 1975, p. 147; C. Volpi, in *Salvator Rosa tra mito e magia*, cat. of the exhibition (Naples 2008), Naples 2008, pp. 148–149; F. Conte, *Tra Napoli e Milano. Viaggi di artisti nell'Italia del Seicento, II, Salvator Rosa*, Florence 2014, pp. 141–149, 565–569; C. Volpi, *Salvator Rosa (1615-1673) "pittore famoso"*, Rome 2014, pp. 192–197, 451–452; S. Parca, in *Rubens e la nascita del barocco*, cat. of the exhibition (Milan 2016–2017), ed. by A. Lo Bianco. Venice 2017, p. 212 (with preceding bibliography).

Prometheus, a figure from classical mythology, was a Titan and a benefactor of humanity to whom he secretly restored the fire that Zeus had taken from them. For this act, he was condemned by the father of the gods to an eternal torment: tied to a rock in the Caucasus, he was tortured every day by an eagle that devoured his liver, which then grew back during the night, in an endless punishment.

Salvator Rosa chooses to depict the most tragic moment of the myth, with Prometheus bound to the rock by heavy chains, while the bird of prey has already torn open his abdomen and is devouring his entrails. The writhing of the limbs tormented by pain and the terrible and desperate scream of the Titan perfectly render the atrocity of the torture, whose impact on the viewer is heightened by the painter's virtuoso focus on the innards, probably the result of a direct study of human anatomy. The trickle of blood that stains the rock and runs down to the foot then leads the viewer's gaze to the lighted torch, symbolizing the fire that Prometheus brought back to humans and the reason for his torture. On the left, the painter's signature—ROSA—stands out proudly, indicating the importance that the painting must have held for the artist.

The work was almost certainly executed during the painter's time in Florence (1640–1649), as confirmed by some writings by the Venetian scholar Gabriele Vendramin, who met Salvator Rosa in the Tuscan city. He dedicated two poems and a letter to the *Prometheus*, praising the artist's ability to arouse emotions in the viewer through the power and drama of the work: "every time I look at your marvelous Prometheus, it seems to me that the eagle is tearing out my heart rather than his."

Unfortunately, we do not know who first commissioned the painting, which was in Rome in 1683, in the collection of the banker Carlo de Rossi, another friend of Salvator Rosa and his great admirer. It later entered the collection of Cardinal Lorenzo Corsini, the future Pope Clement XII, and was hung in the Palazzo alla Lungara, purchased by the family in 1736, in the apartments of Duke Bartolomeo, who oddly chose to keep it in his bedroom. Cardinal Neri Maria Corsini later selected it for display in the painting gallery and from then on it became one of the most hotly debated works in the collection (the 19th-century sources mention that women all turned away in disgust at the sight of that "terrible" spectacle).

Restoration has shown that the work was composed of two pieces of canvas sewn together, of which that on the right was certainly reused, since the face of a boy in profile wearing a shirt is clearly visible in the sky above the mountains in the background.

AC

Pietro Berrettini, called Pietro da Cortona
(Cortona, 1597–Rome, 1669)

Guardian Angel

1656
oil on canvas, 225 × 143 cm
Palazzo Barberini, inv. 1753 (1918, purchased from the Chigi collection)

Bibliography: A. Lo Bianco, in *Pietro da Cortona 1597–1669*, cat. of the exhibition (Rome 1997), ed. by A. Lo Bianco, Milan 1997, pp. 372–373, no. 56; Marta Variali, *Nuove ricerche sulla grafica sottogiacente di alcuni dipinti romani di Pietro da Cortona*, master's thesis in art-historical heritage, Sapienza Università di Roma, 2019, pp. 65–70, 94–95.

"We owe to him the restoration and decoration inside and out of the church of the Pace, whose very graceful portico pleased the high intellect of Alexander VII so much that [...] he honoured him with the title of knight. As a token of his appreciation, Pietro gave two paintings to the Pontiff, one depicting the Guardian Angel, and the other the Archangel Michael, and His Holiness reciprocated with a rich cross hanging from a richer gold necklace." This, according to the biographer Lione Pascoli (1674–1744), is the story of the canvas that Cortona painted in 1656 to thank Pope Alessandro VII Chigi for conferring upon him the title of Knight of the Golden Spur, granted as a mark of esteem for his restoration of the church of Santa Maria della Pace. We also know that the painting later passed into the painting gallery of the cardinal nephew Flavio Chigi and that it was displayed in 1692 at the exhibition of paintings held in the cloister of San Salvatore in Lauro. Although the biographer reports the name of the pope and the year of execution of the canvas accurately, the suggestion that it was a gift from the artist is contradicted by the documents relating to the painting, which mention a payment to the painter of five hundred *scudi*.

 The work depicts a subject closely linked to popular devotion whose iconography, borrowed from the story of the archangel Raphael and the young Tobias, takes shape during the 17th century as the image of an angel who rises up from the ground to greet a young boy and, taking him by the hand, protects him from the devil and guides him, pointing out the righteous path from birth to death. The cult of guardian angels became newly popular thanks to its inclusion in the liturgical calendar by Paul V in 1615, to the extent that the faithful addressed a morning prayer to the archangel Raphael asking him to protect them from diseases and during travel, as he had done with the young Tobias.

 The singular beauty of the angel, accentuated by the silvery and iridescent surface of the fabrics and the gestures of the figures, in harmony with the sentimental landscape, make this painting a masterpiece of the artist's mature period. The theatrical composition is reminiscent of the stage sets designed by Cortona for the inauguration of the Palazzo Barberini theatre in 1632, when the chronicles record "angels speaking and flying through the air" during the performance of the melodrama.

 The diagnostic tests carried out on the painting have brought to light a dynamic and vigorous technique, with fluid brushstrokes reinforced layer after layer with an alternation of fine and broader strokes to define the essential lines of the faces and some details (like the wings of the angel). These brushstrokes are combined with details added only in the final version (such as the third couple in the background at the bottom left), since Cortona uses the initial drawing as a compositional, creative, and flexible tool, with respect to which every modification is no longer a *pentimento* but rather an element used to construct and define the form as it takes shape.

PN

Cynic Philosopher (Crates)

ca. 1660–1665
oil on canvas, 113.5 × 90 cm
Palazzo Barberini, inv. 1254 (1875, Monte di Pietà)

Bibliography: D. Fitz Darby, *Ribera and the Wise Men*, "The Art Bulletin", 44, 4, 1962, pp. 279–307; O. Ferrari, G. Scavizzi, *Luca Giordano. L'opera completa*, Naples 1992, p. 271; R. Vodret, in *Caravaggio e i suoi*, cat. of the exhibition (Rome 1999), ed. by C. Strinati, Naples 1999, pp. 104-105; D.M. Pagano, in *Luca Giordano (1634–1705)*, cat. of the exhibition (Naples 2001), Naples 2001, pp. 82–83.

The painting, depicting an ancient philosopher, is one of the finest works executed by Luca Giordano during the 1660s, shortly after the artist had developed an original interpretation of the naturalistic teachings of Jusepe de Ribera (1591–1652). Indeed, the broad dissemination in Naples of series portraying the philosophers and wise men of antiquity was closely connected to the production of *lo Spagnoletto*, who was responsible for codifying a true genre, strongly influenced by the painting style of Caravaggio. Giordano's revival of Ribera in 1660–1665 made reference to some masterpieces executed by the Spanish artist in the third decade of the century, like the *Drunken Silenus* at Capodimonte, the *Martyrdom of St. Andrew* now in Budapest or the *Martyrdom of St. Bartholomew* in Palazzo Pitti. Of these paintings, Giordano emulated the "heroic" dignity of the figures of old men and the dramatic force of the composition, which he attempted to intensify still further by imbuing the gestures and expressions of the figures with a Baroque theatricality. This revival of Caravaggio waned between the end of 1665 and the early months of 1666, immediately after Giordano's visit to Venice between the spring of 1664 and the start of the following year.

The 19th-century identification of the work as a portrait of a "master mason" or "carpenter" was legitimized by the unkempt appearance of the philosopher, shown in an intentionally ambiguous image of strong emotional impact. In 1962, Delphine Fitz Darby more correctly identified it as an imaginary portrait of Crates, the most famous student of Diogenes the Cynic, recalled in the ancient sources for his ugliness. The philosopher, who lived in Athens in the 5th century BC, presents the attributes traditionally assigned to scholars (the compass, paper, and pens) and to wise men (the walking stick), while the pouch tied to his belt alludes to the handouts for which he habitually begged in order to eat. Crates had given up his large family estate to follow in the footsteps of his master, who had also abandoned worldly things to devote himself wholly to the search for truth.

YP

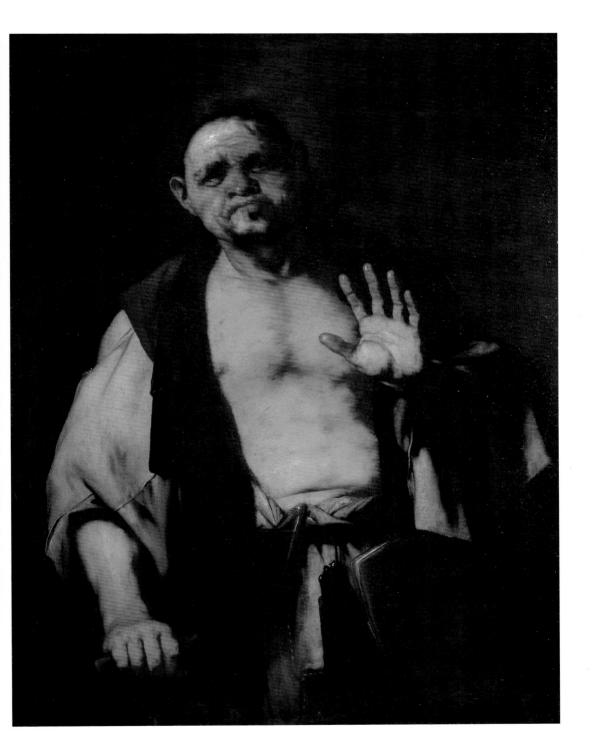

73 | **Luca Giordano**
(Naples, 1634–1705)

Disputation of Jesus Among the Doctors

ca. 1660–1670
oil on canvas, 219 × 298 cm
Galleria Corsini, inv. no. 394

Bibliography: A.M. Tantillo, *Una residenza di cardinali*, in *Palazzo Valentini*, ed. by G. Farina, Rome 1985, p. 207; O. Ferrari, G. Scavizzi, *Luca Giordano. L'opera completa*, Milan 1992, pp. 10, 260; M. Utili, in *Luca Giordano 1634–1705*, cat. of the exhibition (Naples 2001), ed. by O. Ferrari, Naples 2001, pp. 126–127; G. Scavizzi, G. de Vito, *Luca Giordano giovane 1650–1664*, Naples 2012, p. 53; G. Scavizzi, *Luca Giordano. La vita e le opere*, Naples 2017, pp. 30–31.

The Gospel of Luke (2, 41–50) relates that St. Joseph and Mary, after travelling to Jerusalem for Passover, began their return journey without noticing the absence of the young Jesus, then twelve years old.

Back in the city, they found him inside the temple, intent on arguing with the doctors of the law, where "everyone who heard him was amazed at his understanding and his answers."

Luca Giordano's painting depicts this episode, with Mary and St. Joseph—on the top right—bursting into the temple as Jesus sits on a chair, arousing different and opposing reactions in those present. Whilst the man with the hat seems enraptured by his words, his neighbor with his hands resting limply on his lap appears oblivious and indifferent. The three doctors on the left have alarmed and worried expressions, ready to fight back, seeking answers and comfort in their books. Those same books, left heaped on the ground in an extraordinary still life, clarify the meaning of the Gospel passage and the distance between the words of Christ and the empty and literal wisdom of the doctors of the temple.

Executed in Naples during the seventh decade of the 17th century, the complex composition devised by Luca Giordano demonstrates the young Neapolitan painter's ability to blend a variety of influences, from that of the older and more established Mattia Preti—active

in Naples at the same time—to the teachings of the great Venetian painters Tintoretto and Veronese, in a work whose rapid execution foreshadows the nickname "Luca fa presto" ("Luca paints quickly") later given to him by the sources.

Unfortunately, we do not know the original patron of the painting, which in the 18th century entered the collection of Cardinal Giuseppe Spinelli, archbishop of Naples from 1734 to 1754. Upon his return to Rome, the work was placed in his residence in Piazza Santi Apostoli together with other paintings by Giordano, including the *Expulsion of the Merchants from the Temple* now in Greenville, which probably served as its companion piece. In his will of 1763, Spinelli gave instructions to donate the painting to Cardi-

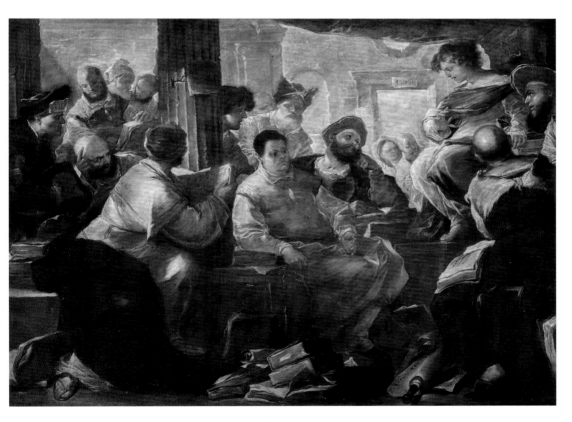

nal Neri Maria Corsini as a tribute to the family that had elevated him to the rank of cardinal and supported him on more than one occasion. Neri Maria therefore decided to hang it in the antechamber of his apartments in the Lungara palace where its monumental dimensions, intended for public display, ensured its immediate visibility. The Corsini family's appreciation for Luca Giordano dated back to the previous century, when they asked the Neapolitan artist to decorate the family chapel in the church of the Carmine in Florence (1682).

AC

74 | Bartolomé Esteban Murillo
(Seville, 1618–1682)

Nursing Madonna
ca. 1670–1675
oil on canvas, 164 × 107.5 cm
Galleria Corsini, inv. 464

Bibliography: D. Angulo Iñiguez, *Murillo. Catalogo critico*, Madrid 1981, pp. 163–164; E. Valdivieso, *Murillo. Catálogo razonado de pintura*, Madrid 2010, pp. 193–194; A. Cosma, *Verso un nuovo fedecommesso. Vicende del palazzo e della collezione Corsini tra dispersioni, restauri e riallestimenti (1795–1829)*, in *Storie di Palazzo Corsini. Protagonisti e vicende nell'Ottocento*, ed. by A. Cosma, S. Pedone, Rome 2016, p. 22; S. Pedone, *Sguardi e copie. I capolavori della Corsini visti dai pittori dell'Ottocento*, ibid., pp. 79–80; P. Nicita, in I. Cano Rivero, M. del Valme Muñoz Rubio, *Murillo IV Centenario*, cat. of the exhibition (Seville 2019), ed. by I. Cano Rivero, M. del Valme Muñoz Rubio, Seville 2019, pp. 160–162; *La Madonna del latte di Murillo alla Galleria Corsini. Storia e restauro*, ed. by A. Cosma, Venice 2021 (with preceding bibliography).

"I am in love with Murillo's Virgin in the Corsini Gallery. Her head haunts me and her eyes constantly pass before me like two dancing lanterns." With these words, in a letter to his friend Louis Bouilhet, the famous writer Gustave Flaubert described his response to the painting seen during his stay in Rome in 1851. His feelings were echoed by many other 19th-century visitors, who recollect in their diaries, letters and even newspaper articles the effect produced by Murillo's work, at the time one of the most admired—and copied—in the Corsini collection.

The "Gypsy Madonna," as the German historian Carl Justi called it, is one of the best examples of the Spanish painter's ability to update religious subjects and bring them to life. The whole composition is constructed around the Virgin and Child, clearly depicted as commoners and placed in a deliberately vague outdoor setting. Mary's bare breast alludes to the well-known iconography of the *Nursing Madonna*. Here, however, the attitude of the figures transforms the devotional image into a real episode of earthly life, of which the viewer is also a protagonist: surprised by our arrival, Mary and the Child interrupt what they are doing and turn to look at us with the profound and magnetic eyes that so profoundly struck the 19th-century imagination.

The work was most likely executed in Seville between 1670 and 1675. X-ray scans have revealed the existence of a kneeling *St. Francis* beneath the current painting, which Murillo decided to abandon to paint the Virgin and Child. He painted over the earlier work without further preparations, even reusing some parts, such as the tree to create the shadows on the wall or the folds in Francis' tunic for Mary's dress.

The painting entered the Corsini collection as a bequest to Cardinal Neri Maria Corsini from Gian Bernardino Pontici (died 1764), a consistorial advocate, poet belonging to the Academy of Arcadia and personal secretary to the cardinal for over thirty years. Placed by Neri Maria in his bedroom, where the famous French painter Jean-Honoré Fragonard saw it in 1773, it was later moved to the new audience hall by Cardinal Andrea, a mark of the appreciation that the painting must have enjoyed among members of the family. This appreciation is also attested by the tumultuous events following the French invasion of Rome and the establishment of the Roman Republic in 1799. The painting was sold together with twenty-five other works by the chief of the Corsini's household staff to pay the forced taxes imposed by the French, receiving one of the highest valuations. The works were purchased by the English merchant William Ottley to be sent to London; only the intervention of Prince Tommaso Corsini prevented the export of some paintings—including Murillo's *Madonna* and Guido Reni's *Salome*—, which were returned to the family's Roman palace.

AC

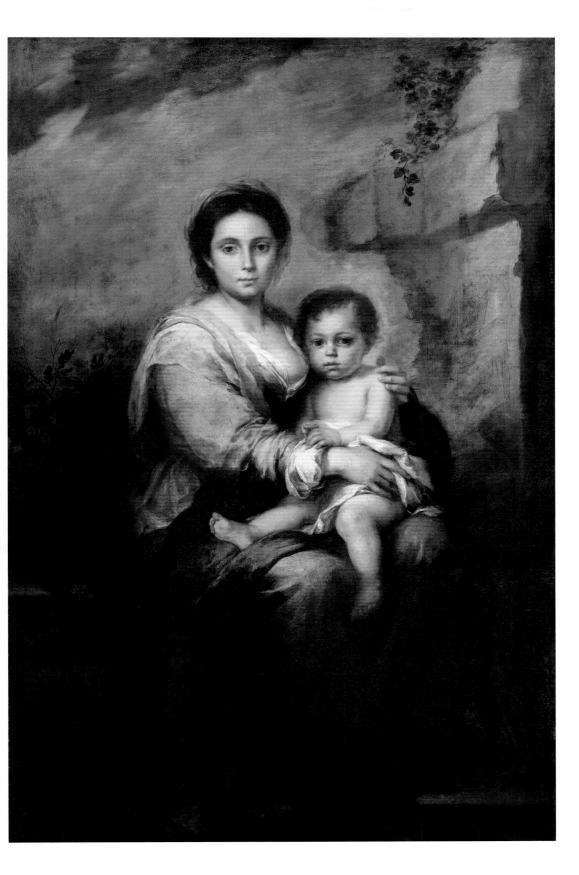

75 | **Gian Lorenzo Bernini, attributed to**
(Naples, 1598–Rome, 1680)

Bust of Alexander VII Chigi

1657
Terracotta, 64 × 75 × 35 cm
Galleria Corsini, inv. 2459 (formerly Pollak and Muñoz collections, 1939)

Bibliography: V. Martinelli, *I ritratti di pontefici di G.L. Bernini*, "Studi romani", 1956, 1, pp. 43–48; F. Petrucci, *Gian Lorenzo Bernini per Casa Chigi: precisazioni e nuove attribuzioni*, "Storia dell'arte", 90, 1997, pp. 176–200; A. Angelini, *Il busto marmoreo di Alessandro VII scolpito da G.L. Bernini*, "Prospettiva", 89–90, 1998, pp. 183–192; O. Ferrari, in *Gian Lorenzo Bernini. Regista del Barocco*, cat. of the exhibition, ed. by M.G. Bernardini, M. Fagiolo dell'Arco (Rome 1999), Milan 1999, pp. 341–342, no. 56.

With this bust of the Sienese Pope Alexander VII (1655–1667), Bernini celebrated the great friend and cultured protector with whom he had shared a vision for art, and the enlightened patron who had commissioned from him the grandiose projects that marked the peak of his career and that helped to profoundly influence the face of Baroque Rome.

The terracotta belongs to the complex and in some ways still mysterious series of events surrounding the various busts of the Pope completed by the master, of which the sources document a number of versions made in various materials and much debated by critics. The fine terracotta bust in the Galleria Corsini lies almost at the start of this sequence, which ends with the large image of the Pope kneeling at his tomb in St. Peter's for which Bernini supplied drawings and models, but that was actually executed by Michel Maille.

This is probably the first bust of the Pope, unfinished and summarily modelled in its essential outlines, a preliminary work for a lost marble as noted by the Pope in his diary for 1657, where the preparatory function of the clay model is described. Indeed, the terracotta presents all the hallmarks of a bozzetto: the rapid strokes of the toothed spatula furrowing the cheeks, neck and mozzetta to create sharp lines of shadow are evident, as are the fingerprints left by the artist as he returned to areas that had already been worked to create deeper depressions or to flatten out thicknesses or edges, making little alterations as he worked.

In accordance with the typology of the official portrait, the Pope wears the camauro and a mozzetta with a broad stole draped over it. His facial features are rendered with a striking, almost caricatural exaggeration that can be explained only by the confidential relationship between the artist and this powerful man. It has rightly been noted that portraits such as this, with their extraordinary modelling and felicitous intensity of expression, paved the way for a new type of portrait often imitated by Bernini's students, especially in the rendering of the cord of the stole hanging to the left and the rumpled mozzettas, puffed out to one side with respect to the soft and natural draping of the fabric.

The bust was formerly in the collection of Bartolomeo Cavaceppi and then in the Pollak and Muñoz collections before finally reaching the Galleria Nazionale.

TC

(Genova, 1639–Rome, 1709)

Apotheosis of St. Ignatius

1683-1685
oil on canvas, 48.5 × 63.5 cm
Palazzo Barberini, inv. 1470 (1907, O. Fallani purchase)

Bibliography: Oreste Ferrari, *Bozzetti italiani dal Manierismo al Barocco*, Naples 1990, pp. 41–44; D. Graf, in *Les Cieux en Gloire*, cat. of the exhibition (Ajaccio 2002), ed. by J.M. Olivesi, Ajaccio 2002, p. 282, no. 53; F. Petrucci, *Baciccio. Giovan Battista Gaulli 1639–1709*, Rome 2009, pp. 236–238, 487–490 with preceding bibliography; F. Petrucci, *Ecclesia Triumphans tra Maratti e Baciccio*, in *Barocco a Roma. La meraviglia delle arti*, cat. of the exhibition (Rome 2015), ed. by M.G. Bernardini, M. Bussagli, Milan 2015, pp. 184–195.

In this preparatory work for the fresco in the chapel of St. Ignatius of Loyola in the church of the Gesù, the protagonist, dressed in a white chasuble with gold embroidery, is wrapped a blaze of light, while around him sinuously-shaped angels move gracefully, scattering flowers. A joyous and airy harmony, already 18th-century in tone, fills the painting. The warm colors of yellow and red, accentuated by the chiaroscuro contrasts with the dark clouds, amplify the effect of heightened brilliance. The decoration of the church of the Gesù, one of the most important religious buildings of the Counter-Reformation—where the founder of the Jesuits, canonized in 1662, is buried—was the most important worksite in Gaulli's career. The building, with its vast single nave, represented the model of the Counter-Reformation church, imitated by all the orders, and was disseminated internationally from France to Latin America thanks to the architects of the Society of Jesus. The same influence was exerted by the spectacular illusionistic decoration designed by the Genoese painter in accordance with the new taste of the High Baroque. Gaulli obtained the prestigious commission thanks to his friend Bernini, who put him in contact with the General of the order, Father Giovan Paolo Oliva, of Genoese origin like the artist. The prelate provided Gaulli with the theological references, in accordance with the Baroque vision of public devotion, aimed at a deeply religious society.

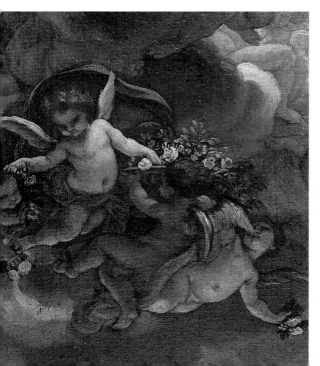

Focused on the theme of the salvation of humankind, Gaulli adopted the rhetorical language of allegory to represent the *Church Triumphant* on the dome, with the saints and blessed of the religious orders, and of the *Church Militant* on the vault, glorifying the missionary work of the Jesuits in the world. Bernini had general oversight of this theatrical visual program, translated by Gaulli into images with a strong emotional component. From 1672, the painter frescoed the dome, vault, and apse, and designed the stucco figures for the building, creating about twenty preparatory works for the undertaking. His efforts ended with the decoration of the chapel, following the typical sequence of Baroque altars, with the saint portrayed in the

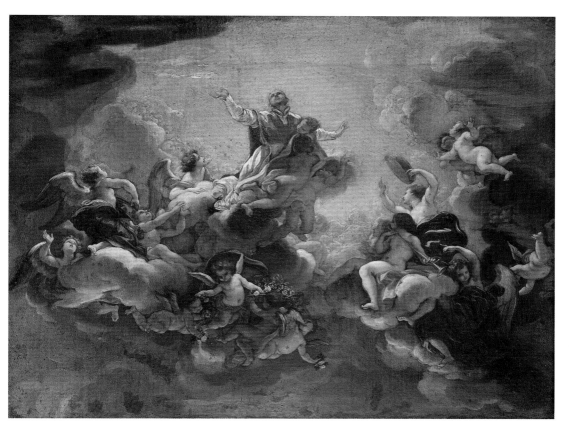

altarpiece by Anton Van Dyck (now in the Vatican Pinacoteca), his remains preserved in a bronze urn and the *Apotheosis of St. Ignatius* in the fresco on the vault, in other words, life, death and resurrection. As was his usual practice, Baciccio prepared some sketches or preliminary test paintings as the experimental phase of his creative process, moving toward the final work. The variations with respect to the fresco are mainly chromatic and to a lesser extent compositional, as in the angel with the trumpet, naked in the sketch and covered by a drapery in the fresco.

PN

(Rome, 1621–1691)

David with the Head of Goliath

ca. 1658–1659
oil on canvas, 153 × 119.5 cm
Palazzo Barberini, inv. 835 (donated by the Torlonia family, 1892)

Bibliography: A. Pampalone, *Per Giacinto Brandi*, "Bolletino d'arte", 58, 1973, 2–3, p. 138; G. Sestieri, *Repertorio della pittura romana della fine del Seicento e del Settecento*, Turin 1994, I, p. 37; R. Vodret, *Primi studi sulla collezione dei dipinti Torlonia*, "Storia dell'arte", 1994, 82, pp. 367, 399, 410; R. Vodret, in *Galleria Nazionale di Arte Antica. Palazzo Barberini. I dipinti, catalogo sistematico*, ed. by L. Mochi Onori, R. Vodret, Rome 2008, p. 105; G. Serafinelli, *Giacinto Brandi 1621–1691. Catalogo ragionato delle opere*, Turin 2015, II, pp. 40–41 (with preceding bibliography).

During the battles to conquer the land of Canaan, the Israelites clashed on several occasions with the Philistines, whose army included the fearsome giant Goliath. During one of these clashes, Goliath challenged Saul's army, proposing a duel that would decide victory in the war. The challenge was accepted by the young shepherd David, who offered to fight the Philistine giant armed only with a sling and defeated him with a blow to the forehead. After seizing the enemy's sword, David decapitated him, thus ensuring the Israelite victory. Word of his deed spread immediately, and on his return he was greeted triumphally: "when the men were returning home after David had killed the Philistine, the women came out from all the towns of Israel to meet King Saul with singing and dancing, with joyful songs and with timbrels and lyres. As they danced, they sang" (I Sam. 18, 6–7).

Brandi's canvas depicts the young warrior welcomed by the women, who sing a song for him following the score that one of them holds between her hands. On the left, a fully armed soldier underscores the nakedness of the young man, who wears only an animal skin and a piece of red cloth in keeping with the Biblical text, which expressly mentions that he refused armor because it impeded his movements. His right hand holds the end of the rope wrapped around the sword and rests on Goliath's large head, on which we see the traces of blood from the blow inflicted by the sling, still grasped between the fingers of the young man's left hand. The center of the painting is dominated by the giant's large sword; intersecting with David's arm, it forms the symbol of the cross, clearly alluding to the fact that David is one of the most common prefigurations of Christ.

The work can be dated to around 1658–1659 on stylistic grounds, but it cannot currently be identified as any one of the paintings on this subject mentioned by the sources. In the 19th century, it was in the Torlonia collection where it is listed several times, correctly attributed to the Roman painter. When the collection was donated to the Italian state in 1892, the painting entered the collections of the Galleria Nazionale di Arte Antica.

AC

78 | Carlo Maratti
(Camerano, 1625–Rome, 1713)

Rebecca and Eliezer at the Well
ca. 1695
oil on canvas, 170 × 120 cm
Galleria Corsini, inv. no. 402

Bibliography: M.G. Bernardini, in *La Galleria Corsini a cento anni dalla sua acquisizione*, cat. of the exhibition (Rome 1984), ed. by S. Alloisi, M.G. Bernardini, Rome 1984, p. 68; S. Rudolph, *Appunti per la contestualizzazione della "Rebecca" Corsini nell'evoluzione artistica di Carlo Maratti*, in *Un capolavoro di Carlo Maratti per Camerano. Rebecca ed. Eliezer al Pozzo della Galleria Nazionale di Palazzo Corsini*, cat. of the exhibition (Camerano 2014), ed. by V. Sgarbi, G. Leone, A. d'Amico, Acqui Terme 2014, pp. 17–20; S. Pedone, *I Corsini collezionisti di Carlo Maratti. I dipinti della Galleria Corsini di Roma*, ibid., pp. 69–73; C. Falcucci, M. Rossi Doria, *Rebecca ed. Eliezer al pozzo. Tecnica di esecuzione, stato di conservazione, intervento di restauro*, ibid., pp. 85–97.

The Bible (*Genesis* 24) tells us that after leaving his homeland to follow God's instructions the elderly Abraham wanted a bride from his own country for his son Isaac. He therefore asked his servant Eliezer to go there and find someone. Arriving at a well, Eliezer asked the Lord to let him meet the predestined woman, identified as she who would offer to give both him and his camels water to drink. Among the many girls present, Rebecca fulfilled the prophecy and, as a tangible mark of his choice, Eliezer "took out a gold nose ring weighing half a shekel and placed it on her nose and placed on her arms two bracelets weighing ten gold shekels."

Maratti's canvas depicts the exact moment at which Abraham's servant gives the two bracelets to the young woman, who puts them on with a theatrical and almost dancing motion, arousing the curiosity—and perhaps even envy—of the other girls. The amphora in the foreground and the camels on the right help to identify the episode, which Maratti stages in a refined and elegant composition, typical of the works that he executed at around the end of the 17th century.

An engraving of the painting made in Rome by Robert van Audenaerd bears an inscription specifying that the canvas was in the home of Michelangelo Maffei, then Treasurer of Romagna to the Apostolic Chamber and most likely the patron who commissioned the painting. The choice of topic was well suited to celebrating the role of someone who, like Eliezer, efficiently managed the wealth of their master. It therefore does not seem coincidental that after Maffei's death the painting was acquired by another papal treasurer, Carlo Maria Sacripanti, who held the post under Clement XII Corsini, the pope who appointed him cardinal in 1739. Sacripanti must have decided to donate the work to the Corsini family to express his gratitude to the pontiff, as confirmed by a letter from Giovanni Gaetano Bottari, the family librarian. On 30 December 1740, he enthusiastically noted the arrival at the Lungara palace of the painting given by Sacripanti to Cardinal Neri Maria Corsini together with the *Concert* now attributed to the Caravaggesque painter Rombouts but at the time ascribed to Merisi himself.

Neri Maria decided to place both works in his bedroom, the so-called "alcove," thus demonstrating his appreciation for the gift and, in particular, for Maratti's work. Indeed, it was hung right next to the bed, as was Rubens's *St. Sebastian*, which the cardinal had sent directly from Brussels.

AC

79 | Carlo Maratti
(Camerano, 1625–Rome, 1713)

Portrait of Cardinal Antonio Barberini jr
1682–1683
oil on canvas, 257 × 172 cm
Palazzo Barberini, inv. 5001 (1692–1704, inventory of Cardinal Carlo Barberini)

Bibliography: S. Rudolph, in *L'idea del bello. Viaggio per Roma nel Seicento con Giovan Pietro Bellori*, cat. of the exhibition (Rome 2000), ed. by E. Borea, L. de Lachenal, Rome 2000, pp. 463–465 no. 7; F. Petrucci, *Pittura di ritratto a Roma. Il Seicento*, Rome 2008, I, p. 71, II p. 338; M. Ulivi in *Da Rubens a Maratta. Osimo e la marca di Ancona*, cat. of the exhibition (Osimo 2013), ed. by V. Sgarbi, S. Papetti, Cinisello Balsamo 2013, pp. 152–153, no. 42; V. Brunetti, *Carlo Maratti al servizio di Carlo Barberini: nuovi documenti*, "Ricerche di Storia dell'Arte", 118, 2016, pp. 77–80; V. Brunetti, in *Il cardinale Gianfrancesco Albani e le arti tra Roma e Urbino*, cat. of the exhibition (Urbino 2017), ed. by L. Simonato, Cinisello Balsamo 2017, pp. 122–125, no. 6.

"From time to time, Carlo executed various pictures of him... [one] standing in his robes with the cloak of a cardinal, and with the order of the Holy Spirit on his chest. To one side he painted an open doorway with a chamber papered inside with flowery brocade, on the other side a little table with an ivory crucifix, the bell, the red hat and some papers." Thus, the scholar Giovan Pietro Bellori describes the full-length portrait that his friend Carlo Maratti painted of Cardinal Antonio Barberini (1607–1671), nephew of Pope Urban VIII and brother of Cardinal Francesco, a prominent diplomat for his pro-French positions and a patron of intellectuals and artists including Gian Lorenzo Bernini and Andrea Sacchi. The figurative culture of the painter from the Marche has its roots in the long time he spent in the workshop of Andrea Sacchi. In this lively cultural climate, the objective was to establish the primacy of the Roman school of painting on the European scene. Maratti was later proclaimed the greatest exponent of that school in the second half of the 17th century, for his vigorous coloring of Venetian origin combined with the more tempered palette of Correggio. The portrait of the cardinal is an exemplary illustration of this style, played out on the iridescent reds, on the bright and opaque shades of white, on the virtuoso rendering of the draperies from the sumptuous garments to the fabric covering the little table, the hat, the theatrical curtain, the tassel, up to the fluffy ermine mozzetta, the gown, the handkerchief, and the valuable ivory crucifix. Mindful of Van Dyck's portraits, the painter here creates a likeness of great naturalism and intensity.

In a studiedly theatrical setting, framed by the curtain that introduces the scene, the cardinal stands at the center of the painting in all his solemnity, with the allusions to his titles, the cross of the order of the Holy Spirit, to his religious virtues and his membership of the Barberini family, signalled by the family's heraldic motifs of the sun and the bees within laurel branches that decorate the brocade on the left and that recall the magnificence of the palace in which he resided from 1638 to 1644, when he held the office of camerlengo. However, the painting was not commissioned directly by Cardinal Antonio, but by his nephew, Cardinal Carlo Barberini (1630–1704), as proven by recently identified documents indicating that it was executed between 1682 and 1683.

PN

80 | **Benedetto Luti**
(Florence, 1666–Rome, 1724)

Head of a Woman
ca. 1704
Pastel on paper, 45.5 × 35 cm
Galleria Corsini, inv. 575

Bibliography: E.P. Bowron, *Benedetto Luti's Pastels and Coloured Chalk Drawings*, "Apollo", 111, 1980, pp. 440–447; R. Maffeis, *Benedetto Luti. L'ultimo maestro*, Florence 2012, p. 325; N. Jeffares, *Dictionary of Pastellists Before 1800*, London 2006 (Online Edition: www.pastellists.com/Articles/Luti.pdf).

Used from the 16th century onwards to execute studies and preparatory drawings, the pastel technique took on a fully autonomous aesthetic dignity in the 18th century, particularly in the genre of portraiture, and even became the chosen means of expression for some artists. In Italy, Benedetto Luti was among the first to realize the creative potential of this medium, and the prospects for expansion of a new market made up not only of major official patrons, but also collectors, amateurs, travelers, tourists and merchants. He himself, as noted by the contemporary sources, was a keen art dealer and assembled a "substantial and rare" collection of drawings and prints (L. Pascoli, *Vite de' pittori, scultori, ed. architetti moderni*, Rome 1730, p. 230).

Luti's pastels in the Corsini collection, including the girl shown from behind, were donated by Abbot Antonio Paluzzi, agent in Rome of the Grand Duke of Tuscany from 1720 to 1738, and then of the Duke of Modena until his death in 1756. This is a characteristic example of a particularly sought-after and popular art form: of small size, rapid but virtuoso execution and above all enlivened by the delicate, luminous, and brilliant colors. These peculiarities are also in keeping with the choice of subjects, explored by the painter in a long series of variants. The so-called "character heads," though neither true portraits nor genuine preparatory studies for works of this genre preserve—or, more accurately, simulate—the immediacy and freshness of life drawing. At the same time, they dwell on the physiognomy, expression, and psychology in a way that, though often generic or highly stereotypical, represented a strong draw for the viewers of the time, who had a clear taste for such subjects.

Here the painter skilfully exploits the effects of the so-called *profil perdu*. The girl is shown from behind but, thanks to the slight twist of the neck, we see something of her profile, though it is in shadow, and perhaps even glimpse the curious and self-satisfied expression of someone aware that she is being watched and on the point of turning around, thanks in part to the presence of the mirror. The academically trained Cavalier Luti was well aware that, when attempting to depict the gaze, the viewer's imagination was elicited more by concealment than overt representation, following a dictate that the treatise tradition ascribed to an invention by the famous Greek painter Timanthes. Over a century later, the writer Théophile Gautier gave a perfect description of the spirit of the lost profile, commenting in his homonymous poem on an image probably not dissimilar from this one, in which "the flirtatious sphinx arouses desire, and speaks volumes whilst remaining silent" (*Le profil perdu*, 1865).

MDM

81 | **Christian Berentz**
(Hamburg, 1658–Rome, 1722)

Still Life with Sponge Fingers (The Fly)
ca. 1715
oil on canvas, 61 × 45 cm
Galleria Corsini, inv. 62

Bibliography: L. Pascoli, *Vite de' pittori, scultori ed architetti moderni*, Rome 1736, II, pp. 357–367; L. Trezzani, in *La natura morta in Italia*, ed. by F. Porzio, Milan 1989, II, p. 823; G. and U. Bocchi, *Pittori di natura morta a Roma. Artisti stranieri 1630–1750*, Viadana 2004, pp. 285–308; A. Cosma, in *I papi della memoria*, cat. of the exhibition (Rome 2012), ed. by M. Lolli Ghetti, Rome 2012, pp. 274–275.

Against a dark background, precious glass objects and valuable tableware gleam in a complex play of colored reflections, and an inviting tray of fragrant biscuits seems almost to project out of the painting. The objects, in their silent but almost tangible presence, are the true protagonists of the work, which belongs to the genre of still life known to the Dutch as a *pronkstilleven*. These presented a carefully arranged display of luxury objects, like the elegant Murano glass and even the renowned sponge finger biscuits which became internationally fashionable in the 18th century—to the extent that they were mentioned even by Giacomo Casanova in an entertaining anecdote in his famous memoirs. Indeed, Christian Berentz—of German origin but who moved to Rome in around 1680, where he joined the community of northern European and Flemish artists under the evocative nickname of *Goudsbloem* (calendula)—looked particularly to the tradition of 17th-century Dutch painting, devoting himself to the specialized production of these subjects, increasingly in demand from the Roman market and from patrons.

Berentz's closest models for the Corsini canvas are the works of the famous Willem Kalf (1619–1693), who in a remarkable series of different versions—like the superb work in the Museum of Art of Indianapolis or that in the Ashmolean in Oxford—developed this exact compositional type: a console table set at a slight angle, with the tablecloth or carpet leaving a corner of the marble top uncovered, on which he arranged, in a well-balanced formal equilibrium, pewter trays, fruit, wine glasses, bottles and other costly table ornaments. Berentz even imitated the angulation of the light falling from the left and to some extent the proportions of the canvas. But it is above all the extraordinary technical skill of the Dutch master that he attempts to emulate in rendering the material consistency of the objects and the way in which the light catches them, though in comparison to Kalf's dense and vibrant execution Berentz's painting appears crystallized, more sharply and incisively drawn. Telling in this sense is the detail of the fly, an illusionistic virtuoso touch, but perhaps also a moralistic *memento* of the ephemeral nature of worldly goods and pleasures, ultimately destined for corruption: another typical feature of Dutch still lifes and also present in other paintings by Berentz.

The *Fly* is one of six paintings given to Neri Corsini by the Swiss native Kaspar Probstat (1652–1730), Governor of the Customs in Rome and a close friend of the painter. In the Corsini collection the painting is paired with another still life by Berentz with fruit and vegetables (inv. 63), signed and dated 1715, when the *Fly* may also have been executed.

MDM

(Amersfoort, 1653–Rome, 1736)

View of the Tiber at Castel Sant'Angelo

1683
tempera on parchment, 26.5 × 47.3 cm
Palazzo Barberini, inv. 1408 (Odescalchi gift, 1895)

Bibliography: L. Laureati, L. Trezzani, *Gaspar van Wittel*, Milan 1996, pp. 178–181, nos 126–136; J. Garms, *Vedute di Roma. Dal Medioevo all'Ottocento*, Naples 2000, p. 125, no. A 41; L. Mochi Onori, *Galleria Nazionale d'Arte Antica di Palazzo Barberini. Dipinti del '700*, Rome 2007, pp. 198–199, no. 289 (with preceding bibliography).

The painting, signed and dated "Gas: Van Witel 1683" on the herms on the terrace to the left, was acquired for the Italian state collections in 1895 (as a gift from the Odescalchi family). On the reverse of its companion piece (*Rome, View of the Piazza del Quirinale*, same measurements, inv. 1497), also in the Gallerie, we read "Gesicht van Montecavallo Gaspare van Wittel 1683," while the words "Gas. V. Witel 1681" appear on the back. According to Laura Laureati, the difference in date may be due to the deterioration of the painted surface.

Both temperas are part of a gift from the Odescalchi family to the newly established Reale Galleria d'Arte Antica e Gabinetto delle Stampe: fourteen small paintings by "Gasparo of the glasses," thus nicknamed for the spectacles he habitually wore. Their first owner was Livio Odescalchi, the nephew of Pope Innocent XI.

This is one of the numerous images of Rome created by the Dutch painter for foreign travellers on the Grand Tour who wanted a souvenir of the city to take home. The view, in which the imperial Rome of Hadrian meets that of the popes, offers the viewer an image of the wide course of the Tiber flowing from the Castel Sant'Angelo toward St. Peter's. The enormous popularity of the scene is attested by the numerous replicas of the subject: at least eleven, of which the oldest, formerly in the Sacchetti collection and dating to 1682, is now in the Capitoline painting gallery. The preparatory drawing from which all the known versions derive is in the National Central Library of Rome (Drawings, 3, III, 18).

A variant surveyed by Federico Zeri (Fototeca Zeri, 62615), which differs from the Barberini version for the figures congregating on the terrace in the left-hand foreground and for the scenes of daily life on the river, appeared in 2018 at auction in Florence (*Capolavori da*

collezioni italiane, Pandolfini auction house, 31 October 2018, lot no. 5). Both show Palazzo Altoviti on the left bank of the river (later destroyed by the Piedmontese kings of Italy when they built the Tiber embankments), on the square that leads to the Sant'Angelo bridge. Also visible is the complex of Santo Spirito in Sassia with its hexagonal bell tower. On the right is the Borgo district, still intact.

83 | **Pietro Paolo Cristofari**
(Rome, 1685–1743)

Clement XII Corsini and Cardinal Neri Maria Corsini
1738
Mosaic, 227 × 152 cm
Galleria Corsini, inv. 467 (Corsini collection)

Bibliography: M.B. Guerrieri Borsoi, *La collezione di dipinti di Fabio e Pietro Paolo Cristofari*, in *Collezionismo e ideologia: mecenati, artisti e teorici dal classico al neoclassico*, ed. by E. Debenedetti, Rome 1991, pp. 118, 122; M. Costantini, in *Quadri senza casa dai depositi della Galleria Corsini*, cat. of the exhibition (Rome 1993–1994), ed. by S. Alloisi, Rome 1993, pp. 78–79; A. González-Palacios, *Ritratti musivi del Cristofari*, in Id., *Il gusto dei principi: arte di corte del XVII e XVIII secolo*, Milan 1993, ı, pp. 173–175; G. Bocconi, in *La collezione del principe da Leonardo a Goya. Disegni e stampe della raccolta Corsini*, cat. of the exhibition (Rome 2004), ed. by E. Antetomaso, G. Mariani, Rome 2004, pp. 386–387; S. Pierguidi, *Guido Reni, i Barberini e i Corsini. Storia e fortuna di un capolavoro*, Milan 2018, pp. 71–74.

On 12 July 1730, Lorenzo Corsini was elected pope with the name of Clement XII. Just over a month later, on 14 August, he appointed his nephew Neri Maria cardinal, in accordance with an age-old practice known as nepotism. Neri Maria's decision to purchase Palazzo Riario alla Lungara in 1736 and the start of the monumental enlargement project designed by Ferdinando Fuga were the first concrete reflection of the new importance acquired by the family. This was accompanied shortly afterwards by the direct celebration of the two protagonists in a monumental full-length portrait to be executed entirely in mosaic. The work was commissioned for the new family palace just before 1738, with a view specifically to the completion of the first phase of the renovation project. The choice of mosaic, by contrast, is explained by the new popularity attained by this technique in the 18th century, both for its symbolic references to the early Christian period and for its "eternal" durability, which led in these same years to the decision to replace all the altarpieces in St. Peter's basilica with mosaic copies.

The Corsini family entrusted the work to the principal mosaicist active in Rome at the time, Pietro Paolo Cristofari, then superintendent of all the "painters in mosaic" working at St. Peter's, while the preparatory model—now in the Library of the Accademia dei Lincei—was entrusted to Agostino Masucci, a painter much appreciated by Cardinal Neri Maria. Masucci and Cristofari had already worked together on the mosaic altarpiece in the Córsini chapel in the basilica of San Giovanni in Laterano (1733–1734) and thus represented a guarantee of success for patrons.

Placed in the so-called corner chamber—where it can still be found today—, in other words a public area of the first floor, the grandiose mosaic was intended to make an instant impression on visitors to the palace, as attested by the 18th-century guidebooks to Rome which do not fail to stress its technical quality, capable of perfectly simulating the effects of painting.

The work shows the Pontiff and Cardinal Corsini in accordance with the now canonical iconography of the official portrait of the pope with his cardinal nephew, with the latter standing and holding out a letter to the pope, seated on a chair on whose backrest the family coat of arms can be seen. Both protagonists turn toward the viewer, with the pope's red slipper clearly visible as an allusion to the act of reverence, the ceremonial approach to the pope involving three bows and, finally, the kissing of the slipper.

AC

84 | Carlo Monaldi, attributed to
(Rome? ca. 1683–Rome ca. 1760)

Bust of Clement XII Corsini
1735–1745
marble, h 104 cm
Galleria Corsini, inv. 1939 (1929, purchased at the suggestion of the General
Directorate of Antiquities and Fine Arts).

Bibliography: A. De Rinaldis, *La Galleria Nazionale d'Arte Antica in Roma*, Rome 1932,
p. 10; A. Riccoboni, *Roma nell'arte: la scultura nell'evo moderno, dal Quattrocento ad oggi*,
Rome 1942, p. 299; I. Faldi, *Galleria Borghese. Le sculture dal secolo XVI al XIX*, Rome 1954,
p. 43 no. 40; S. Alloisi, M.G. Bernardini, *La Galleria Corsini a cento anni dalla sua acquisizio-
ne*, cat. of the exhibition (Rome 1984), Rome 1984, p. 90; V. Brunetti, *Catalogo online delle
Gallerie Nazionali di Arte Antica*, 2020, *ad vocem*.

The face of Pope Clement XII lights up with a lively and alert gaze, the deeply carved irises
making the pupils shine against a dark background. The monumental nature of the bust is
accentuated by its size, larger than life, and by the ample vestments worn by the Florentine
pontiff, embellished with floral decorations and with the dove of the Holy Spirit.

The sculpture was purchased by the Italian State in 1929 to celebrate the Trastevere pal-
ace's former owner in the rooms of the Corsini Gallery; until recently it was unanimously
considered to be a work by Pietro Bracci, with the sole exception of Alberto Riccoboni, who
downgraded it to the "manner" of the artist in 1942. However, the work, not mentioned in
the "diary" kept by the Roman sculptor, differs from most of his marble busts, above all for
the horizontally expanded mozzetta.

Recently, Vittoria Brunetti astutely attributed the sculpture to the still little-known Carlo
Monaldi, who trained in Rome in the circles of Camillo Rusconi. According to the scholar, the
persisting attribution to Bracci was justified by the complex folds of the sculpture's drapery,
not dissimilar to those in the bust of Benedict XIII in Santa Maria Maggiore, now definitively
expunged from Bracci's catalogue. In the same chapel hosting the bust of the Orsini pope
there is also another marble effigy of Clement XII—already ascribed to Monaldi by documen-
tary sources—which presents greater similarities with our work (the sculptor was paid 200
scudi to execute the two papal "memorials" consisting of marble busts, stucco angels and the
inscriptions in the chapel). Admittedly, however, we do not know of many other certain por-
traits by the artist, although we do know that he worked on several occasions for Clement XII.
In 1732, Monaldi was commissioned to execute a statue of the pope for the Corsini chapel in
San Giovanni in Laterano: however, the work was considered unsatisfactory by the patrons,
who replaced it with another portrait by Giovan Battista Maini, assigning Monaldi's sculpture
to Palazzo Corsini on the Lungarno, where is still found today. Specifically, the comparison
with the Florentine effigy has made it possible to suggest Monaldi's name for the portrait in
the Corsini Gallery: the pope has the same decrepit and rubbery face, and the decoration on
the stole is identical, presenting floral motifs on a striped background.

YP

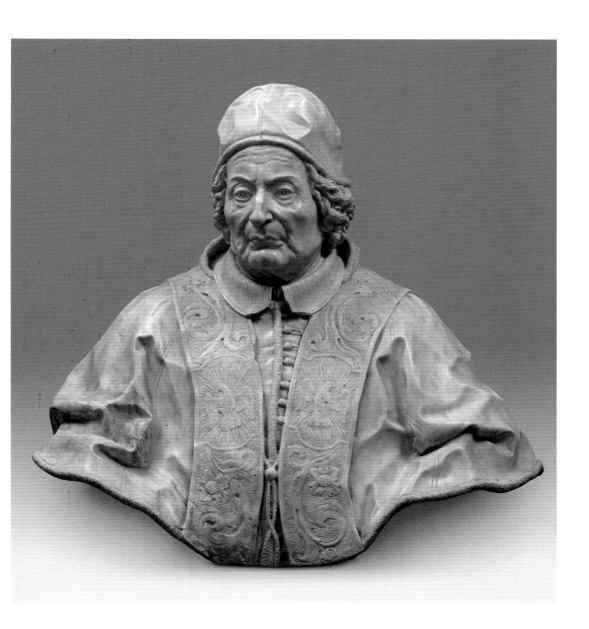

(Koper, 1656–Rome, 1746)

Portrait of Cardinal Pietro Ottoboni

ca. 1710–1712
oil on canvas, 76 × 64 cm
Palazzo Barberini, inv. 4243 (purchased, 1991)

Bibliography: F.R. Di Federico, *Francesco Trevisani: Eighteeenth Century Painter in Rome*, Washington 1977, pp. 21–24; D. Tommaselli, in *Il Settecento a Roma*, cat. of the exhibition (Rome 2005–2006), ed. by A. Lo Bianco, A. Negro, Cinisello Balsamo 2005, p. 262; L. Mochi Onori, *Galleria Nazionale d'Arte Antica di Palazzo Barberini. Dipinti del '700*, Rome 2007, pp. 185–186, no. 268 (with preceding bibliography); L. Mochi Onori, R. Vodret, *Palazzo Barberini. I dipinti. Catalogo sistematico*, Rome 2008, p. 434.

The painting was acquired by the Italian state in 1991 through private negotiations with Count Clemente Castelbarco Albani.

Cardinal Pietro Ottoboni was a protector of musicians, writers, and artists, as well as the most important patron of Francesco Trevisani who lived in the Palazzo della Cancelleria in 1698 thanks to his intercession. A powerful politician, Ottoboni was already cardinal deacon of San Lorenzo in Damaso and vice-chancellor of the Holy Roman Church at the age of only twenty-two (1698). However, his wealth was not sufficient to cover the debts incurred for artistic expenses. The ties between painter and patron are confirmed by the fact that both were heavily involved in the Academy of Arcadia, as well as by their shared interest in theatre.

The painting is signed on the letter held by the sitter: "Rev. / mo / Sig.re / Card. Otthoboni / Per / Fran.co Trevisani." This is certainly a later version than that in Barnard Castle (The Bowes Museum), in which Ottoboni is depicted at a young age, probably shortly after his election to cardinal or in any case no later than 1700–1705. The canvas in the Barberini Gallery, on the other hand, shows him later in life, supporting the hypothesis of a later execution (1710–1712).

In the inventory of Arcangelo Corelli, drawn up between 11 and 16 January 1713, there is "A painting on emperor canvas with its gilded carved frame depicting the Portrait of his Eminence Card. Ottoboni by Trevisani." The size (an emperor canvas measures approximately 100 × 130 cm) therefore rules out that the work listed is our painting, while it is in keeping with the aforementioned portrait in the Bowes Museum (134.3 × 98.5 cm).

In an inventory of the Ottoboni house drawn up by Ludovico Sergardi (8 January 1727), a portrait of the cardinal is recorded as being in the second antechamber of the first apartment ("Portrait called boni by Trevisani"). This may perhaps refer to our canvas. Another small portrait of Pietro Ottoboni, formerly in the Albani collection and later in the Torlonia collection, is held in this same museum (inv. 1111): it is a companion on copper to the *Portrait of Cardinal Ruffo* (inv. 1109), previously attributed to Pier Leone Ghezzi by Anna Lo Bianco.

CA

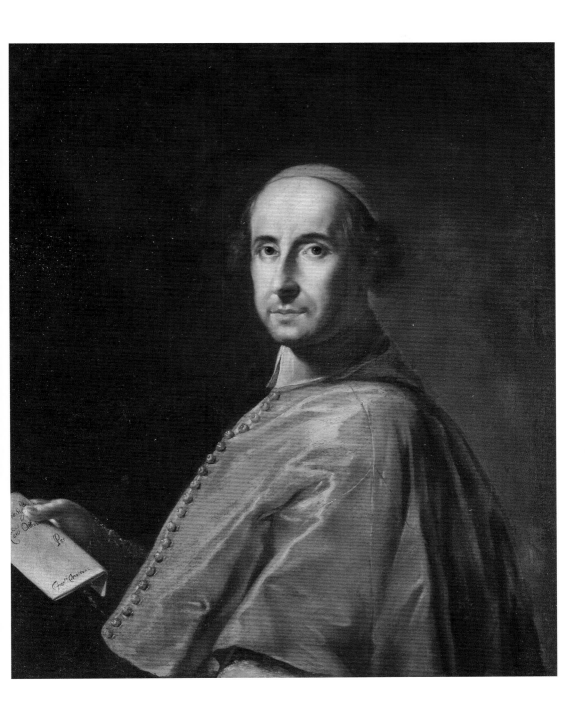

Judith and Holofernes

1715–1720
oil on canvas, 114 × 98 cm
Galleria Corsini, inv. 601

Bibliography: A. Mariuz, *L'opera completa del Piazzetta*, Milan 1982, p. 100, no. 109; U. Ruggeri in *Giambattista Piazzetta. Il suo tempo, la sua scuola*, cat. of the exhibition (Venice 1983), Venice 1983, p. 72, no. 14; S. Alloisi, *Guida alla Galleria Corsini*, Rome 2000, pp. 77–78.

This dramatic biblical episode was very dear to the Venetian painter, who depicted it several times during his career; examples are the painting in the Accademia Nazionale di San Luca and that in the Scuola Grande dei Carmini in Venice.

The young Jewish widow is known for bravely liberating the city of Bethulia from the long siege by the troops of the Assyrian general Holofernes against the people of God. Devising a cunning plan, the girl entered the enemy leader's tent and, taking advantage of his state of intoxication, grabbed the scimitar and struck two energetic blows to his neck, severing his head from his body. Outside, her faithful servant Abra waited with her saddlebag open, ready to receive the macabre trophy.

The biblical episode, a traditional allegory of the triumph of virtue over vice, is a tribute to the virtuous heroine who committed tyrannicide to save her oppressed people. Piazzetta focuses on the time immediately preceding the act of decapitation: the moment when Judith prepares to untie the cord holding Holofernes' sword with a stylized gesture, praying for divine assistance.

The painting is first mentioned in a Corsini inventory of 1750 and, thanks to an annotation by Giovan Gaetano Bottari, we know that Cardinal Neri Maria Corsini (1686–1770) bought it directly from the Venetian painter for 133 *scudi*.

The canvas is not fully finished, as indicated by the incomplete rendering of Holofernes' head, Judith's right hand and the left-hand curtain, which appear to have been left in a rough state.

TC

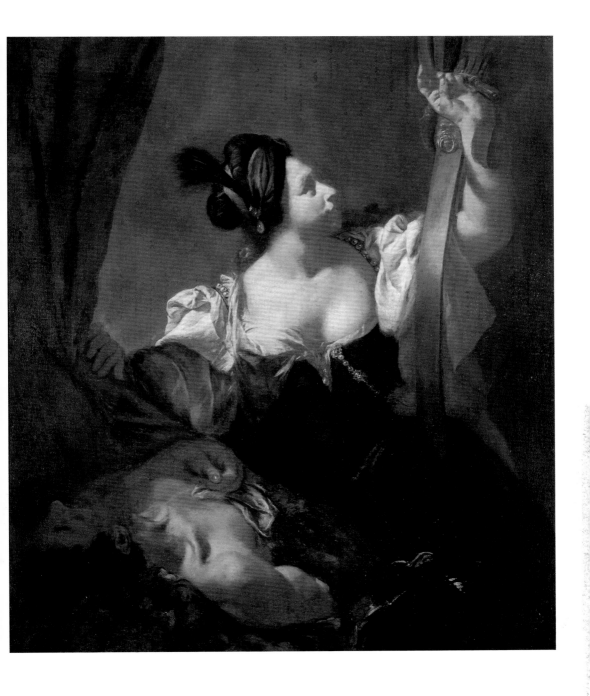

Expulsion of Heliodorus from the Temple

Before 1725
oil on canvas, 152.7 × 206 cm
Palazzo Barberini, inv. 1556

Bibliography: N. Spinosa, in *Settecento napoletano: sulle ali dell'aquila imperiale 1707–1734*, cat. of the exhibition (Vienna-Naples 1993–1994), ed. by W. Prohaska, N. Spinosa, Naples 1994, pp. 248–250; N. Spinosa, *La cacciata di Eliodoro dal tempio. Il restauro di un affresco di Francesco Solimena al Gesù Nuovo*, Naples 1994, p. 20; L. Mochi Onori, *Galleria Nazionale d'Arte Antica di Palazzo Barberini. Dipinti del '700*, Rome 2007, p. 115, no. 144 (with preceding bibliography).

This is one of several preparatory works for Francesco Solimena's fresco in the church of the Gesù Nuovo in Naples. The fresco, signed and dated 1725 (F SOLIMENA P: 1725), is the *terminus ante quem* for the canvas. In 1913, the painting was given to the Galleria d'Arte Antica in Rome by the Museo Nazionale di San Martino in Naples, thanks to the intercession of the Minister of Education, Luigi Rava, and at the suggestion of the director of the Roman museum, Federico Hermanin. On 1 December 1909 the proposal was ratified by the minister, responsible for drafting the first Italian safeguarding law with Corrado Ricci (Law no. 364 of 20 June 1909, "which establishes and sets rules for the inalienability of antiquities and fine arts"). In exchange, Hermanin granted Vittorio Spinazzola, director of the Museo di San Martino, a painting of the *Trinity* also by Solimena.

The biblical subject comes from 2 Maccabees and is inspired by Raphael's *Expulsion of Heliodorus from the Temple* painted for the Room of Heliodorus in the Vatican. Heliodorus, minister of Seleucus IV Philopator, the ruler of the Seleucid kingdom stretching from Syria to western Persia, came to Jerusalem in 176 BC to steal the treasure from the temple of Solomon, gathered thanks to the efforts of the priest Onias. After the conflict with Rome, the peace

of Apamea (188 BC) had led the kingdom's finances to collapse as it was indebted to the Republic for war reparations of about 15,000 talents. In the painting, the narrative focuses on the events that follow the looting. Onias, pictured on the right kneeling in front of the menorah, prays to the Almighty to enact justice. Heliodorus, shown to the left on the ground with his arm raised, is immediately attacked by a divine emissary on horseback and two angels armed with scourges. Further to the right, some worshippers have recovered the looted treasure and are returning it to the temple. The painting corresponds to the central part of the fresco, in which the characters in the foreground, reclining on the staircase, have left room for the entrance door of the church.

CA

88 | **Vittore Ghislandi, called Fra Galgario**
(Bergamo, 1655–1743)

Portrait of a Man
ca. 1730–1740
oil on canvas, 57 × 46 cm
Palazzo Barberini, inv. 1688 (purchase, 1917)

Bibliography: G. Ronci, in *Da Caravaggio a Tiepolo. Pittura italiana del XVII e XVIII secolo*, cat. of the exhibition (São Paolo, Brazil 1954), Rome 1954, p. 79, no. 57; L. Mochi Onori, *Galleria Nazionale d'Arte Antica di Palazzo Barberini. Dipinti del '700*, Rome 2007, p. 115, no. 144 (with preceding bibliography).

In a letter dated 28 May 1917, the Minister of Education informed the director of the Galleria d'Arte Antica e Gabinetto Nazionale delle Stampe, with a request to take action, that the *Portrait of a Young Man* by Fra Galgario had been purchased for 3000 lire from Michelangelo Chiaserotti. A month later, the Director General for Antiquities and Fine Arts ratified the payment (28 June 1917), due on 1 July of the same year. This is interesting considering that at the time Italy was engaged in the Great War and that the Minister of Education, Francesco Ruffini, was a member of the Boselli government which had declared war on the German Empire on 27 August 1916; he remained in office only until 30 October 1917, when he was forced out by the defeat at Caporetto (24 October 1917). Though concise, this archive document shows that the kingdom of Italy, despite the serious political situation, did not abandon the protection of its cultural heritage.

The painting was executed in the final decade of the painter's life (1730–1740), as also suggested by the close parallels with a series of small portraits of young artists painted by Ghislandi at around the same time. Ghislandi, nicknamed Fra Galgario from his time as a friar at the Galgario monastery in Bergamo between 1702 and 1705, was a follower of Sebastiano Bombelli, whose workshop he frequented assiduously during the twelve years in which he lived in Venice (ca. 1689–1701). After returning to Bergamo in the early 18th century, Fra Galgario defined the key features of his production, much indebted to the Lombard portraiture of the 16th and 17th centuries. Indeed, his portraits are devoid of any idealization, reflecting the explicit realism characteristic of Giovan Battista Moroni's works. The same is true of the Pauline friar's later paintings. The most famous of these include the *Portrait of Giovanni Secco Suardo with his Servant* (Bergamo, Accademia Carrara, ca. 1720–1725) and the *Gentleman in a Three-Cornered Hat* (Milan, Museo Poldi Pezzoli, ca. 1740). Between his time in Venice and that in Bergamo at the beginning of the century, Ghislandi refused an invitation to work in Rome from Cardinal Pietro Ottoboni, the nephew of Alexander VIII. This is a confirmation of the reputation as a portraitist enjoyed by the painter, whose "character heads" were extremely popular among cultured Italian and foreign collectors such as Matthias von Schulenburg (1661-1747).

CA

(Saint-Gilles du Gard, 1699–Rome, 1749)

Female Nude from the Back

ca. 1740-1741
oil on canvas, 74 × 136 cm
Palazzo Barberini, inv. 2529 (bequest of Marquise Maria Rosa Gabrielli Gagliardi, 1963)

Bibliography: *Subleyras, 1699–1749*, cat. of the exhibition (Paris 1987), Paris 1987, pp. 231–233, no. 59; P. Rosenberg, N. Lesur, *Pierre Subleyras (1699–1749)*, Paris 2013, pp. 97–99.

The painting is part of a donation from Marquise Maria Rosa Gabrielli Gagliardi, initiated in 1963 and completed in 1970, when the work was delivered to the gallery together with other pieces.

Pierre Subleyras lived in Rome from 1728 as a *pensionnaire* of the Académie de France in Palazzo Mancini, where he remained until 1735 thanks to the protection of Princess Pamphilj. He was also supported by the Duke of Saint-Agnan, the French ambassador to Rome, who in those early Roman years was the painter's illustrious and influential patron. These relationships and the undisputed quality of his paintings made him a key player on the Roman scene, to the extent that the newly elected pope Benedict XIV (1740) commissioned a portrait from him (1740–1741), now in the Versailles museum. It was in these years that Subleyras painted the *Female Nude*, taking full advantage of the freedom to express himself in a way less fettered by the dictates of public patrons. The woman portrayed may be his wife, Maria Felice Tibaldi, a painter and miniaturist whom Subleyras married in Rome in 1739. In this work, the artist seems to draw on a repertoire of past nudes from the *Sleeping Hermaphrodite* (formerly Rome, Galleria Borghese) to the prints of Giulio Campagnola (*Venus*) and Agostino Veneziano (*Venus and Cupid*), up to Diego Velázquez's Rokeby *Venus* (London, National Gallery), via Annibale Carracci (*Venus and Satyr with Two Cupids*, Florence, Uffizi) and Alessandro Varotari (*Leda and the Swan*, Venice, Museo Correr). Our painting became famous and, together with the masterpiece by the Spanish artist, later served as a source of inspiration for many artists of the 19th century and

in particular Jean-Auguste-Dominique Ingres, who in 1814 painted the *Grande Odalisque* (Paris, Musée du Louvre), in which the girl's face and above all her hairstyle were quoted from Raphael's *Fornarina*.

Also dating to 1740 is the papal commission for St. Peter's: the *Mass of St. Basil* (1743–1747), now in the basilica of Santa Maria degli Angeli, which established Subleyras as one of the most important artists in Rome.

CA

(Venice, 1673–1757)

Allegories of the Four Elements (Air, Water, Fire, Earth)

1741–1743
Pastel on paper, 33.5 × 30.5 cm
Galleria Corsini, inv. 569–572

Bibliography: M. Costantini, in *Quadri senza casa*, ed. by S. Alloisi, Rome 1993, pp. 76–77; B. Sani, *Rosalba Carriera. 1673–1757. Maestra del pastello nell'Europa ancien régime*, Turin 2007, p. 369; A. Pasian, in *Rosalba Carriera "prima pittrice de l'Europa"*, ed. by G. Pavanello, Venice 2007, pp. 144–146.

The traditional allegorical theme of the four natural elements forms the inspiration, or more accurately the pretext, for a small and refined series of *têtes de fantaisie*. The pastel technique gives them the delicate, luminous, and brilliant character that made this a highly fashionable genre, in great demand in the mid-18th century. The Venetian artist Rosalba Carriera, already appreciated for her miniature portraits, had garnered an international reputation thanks precisely to her perfection of this technique, which in the Corsini series offers an exemplary combination of effortlessly skillful execution, a slightly affected preciousness of style and a portrait-like rendering apparent even in these fantasy figures.

Indeed, the four pastels form a sort of elegant variation on the motif of the female gaze, from the seductive and vivaciously witty expression of *Fire* to the absent-minded look of *Air* or the dreamy melancholy of *Water*. The four coquettish and charming young women, of a type often encountered among Rosalba Carriera's works, gave the painter an opportunity to differentiate not just the conventional distinctive iconographical attributes, but also the dominant shades of color, the hairstyles, the poses and even a certain temperament or mood appropriate to the individual elements. She thus reinterpreted the complex play of associations and correspondences of the ancient tradition in a modern vein and to clearly decorative ends. Not coincidentally, the same figurative rationale also informs the similar but slightly later series commissioned in 1744 by Count Francesco Algarotti for August III of Saxony and executed by the end of 1746 (now in the Gemäldegalerie in Dresden).

The Corsini pastels are recorded in the inventories of the family's Roman palace already in 1750, when they are registered, with an attribution to "Rosalba," as a "gift from Monsignor Stoppani." This was probably Giovan Francesco Stoppani, a prelate of Milanese origin with close ties to the Corsini family, and a particular debt of gratitude to the pope and his cardinal nephew Neri Maria. Clement XII had appointed him inquisitor of Malta in 1730, archbishop of Corinth in 1735 and then apostolic legate, first to Florence and then to Venice in 1739. The Nuncio made his official entry into Venice only in May 1741 and resided there until 1743: it was probably during this time that he commissioned or purchased Carriera's pastels, perhaps already with the intention of giving them to Cardinal Corsini.

MDM

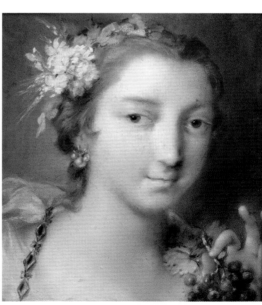

91 | Antonio Corradini

(Este, 1688–Naples, 1752)

Veiled Woman (the Vestal Virgin Tuccia)

1743-1747
Marble, h. 230 cm
Palazzo Barberini, inv. 2257 (purchase, 1952)

Bibliography: C. Faccioli, *Di uno scultore estense a Roma, alla metà del Settecento (Antonio Corradini)*, "Studi romani", 12, 1964, pp. 296–315; C. Semenzato, *La scultura veneta del Seicento e del Settecento*, Venice 1966, p. 112; B. Gogo, *Antonio Corradini: scultore veneziano, 1688-1752*, Este 1996. pp. 296–301; J. Montagu, in *Il Settecento a Roma*, cat. of the exhibition (Rome 2005–2006), ed. by A. Lo Bianco, A. Negro, Cinisello Balsamo 2005, pp. 158-159, no. 41; M. Di Monte, in *Eco e Narciso*, cat. of the exhibition (Rome 2018), Milan 2018, p. 168.

The official sculptor of the Venetian Republic since 1721, Antonio Corradini moved to Vienna in 1731, where he was appointed court sculptor in 1733. After the death of Emperor Charles VI (1740) and the ascent of Georg Raphael Donner, he left the Austrian capital for Rome, where he is documented from February 1743. Here he opened a studio near Palazzo Barberini where he created this sculpture, still one of the most important works in the Italian state collection today.

From a caricature executed by Giuseppe Ghezzi we know that in February 1743 Corradini was working on the statue of the *Vestal Virgin Tuccia* (Faccioli 1964, pp. 308 ff.). The engraver from Belluno, Francesco Monaco, active in Rome at this time, reproduces the *Tuccia*, already so famous that even the Old Pretender to the throne of England, James III Stuart, wished to see it (Faccioli 1964, p. 302). Put up for auction for 4000 *scudi* in 1747, the sculpture was not sold and remained in Palazzo Barberini, as Ghezzi himself recalls in a caricature dated 29 June 1752. In 1952 it was purchased by the Italian state.

The sculpture depicts the Vestal Virgin featured in a legendary story, reported among others by Valerius Maximus (*Factorum et dictorum memorabilium*, VIII, 8.1.abs.5): accused of violating her vow of chastity, Tuccia was subjected to a trial that revealed her innocence. This was a sort of ordeal, in which the accused relied on divine intervention. If the woman managed to collect water from the Tiber with a sieve, her life would be spared. The water froze miraculously, allowing the Vestal Virgin to collect it. The veil covering the entire figure alludes to the chastity of the woman, who holds the sieve or sifter, also a symbol of virginal purity, in her left hand. In Cesare Ripa's *Iconologia* (Rome 1593) the image of chastity also presents this attribute: "Woman, dressed in white, leaning on a column, above which there is a sieve full of water."

Tuccia is one of the veiled figures for which Corradini was much celebrated even during his lifetime. The *Veiled Faith* dates to 1717 and was kept in the Manfrin collection in Venice until 1856. Its execution was followed, in 1718, by the sculptures for the Cathedral of Rovigo (*Risen Christ, Hope* and a *Putto*) and, in 1720, by those for the Cathedral of Gurck in Carinthia (*Faith, Hope* and the relief with the *Death of St. Emma*). Then there were the six statues for the Scuola del Carmine in Venice of which only *Virginity* (1721) survives. Others were purchased for the Czar in 1722 (*Religion, Faith*—both lost after the 1835 fire in the Winter Palace). Probably between 1747 and 1748, Corradini left Rome for Naples, where he worked for Raimondo di Sangro, Prince of Sansevero, whose funerary chapel houses the famous *Veiled Christ*. Designed by Antonio Corradini, as demonstrated by the model now in the Museo di San Martino, the *Christ* was sculpted after his death (1752) by Giuseppe Sanmartino.

CA

212

BARBERINI GALLERIE CORSINI NAZIONALI

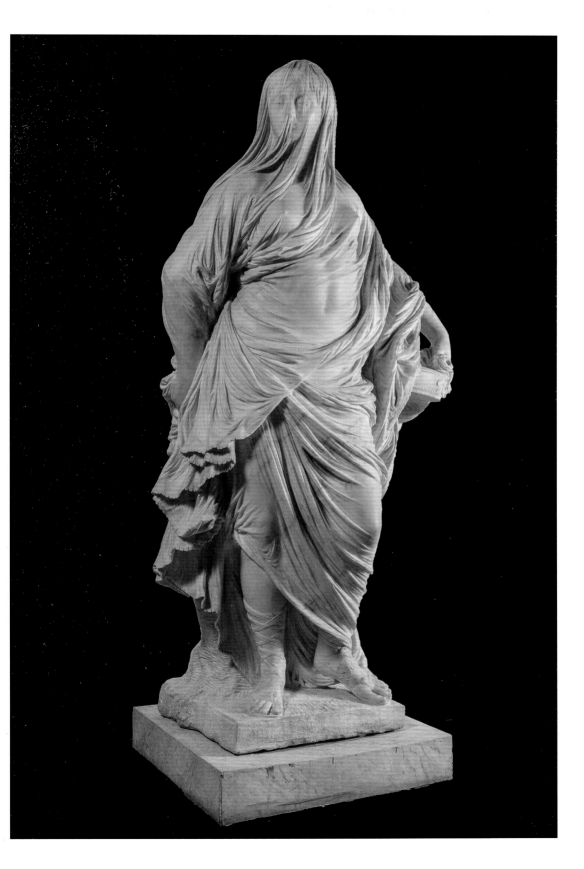

92 | Giovanni Antonio Canal, called Canaletto

(Venice, 1697–1768)

View of the Grand Canal in Venice (Grand Canal looking toward Ca' Foscari)

ca. 1735–1740
oil on canvas, 69 × 94 cm
Palazzo Barberini, inv. 1037 (Torlonia donation, 1892)

Bibliography: L. Mochi Onori, *Galleria Nazionale d'Arte Antica di Palazzo Barberini. Dipinti del '700*, Rome 2007, p. 75, n. 79 (with preceding bibliography); A. Lo Bianco, in *Canaletto. Venezia e i suoi splendori*, cat. of the exhibition (Treviso 2008–2009), Venice 2008, pp. 266–267, no. 41; *Canaletto e Bellotto. L'arte della veduta*, cat. of the exhibition (Turin 2008), Cinisello Balsamo 2008, p. 70, no. 8.

This painting and its companion piece showing the *Rialto Bridge* (inv. 1033) come from the Torlonia collection and are numbered 3 and 4 on the back, in reference to a series that, in addition to these pieces, also included the views identified by inventory numbers 1005 (*Venice, the Piazza and Library of San Marco*) and 1061 (*Venice, Piazza San Marco with the Procuratie*).

The four canvases are listed as original paintings by Canaletto in the inventory of the artworks owned by Giovanni Torlonia, drawn up between 1818 and 1821 by Antonio Guattani (*Descrizione ragionata degli oggetti d'arte esistenti nel palazzo di S.E. il sig. don Giovanni Torlonia, duca di Bracciano*). The transfer to the Italian state of the Torlonia collection led to the acquisition of approximately 380 works, including this series. It is not known for certain how Prince Torlonia acquired these paintings, although the transaction likely took place through a merchant, perhaps Joseph Smith, a collector and patron of Canaletto who also made a significant contribution to the artist's fame in England.

The view of the Canal Grande is seen from the Rialto Bridge facing south and is the opposite of that shown in inventory no. 1033, to the extent that together they constitute a complete image of this area of the city. Although the attribution to Canaletto has been questioned in

favor of Bellotto since 1914 (G. Ferrari, *I due Canaletto. Antonio Canal, Bernardo Bellotto*, Turin 1914), the restoration work undertaken in 1956 by Augusto Vermehren and Laura De Lama helped to re-establish its ascription to the former. There are two other differently sized versions of the same view: one in the Museum of Fine Arts in Houston and one in Windsor Castle. According to Bożena Ana Kowalczyk (2008), the close relationship between the Barberini series and the pieces executed for English patrons supports a date in the early 1740s, contrary to most previous studies which placed its execution between 1730 and 1735.

CA

214

BARBERINI
GALLERIE
CORSINI
NAZIONALI

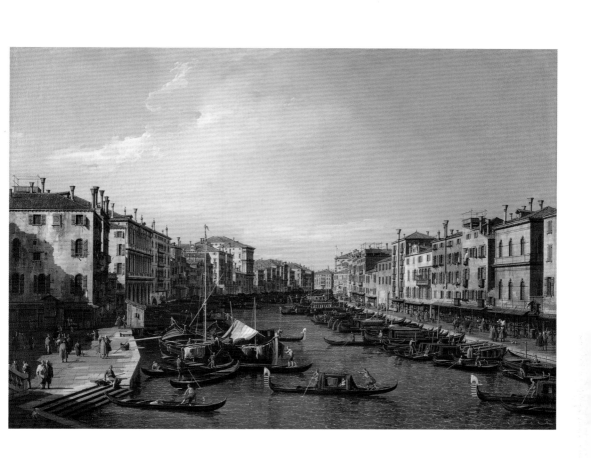

The Quarantotti Family

1756
oil on canvas, 245 × 335 cm
Palazzo Barberini, inv. 2391 (purchased from Ludovico Silvestri, 1956)

Bibliography: E. Debenedetti, *Quarantotti e Pellegrini Quarantotti: un Baciccio e due Benefial*, "Studi di Storia delle Arti", special issue in honour of Ezia Gavazza, 2003, pp. 69–74; L. Barroero, *Benefial*, Milan 2005, pp. 22–24; A. Lo Bianco, in *Il Settecento a Roma*, cat. of the exhibition (Rome 2005-2006), ed. by A. Lo Bianco, A. Negro, Milano 2005, p. 194; K. van Dooren, *The Drawings of Marco Benefial*, "Master Drawings", 46, 2008, 1, pp. 61–90 (especially p. 72).

This unusual painting by Benefial is a large group, or more accurately family, portrait, as revealed by the strong resemblance between some of those depicted. The canvas was commissioned by the Quarantotti family, originally from Norcia but permanently resident from the early 18th century in Rome, where they had established a profitable banking business. From 1711, the bank managed by Giulio Cesare and Ludovico Quarantotti was the depositary of the Congregation of the Reverend Basilica of St. Peter's, and consequently handled large sums of money. In 1754, Ludovico himself was made Marquis of Casciolino by Benedict XIV. The imposing portrait thus probably served to commemorate and celebrate a fortunate moment in the family's history, depicted by the painter in an image that is simultaneously coherent and variegated, and not just in terms of its coloring.

The gaudy and typically eastern style of dress worn by some of the figures seen posing is striking, as is the even more bizarre landscape in the background with a leafy palm tree towering just behind the group on the right. To explain this apparently exotic setting, it has been suggested that it might allude to the presumed missionary work undertaken in the distant Indies by the young cleric standing on the left, who should probably be identified as

Ludovico's son, Giovan Battista Quarantotti (1733–1820). In fact, Giovan Battista was just twenty-three in 1756 and he does not appear to have worked in missionary lands: his promising church career, though already off to a good start, only reached its greatest attainments later, with the post of secretary of the Congregation for the Propagation of the Faith in 1808, and a late appointment to cardinal in 1816.

As such, the unusual iconographical details probably have a different explanation. Rather than denoting an unlikely realistic landscape the palm, together with the oak on the far left, may hold an allegorical meaning as a well-established symbol of resistance against adversity and fruitful longevity, perhaps partly in reference to the churchman's oratorical eloquence, which enlivens a scene that

is otherwise staged as a static *tableau vivant*. Such symbolic language was common in the visual rhetoric of the Company of Jesus, in which Giovan Battista was educated and to which the family had close ties. Finally, as concerns the eccentric costumes, it is worth recalling that the Quarantotti family, in addition to their financial activities and thanks to the international contacts they brought, also had interests in the textile trade, of which the painter indulgently displays an all too rich variety.

MDM

94 | Gaspare Traversi
(Naples, 1722–Rome, 1770)

The Marriage Contract
ca. 1750-1758
oil on canvas, 61 × 74.5 cm
Palazzo Barberini, inv. 1172 (1892, Torlonia donation)

Bibliography: R. Longhi, *Di Gaspare Traversi*, "Vita Artistica", 53, August-September 1927, pp. 145–167, no. 149; T. Scarpa, in *Luce sul Settecento. Gaspare Traversi e l'arte del suo tempo in Emilia*, cat. of the exhibition (Parma 2004), ed. by L. Fornari Schianchi, Naples 2004, p. 136 no. 40a; *Luci, arte e "lumi" nel Settecento tra Parma, Napoli e Roma*, ed. by F. Barocelli, Milan 2006; R. Terrone, *Nuovi documenti su Gaspare Traversi. Un contributo all'interpretazione delle opere del tempo romano (1759–1760)*, "Kronos," 12, 2009, pp. 85–108; G. Forgione, *Gaspare Traversi (1722–1770)*, Soncino, 2014 (with preceding bibliography).

The painting comes from the Torlonia collection, part of which was donated to the gallery in 1892. In the first inventories of the house (1814, 1817) it is recorded, together with its companion piece (*The Married Couple's Dance*, private collection), as a work by Pier Leone Ghezzi. The same attribution is given in the inventory drawn up between 1818 and 1821 by Giuseppe Antonio Guattani. It was Roberto Longhi who established its correct attribution in 1927, dating it to the middle of the century (1745–1750). Ferdinando Bologna postpones its creation to 1752, tracing the painting back to the years when the artist lived in Rome, while Nicola Spinosa dates it to 1758 based on the parallels with the works executed by the painter in Parma.

The scene accurately depicts the practice of drawing up a marriage contract, an instrument of family, political and economic alliances. The moment shown is that of the civil ceremony that precedes the religious celebration. In the house of the betrothed, witnesses and family members meet in the presence of a notary who, after verifying the dowry, reads the contract out to those present. Traversi faithfully reproduces the bride's traditional dress: silver and gold brocade with white lace that emphasizes the neckline, framed by jewels.

The *Dance*, its companion canvas, completes the religious rite, introducing the spouses to the social context to which they belong. The affinities with the realism of the works of William Hogarth (*Marriage à la Mode*) or of other Anglo-Saxon artists is explained by the popularity of the engravings based on their paintings, indicating that the taste of the time was interested in certain bourgeois subjects. Contemporary theatre also played a role in Traversi's artistic conception, providing some expressive elements.

CA

95 | Pompeo Batoni
(Lucca, 1708–Rome, 1787)

Portrait of Abbondio Rezzonico, Senator of Rome

1766
oil on canvas, 296.5 × 196.5 cm
Palazzo Barberini, inv. 4659 (purchased from the heirs of the Rezzonico family, 2016)

Bibliography: E. Noè, *Rezzonicorum cineres. Ricerche sulla collezione Rezzonico*, "Rivista dell'Istituto Nazionale di Archeologia e Storia dell'Arte", s. III, III, 1980, pp. 173–306; G. Pavanello, *I Rezzonico. Committenza e collezionismo tra Venezia e Roma*, "Arte Veneta", 52, 1998, pp. 87–111; L. Barroero, in *Pompeo Batoni (1708–1787). L'Europa delle corti e il Grand Tour*, ed. by L. Barrorero, F. Mazzocca, Cinisello Balsamo 2008, p. 324; E.P. Bowron, *Pompeo Batoni: A Complete Catalogue of His Paintings*, Yale 2016, pp. 370–372.

This majestic canvas is one of the high points of Batoni's portraiture and a perfect example of a state portrait, in the genre that the painter himself described as "historiated" because it did not just immortalize an individual visage but transformed it into a ritual icon through its sumptuous staging: a solemn and luxurious display of political and dynastic prestige, intended to glorify the honor of the role and the virtues of its holder.

The portrait was commissioned and executed in 1766 for the appointment of the young prince Abbondio Rezzonico (1742–1810), nephew of Pope Clement XIII, to Senator of Rome. More specifically, the formal election took place on 1 July 1765, and the official public investiture a year later, on 9 June 1766, in the presence of the pope and his court. It was followed by the ostentatious "cavalcade" which, as etiquette dictated, led the newly elected senator from the papal apartments on the Quirinal to the Palazzo Senatorio on the Capitoline, his official residence.

It is to this official ceremony that the image alludes in the magnificent description of the garments, the meticulous array of status symbols and careful choice of compositional arrangement. Batoni portrays Rezzonico as he prepares to exercise his high office and displays its honorary insignia. Having just risen from his chair, the senator holds in his hand the ivory scepter received directly from the pope with the ritual formula: "Accipe sceptrum et esto Senator Urbis"; on the elegant console table against which he leans with studied nonchalance, we see—in addition to the writing set, the book and the indispensable missive—the senatorial hat that completes his processional outfit. Also in evidence is the little golden bell used by the senator "when he left his palace on the Capitoline on formal occasions" and for official visits, traditionally the prerogative of cardinals but recently granted by the pope to Rezzonico's predecessor, Count Niccolò Bielke.

At don Abbondio's feet, as if to guide his steps, is the genius of Justice, exercised with perfect equity, tempered by clemency and inspired by peace, as befits an individual who administers it with power over life and death and, as indicated by the fasces and the sword resting on the table, perhaps not coincidentally in the very place in which we glimpse the petition addressed to the "Senator of Rome." Finally, the background with the imaginary ceremonial loggia in which Rezzonico "receives" the viewer is theatrically closed by a view of the cordonata leading up the Capitoline to the Palazzo Senatorio and, keeping watch in the shadows, the city's tutelary deity, the statue of the goddess Roma.

MDM

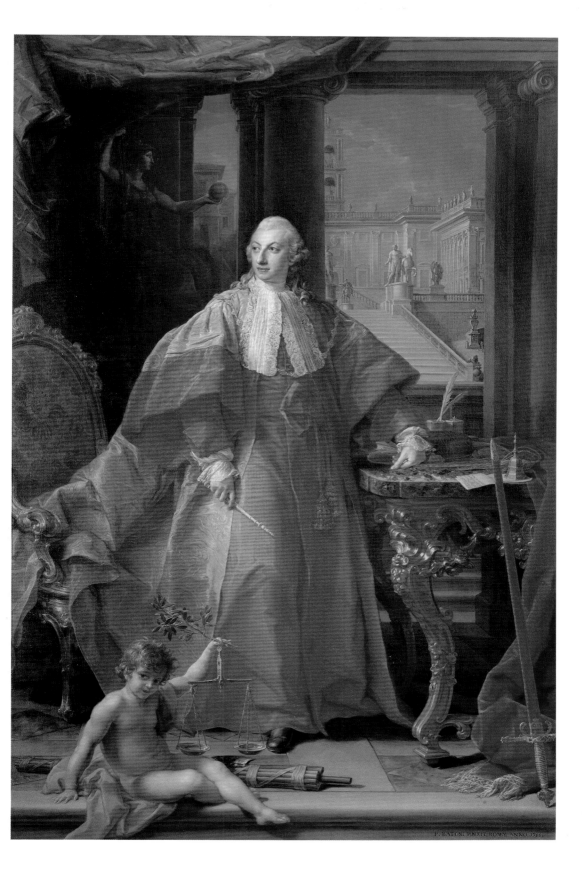

P. BATONI PINXIT ROMÆ ANNO 1766.

96 | François Boucher
(Paris, 1703–1770)

The Little Gardener
ca. 1767
oil on canvas, 58 × 45 cm
Palazzo Barberini, inv. 2472 (bequest of the Duke of Cervinara, 1962)

Bibliography: A. Ananof, *François Boucher*, Lausanne-Paris 1976, II, p. 272, no. 642; L. Mochi Onori, *Galleria Nazionale d'Arte Antica di Palazzo Barberini. Dipinti del '700*, Rome 2007, pp. 68–69, no. 71 (with preceding bibliography).

The *Little Gardener* was acquired in 1962, when Dimitri Sursock, Duke of Cervinara, left it to the Italian state in his will, together with the other paintings in his collection. The bequest consisted of twenty-six works, mostly by 18th-century French artists: in addition to Boucher, they include Hubert Robert, Antoine Le Nain, Nicolas Lacret, Jean-Honoré Fragonard, Jean-Baptiste Greuze, Jean Frédéric Schall and Louis Leopod Boilly. To these we can add works by Francesco Guardi, Bernardo Bellotto and Bartolomeo Montagna.

The duke, the older brother of Isabelle Colonna, decided to leave his collection, kept in his London residence in Cumberland Place, to the Italian state, entrusting his nephew Aspreno Colonna with choosing the most suitable museum. His ties to Italy originated with the honor accorded to him by Vittorio Emanuele III, who had made him duke in 1940 thanks to the intercession of his powerful sister. On the death of his uncle (10 January 1960), Prince Colonna designated the Galleria Nazionale di Palazzo Barberini as the beneficiary, but the transfer to Italy was hindered by taxation issues. Thanks to the director of the Galleria Nazionale d'arte antica, Emilio Lavagnino, the paintings arrived in Rome in 1962. Here all the works, including the *Little Gardener*, underwent restoration.

Boucher became familiar with the models of 18th-century Venice, from Sebastiano Ricci to Rosalba Carriera, in the studio of François Lemoyne, where he began to work in 1721. In 1723 he won the Prix de Rome and, between 1727 and 1731, he lived in the city, where he

took an interest mainly in the paintings of Correggio, Veronese, Guercino and Tiepolo. On his return to Paris, he was admitted to the Acad.mie royale de peinture et de sculpture and later became First Painter to the King (1765). In Paris he created scenes drawn from mythology, through which he portrayed the society gravitating around King Louis XV, later devoting himself to elegant and sensual works with women as their protagonists. These choices left him open to criticism from intellectuals such as Diderot, who harshly rebuked the superficial and decorative painting style of which the Barberini painting is a striking example. Like Fragonard after him, Boucher became an artist censored by the ethics of the neoclassical movement as a backward exponent of the *ancien régime*.

CA

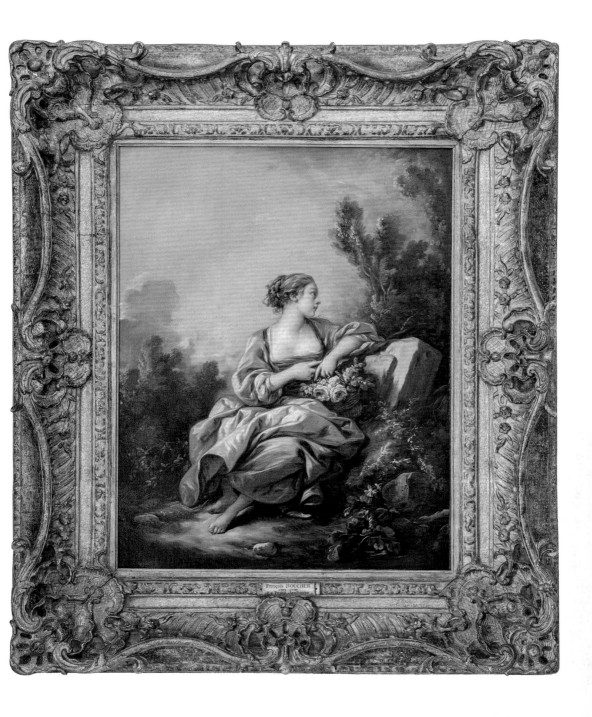

François BOUCHER
1703 - 1770
La Petite Jardinière

97 | Anton Raphael Mengs
(Aussig, 1728–Rome, 1779)

Jupiter and Ganymede
ca. 1760
fresco attached to canvas, 178.7 × 137.5 cm
Palazzo Barberini, inv. 1339 (1895, Monte di Pietà)

Bibliography: A.M. Morghen Tronti, *Un falso antico opera di Raffaello Mengs*, "Commentari", 1, 1950, pp. 109–111; D. Tommaselli, in *Il Settecento a Roma*, cat. of the exhibition (Rome 2005–2006), ed. by A. Lo Bianco and A. Negro, Cinisello Balsamo 2005, pp. 241–242, no. 139; L. Mochi Onori, *Galleria Nazionale d'Arte Antica di Palazzo Barberini. Dipinti del '700*, Rome 2007, pp. 179–180, no. 257 (with preceding bibliography).

The fresco is part of the batch of around one hundred-eighty paintings chosen from among those unsold in the Monte di Pietà auctions and ceded in 1895 to the new Galleria di Arte Antica. This is a famous case of fraud perpetrated against the most famous archaeologist of the 18th century and the theorist of Neoclassicism: Johann Joachim Winckelmann. He was the most ardent supporter of the authenticity of the painting, found in 1760 just outside Rome, near Bolsena. After reproducing it in his *Geschichte der Kunst des Alterthums* (1764), he later omitted it from the second edition (1766), perhaps suspicious of the machinations of the painter Giovanni Casanova, brother of Giacomo. The latter offered Winckelmann the reproductions of two frescoes recovered together with the *Jupiter and Ganymede*. In fact, these were drawings executed by mediator himself, who failed to fool the archaeologist, instead earning himself a charge of forgery. Essentially, Casanova attempted to exploit the fame of the fake painting of which he knew the true story since he was a direct collaborator of Mengs, the artist actually responsible for creating it. The latter kept the secret until, at the end of his life (1779), he entrusted it to his sister to be revealed after the funeral. Mengs' forgery is a product of the imagination based on antiquity (*Marsyas and Olympus*, formerly Herculaneum, reproduced in the *Antichità di Ercolano esposte*, 1757) and on reworkings of antiquity, like *Jupiter Kissing Cupid* (Rome, Villa Farnesina, Loggia of Psyche) or *Jupiter and Ganymede*, frescoed by Giorgio Vasari for the Roman villa of the Florentine banker Bindo Altoviti (no longer extant) and disseminated through the reduced-sized prints of the mid-19th century. The subject aimed to take advantage of Winckelmann's projection of his homosexuality onto his vision of antiquity. Entering the Albani collection in 1811, the painting was still famous when Goethe mentioned it in his *Journey to Italy* (1816–1817). In 1895 it appears as an anonymous copy of the 16th century in the Monte di Pietà auction. Long forgotten by scholars, it was noticed in 1950 during the reorganization of the Corsini Gallery by Anna Maria Morghen Tronti, who reconstructed its history.

CA

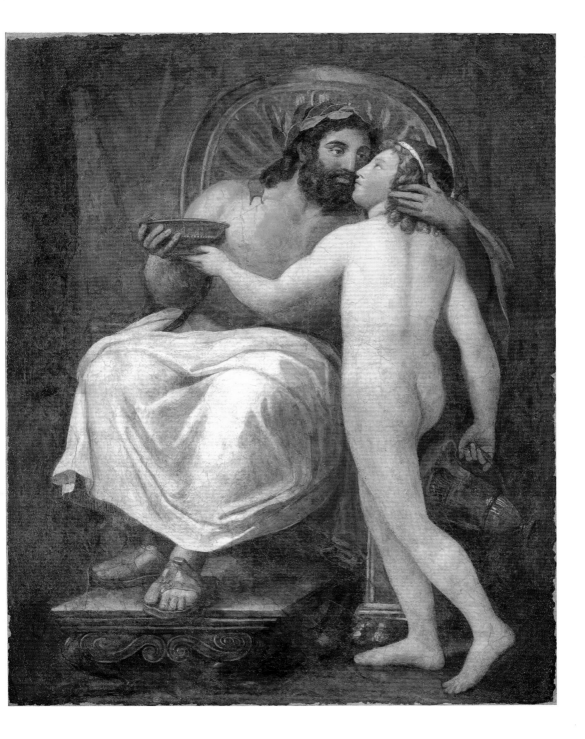

(Paris, 1733–1808)

Imaginary View of the Pantheon (The Dock)
1782
oil on canvas, 44 × 38 cm
Palazzo Barberini, inv. 2475 (1962, bequest of the Duke of Cervinara)

Bibliography: C. Boulot, J.P. Cuzin, in *J.H. Fragonard e H. Robert a Roma*, cat. of the exhibition (Rome 1991), ed. by Ph. Morel, Rome 1990, pp. 136–137 no. 83; L. Mochi Onori, *Galleria Nazionale d'Arte Antica di Palazzo Barberini. Dipinti del '700*, Rome 2007, pp. 165–166, no. 235 (with preceding bibliography).

Formerly in the Weil collection, the painting was acquired by the Duke of Cervinara and in 1960 passed to the Galleria di Palazzo Barberini as a testamentary bequest. It is an imaginary view in which the painter chooses to depict Piazza del Campidoglio and the Pantheon overlooking the river, creating a very striking scene in which the temple invades the space between the Palazzo dei Conservatori and the Palazzo Nuovo.

Signed and dated at the bottom center in the inscription on the plaque (SPQR / H. ROBERT / 1782 PINXIT / A CHOISY LE / ROY), Robert executed the work in France, to which he had returned after his long stay in Rome. In Rome, where he had arrived in 1754 in the retinue of the French ambassador, Étienne François de Choiseul, Hubert made some acquaintances crucial to his career: Giovanni Paolo Pannini, Giovan Battista Piranesi and Jean-Honoré Fragonard. Admitted to the courses of the French Academy, he attended the classes of Charles-Joseph Natoire who became his supporter. His meeting with Fragonard in 1756 was key to the painter's artistic development. With Fragonard, he made a trip to the south of the peninsula, to visit the antiquities of Naples, Pompeii, and Herculaneum (1760). He then travelled to Sicily. In 1765 he left Rome and in 1766 he was admitted to the Académie royale de peinture et de sculpture thanks to the *Architectural Capriccio with the Pantheon and the Porto di Ripetta* (Paris, École nationale supérieure des Beaux-Arts), a subject similar to that of the Barberini painting. A first version, in

the Liechtenstein collection of Vaduz, dates to 1761, as reported in the inscription (D.CHOISEVL / H.ROBERTI... /..ACADEMIAE.. / QVADR...1761). Compared to the previous versions, more similar to each other, the Cervinara painting is presented from a wider angle, with the building on the right being inserted to form a scenic backdrop. The foreground, shown from closer up, is populated by a group of men and women disembarking onto the dock.

Robert's repertoire combines archaeological taste with a visionary element assimilated from Piranesi. His numerous drawings of ruins are the starting point, the real world from which to move toward a fantastical and dreamlike vision. This formula was a great success with the public, as evidenced by his prolific production and the wide dissemination of his paintings and drawings.

CA

99 | Jacob Philipp Hackert

(Prenzlau, 1737–San Pietro di Careggi, Florence, 1807)

The Waterfall at Tivoli

ca. 1769
oil on canvas, 82.5 × 65.5 cm
Palazzo Barberini, inv. 1177

Bibliography: L. Laureati, in *Il Settecento a Roma,* cat. of the exhibition (Rome 2005–2006), ed. by A. Lo Bianco and A. Negro, Cinisello Balsamo 2005, p. 226, no. 118; L. Mochi Onori, *Galleria Nazionale d'Arte Antica di Palazzo Barberini. Dipinti del '700,* Rome 2007, pp. 125–126, no. 158 (with preceding bibliography).

The note on the back of the painting that placed Hackert in Tivoli in 1769 in the act of depicting the waterfall from life (*Peint d'après nature à Tivoli 1769 par Ja. Ph. Hackert*) is no longer visible today. After arriving in Rome in December 1768 with his younger brother Johann Gottlieb, Hackert established himself in the Caffè Inglese in Piazza di Spagna. From here he travelled to see the surroundings of the city, from Frascati to Albano to Palestrina, even residing in Tivoli for four months. The artist's presence and work here are also attested by Johann Wolfgang Goethe who, in his biography of the painter, recounts that he devoted himself to life studies of that area of the Roman countryside. In Tivoli "he painted, among other things, the famous waterfalls in a painting executed entirely from life, three feet high, which occupied him every afternoon for two months at the same time because of the light and its effect" (*Phlipp Hackert. La vita*, ed. italiana ed. by M. Novelli Radice, Naples 1988, p. 44). From the 17th century onward, the area became a destination for many foreign artists in search of inspiration, drawn by the picturesque charm of the waterfall. Hackert painted multiple versions of the same subject, which was in great demand along with his Tiber landscapes from the *grand-touristes* who fueled the success of his painting. His popularity probably earned him the hostility of less fortunate artists, such as Thomas Jones, who described him as a man capable of persuading others of his genius, of which he was so confident as to flaunt it. What is certain is that Hackert obtained the favor of powerful figures such as the Empress of Russia, Catherine II, and Ferdinand IV of Naples, by whom he was appointed court painter in 1786. In Naples, at the beginning of 1787, he met Goethe and became friendly with him. The latter contributed significantly to the artist's fame: "Today we visited Philipp Hackert, the famous landscape painter, who enjoys the special confidence and distinguished favor of the king and queen. A wing of the Francavilla palace was reserved for him, which he had decorated with an artist's taste and where he lives contentedly. He is a man of very clear and ingenious ideas who works tirelessly but knows how to enjoy life" (*Viaggio in Italia*, Milan ed. 2017, p. 206).

CA

100 | Luigi Bienaimé
(Carrara, 1795–Rome, 1878)

Dancer
ca. 1830
Marble, 177 cm
Galleria Corsini, inv. 1198

Bibliography: L. Cicognara, *Storia della scultura*, Venice 1818, III, p. 254; E. Borsellino, *Una "Danzatrice" di Antonio Canova dispersa in Russia*, "Paragone", XLIX, 19, 1998, pp. 2–29; Id., in *Canova e Appiani: alle origini della contemporaneità*, ed. by R. Barilli, Milan 1999, pp. 106–107; F. Leone, *Canova. L'ideale classico tra pittura e scultura*, ed. by S. Androsov, F. Mazzocca, A. Paolucci, Cinisello Balsamo 2009, pp. 268–270.

Though often thought in the past to be the original of a famous work by Antonio Canova, the Corsini *Dancer* is actually a faithful copy of it sculpted by Luigi Bienaimé, a student and close collaborator in Rome of Canova's great antagonist, Bertel Thorvaldsen. Canova's sculpture was executed by 1814 after the model was made in 1809 and purchased by the wealthy and unscrupulous banker from Forlì, Domenico Manzoni; however, he was unable to enjoy possession of it since he was murdered in 1817, before the statue was delivered. In 1830, Manzoni's widow put the marble up for sale and it was soon purchased, for 5000 *scudi*, by the Russian ambassador to Rome, Count Nikolaj D. Gurev.

Bienaimé's copy was commissioned shortly afterwards by Prince Alessandro Torlonia, who displayed it in his Roman palace—since demolished—in Piazza Venezia, before the work was donated to the recently established Galleria Nazionale in 1892, together with many other pieces from the collection. It is not known what led the prince to have the *Dancer* copied, whether pure aesthetic appreciation for a piece that was clearly already much sought-after or perhaps a more personal connection to the Gurev family, and in particular the ambassador's attractive wife, Marina Dmitrievna Naryshkina. She was said to be "very frivolous and [...] had a special interest in the banker Torlonia, who visited their palace by night"—as the Russian painter Fedor I. Iordan recalled in 1836 (*Note del rettore e professore dell'Accademia d'Arte F.I. Iordan*, St. Petersburg 2012, p. 162).

In any case, Canova's charming ballerina must have been extremely popular and several copies of it are known; all trace of the original, taken to Russia by the Gurev family, has been lost despite repeated attempts to find it. As Leopoldo Cicognara observed early on, the work embodied the neoclassical ideal of feminine grace with its "highly voluptuous beauty," and the dancer's sinuous figure was reminiscent of the serpentine line that according to William Hogarth was the distinctive feature of beauty (*The Analysis of Beauty*, 1753). The young dancer is captured at a moment of suspension, as if considering a new step, already barely suggested by her delicately raised foot. Bienaimé's sculpture replicates all these characteristics fairly diligently to judge from the plaster original held at Possagno, though its surfaces are worked in a flatter and more linear way, and the figure's expression has lost something of that "regard de coquetterie" that struck the more sensitive admirers of the time, like Quatremère de Quincy (*Canova et ses ouvrages*, Paris 1834, pp. 167).

MDM

Printed in the month of December 2021
on the presses of Esperia, Lavis (Trento)
ex Officina Libraria Jellinek et Gallerani